MAYDAY OVER WICHITA

THE WORST MILITARY AVIATION DISASTER IN KANSAS HISTORY

D. W. CARTER

THE
History
PRESS

Published by The History Press
Charleston, SC 29403
www.historypress.net

Front cover: Courtesy of Wichita-Sedgwick County Historical Museum (crowd) and 22nd Air
Refueling Wing History Office (plane).

Back cover: Courtesy of 22nd Air Refueling Wing History Office.

First published 2013

ISBN 9781540208491

Library of Congress Cataloging-in-Publication Data

Carter, D. W.
Mayday over Wichita : the worst military aviation disaster in Kansas history / D.W. Carter.
pages cm
ISBN 978-1-62619-052-8 (pbk.)
1. Aircraft accidents--Kansas--Wichita. 2. Airplanes, Military--Accidents--Kansas--
Wichita. 3. Aircraft accident victims--Kansas--Wichita--History--20th century. 4. African
Americans--Kansas--Wichita--History--20th century. 5. KC-135 (Tanker aircraft)--
Accidents--History. 6. United States. Air Force--History--20th century. 7. Wichita (Kan.)--
History--20th century. I. Title.
TL553.525.K36C37 2013
363.12'40978186--dc23
2013030401

In Memory Of

Crew Members:

Captain Czeslaw Szmuc, 35, North Royalton, Ohio
Captain Gary J. Widseth, 26, Minneapolis, Minnesota
Second Lieutenant Arthur W. Sullivan, 22, Miami, Florida
Staff Sergeant Reginald Went, 34, Baltimore, Maryland
Staff Sergeant Joseph W. Jenkins, 29, Middlesboro, Kentucky
Airman First Class Daniel E. Kenenski, 20, Harrisville, Rhode Island
Airman Second Class John L. Davidson, 21, Philadelphia, Pennsylvania

Wichita Residents:

Gary L. Martin, 17, 2031 North Piatt
Joe T. Martin Jr., 25, 2031 North Piatt
Clyde Holloway, 44, 2037 North Piatt
Tracy Randolph, 5, 2037 North Piatt
Dewey Stevens, 66, 2037 North Piatt
Claude L. Daniels Sr., 32, 2037 North Piatt
Mary Daniels, 56, 2037 North Piatt
Julia A. Maloy, 8, 2041 North Piatt
Julius R. Maloy, 6, 2041 North Piatt
Emmit Warmsley Sr., 37, 2041 North Piatt
Emmit Warmsley Jr., 12, 2041 North Piatt
Laverne Warmsley, 25 and her unborn child, 2041 North Piatt
Ernest E. Pierce Jr., 46, 2047 North Piatt
Delwood Coles, 34, 2047 North Piatt
Albert L. Bolden, 22, 2053 North Piatt
Wilma J. Bolden, 24, 2053 North Piatt
Leslie I. Bolden, 9 months, 2053 North Piatt
Denise M. Jackson, 6, 2053 North Piatt
Brenda J. Dunn, 5, 2053 North Piatt
Cheryl A. Dale, 2, 2059 North Piatt
Alice Dale, 47, 2059 North Piatt
James L. Glover, 22, 2101 North Piatt

Remembering and telling the truth about terrible events are prerequisites both for the restoration of the social order and for the healing of individual victims.

—Judith Herman, *Trauma and Recovery*[1]

CONTENTS

Acknowledgements 7

1. Seven Men 9
2. A Routine Sortie 17
3. Impact 22
4. Fire All Around 27
5. Going into Hell 31
6. The KC-135 42
7. Inside the Cockpit 52
8. Recovering Victims 57
9. Picking Up the Pieces 63
10. Racial Barriers in Recovery 72
11. A Divided City and Country 76
12. Why It Crashed: The Rumors 86
13. Why It Crashed: The Report 96
14. A Subtle Killer 106
15. The Settlement Process 112
16. Final Settlements 117
17. The Long-Awaited Memorial 122

CONTENTS

Epilogue 129
Notes 133
Bibliography 151
Index 157
About the Author 159

ACKNOWLEDGEMENTS

It would take a much larger volume to capture every story and document every heart touched by the Piatt Street tragedy. This short work is merely a glimpse, only a highlight, as far more could be said. Notwithstanding, primary source material is the lifeblood of historians, and the work of history is a never-ending search—lest we historians would soon be without employment. Therefore, I am grateful to many for their contributions in creating this chronicle.

First, I thankfully acknowledge the Piatt Street crash survivors and the victims' family members who shared their stories, historic documents and photographs with me: Mark Carlyle, Victor Daniels, Sonya House, Irene J. Huber, Clyde Stevens and Jeanine Widseth.

I express my gratitude to: Mary Nelson at the Special Collections and University Archives at Wichita State University Libraries, who made available numerous primary source documents on the disaster and Wichita history; Daniel P. Williams, the 22nd Air Refueling Wing Historian at McConnell Air Force Base, for his extensive help in locating source materials and photographs; and Pat Young, the Resource Collection Coordinator at the Disaster Research Center in Delaware for her assistance in finding taped interviews and valuable documents (once thought to be lost).

Additionally, I am appreciative for all those who aided me through the sharing of their firsthand accounts: Walt Campbell, one of the first firemen to arrive on scene that terrible day; Merv Criser, also a fireman, who provided me with an abundance of resources from the Kansas Firefighters' Museum that he has so meticulously preserved; and Earl Tanner, a Wichita

fireman who, like Campbell and Criser, battled the blaze on Piatt Street. Of great help, too, was Larry Hatteberg, who in addition to his story donated important and stunning photographs to this project, and Larry McDonough and John Polson, who provided vivid accounts of the events on the day of the disaster.

Others to whom I am indebted for their contributions are: Technical Sergeant Brandon Blodgett and Airman First Class Thomas Carter, for their extensive help with researching the KC-135; Gene Countryman for his support on the *Gene Countryman Radio Show*; Caitlin R. Donnelly, Head of Public Services at the Kenneth Spencer Research Library; Dr. Gretchen Cassel Eick, who was gracious in sharing her knowledge of the Civil Rights Movement in Wichita; Kansas Senator Oletha Faust-Goudeau, for her assistance in locating survivors and photographs; Jamie M. Haig, Division Manager for the U.S. Courthouse in Wichita, Kansas; Richard Harris, Chairman, Kansas Aviation Centennial; Ralph Hipp and his support from WIBW; Captain Benjamin Jamison and his help with understanding the complex aspects of aviation; the Kansas State Historical Society; Cindy Klose and her support at KWCH 12; KAKE-TV for providing still images; and Richard Kluger, one of the greatest social historians of our time, who graciously encouraged my efforts.

I must thank, too: Amy Renee Leiker, a reporter for the *Wichita Eagle*, who first broke the story of my book in print; Becky LeJeune, my Commissioning Editor at The History Press, for her passion and support of local history; my manuscript proofreaders, David D. Ross and Tess Wilson; Pat Moyer from KPTS, for a wonderful interview on *Impact*; Thom Rosenblum, a friend and historian for the National Park Service; the Topeka and Shawnee County Public Library; Jami Frazier Tracy, Curator of Collections at the Wichita-Sedgwick County Historical Museum; Van Williams, City of Wichita Spokesman; and J. Schafer, the voice of Kansas Public Radio, who gave me my first shot at publicizing the book on the radio.

And for their inspiration, I wish to thank: Apostle Cornelius Sanders II, PhD, whose faith, prayers and overwhelming support is beyond words; Paul and Laurie Browning, my family, whose love and enthusiasm for my work are without measure; and to my wife, Lyndzie, my chief supporter and advisor, who first read and edited the manuscript and endured my incessant talk about the project and who, above others, understands the solitude of a military historian.

With much gratitude and affection,
D. W. CARTER

1
SEVEN MEN

They were seven capable and confident men. Some were officers, some enlisted. Some wore bars, others stripes. Each was dressed in a sage green K-2B flight suit—affixed with an abundance of zippers, pockets and patches—distinguishing their ranks and titles. They carried maps, checklists and orders outlining their mission. Their time in service was wide-ranging, some longer than others. Most, though not all, had never set foot in Kansas. They came from all over: Ohio, Minnesota, Florida, Maryland, Kentucky, Rhode Island and Pennsylvania. Their occupations varied—pilot, copilot, navigator, boom operator and crew chief—but each had a specific commitment to the service that intertwined their destinies.

They were common men, young with high aspirations. Only two were above the age of thirty. All were determined; not one was passive. They lacked nothing in spirit, diligence or temerity. Each had a burning conviction of his devotion to country. None claimed to be a hero, though they were heroic. Each possessed his own talents, idiosyncrasies and flaws. But when assembled, they were a solid crew. These airmen represented another wave of patriotic, steadfast Americans heading into what had become, by 1965, an escalating and ultimately protracted war: Vietnam. Leaving their homes, serving their country, sacrificing time with loved ones, using all their strength, they were taking part in something bigger than themselves.

They were seven men in the prime of their lives, completely unaware of the grim fate awaiting them. And on the frigid morning of January 16, 1965,

they entered through the gates of McConnell Air Force Base (AFB) and onto the flight line for the very last time.

Duty-bound, their boots shining in the Kansas morning sun, they climbed aboard Boeing Aircraft Company's revolutionary design for aerial refueling—a mammoth KC-135A-BN Stratotanker with the tail number 57-1442, or "Raggy 42," as it was so nicknamed—to engage in a vital undertaking.

THE MISSION

Their mission was ironically named "Operation Lucky Number," but it was not their original assignment. Their orders were switched at the last minute from a refueling mission in the Pacific called "Flying Fish"—which developed as a result of the Gulf of Tonkin incident on August 2, 1964, when the USS *Maddox* opened fire on three North Vietnamese Navy torpedo boats of the 135th Torpedo Squadron.[2] The Gulf of Tonkin incident marked the beginning of America's deeper involvement in Vietnam. And with the passage of the Gulf of Tonkin Resolution only five days later, President Lyndon B. Johnson gained the authority from Congress "to take all necessary steps," the resolution said, "including the use of armed force, to assist any member or protocol state of the Southeast Asia Collective Defense Treaty requesting assistance in defense of its freedom."[3] Despite not having a formal declaration of war from Congress, the resolution provided a *legal* justification for Johnson to begin deploying U.S. conventional forces into Southeast Asia. It was also a signpost of America's further entanglement with and warfare against North Vietnam and communist aggression.

As a consequence of Johnson's actions, the resolution greatly affected members of the U.S. Air Force (USAF) stationed at air refueling bases. Bombers do not fly without fuel, and there was work to be done. Tactical Air Command (TAC) aircraft, frequently heading into Southeast Asia during this period, were refueled by KC-135s.[4] Strategic Air Command (SAC) bombers, making rotations to Andersen AFB in Guam, were refueled by KC-135s. And just about any U.S. military aircraft, needing close air support, especially in Vietnam, were often refueled by KC-135s. The United States dropped "three times as many bombs in Southeast Asia," one historian noted, "as it did in all of World War II."[5] The tremendous bombing and refueling by the U.S. military between 1965 and 1974 even gave rise to a new acronym amongst aerial refuelers: NKAWTG or "Nobody Kicks Ass Without Tanker Gas." Enough said.

The 22nd Air Refueling Wing (ARW), located at McConnell AFB in Wichita, Kansas, received the first of many KC-135 jet tankers to replace the slower, propeller-driven and less capacious KC-97 fleet on October 4, 1963.[6] Soon thereafter, the KC-135s at McConnell were actively engaged in air refueling missions to support bombers. One such operation, known as Operation Lucky Number, involved the flight-testing of modified B-52s for low-level flying in Vietnam. The 70th Bombardment Wing, then located at Clinton-Sherman AFB in Oklahoma (which included the 6th Bombardment Squadron and 902nd Air Refueling Squadron), began strategic bombardment training and air refueling on February 1, 1963, with B-52s and KC-135s.[7] Between 1964 and 1965, the 70th provided "refueling support for experimental flight tests conducted by Boeing Company under contract to the USAF."[8] Thus, Operation Lucky Number emerged as an arrangement between Boeing and SAC.

The Airmen

The KC-135 they climbed aboard that morning was from Clinton-Sherman AFB, not McConnell. Likewise, the seven men flying Operation Lucky Number were from the 902nd Air Refueling Squadron (ARS) and the 70th Organizational Maintenance Squadron (OMS) at Clinton-Sherman, not the 22nd ARW. Aircraft commander, Captain (Capt.) Czeslaw "Chester" Szmuc; copilot, Capt. Gary J. Widseth; navigator, Second Lieutenant (2nd Lt.) Arthur W. Sullivan; and boom operator, Staff Sergeant (SSgt.) Reginald Went, were all from the 902nd ARS, while crew chief, SSgt Joseph W. Jenkins; assistant crew chief, Airman First Class (A1C) Daniel E. Kenenski; and assistant crew chief, Airman Second Class (A2C) John L. Davidson, were from the 70th OMS.[9]

Capt. Czeslaw "Chester" Szmuc—square-jawed with a muscular build, who had flown for nearly a decade and possessed an impressive flying record—was considered by his peers to be an extremely skillful pilot. Chester was a disciplined martinet: laconic, detailed and easily distinguishable as a military commander. His crew felt "he could manage anything that came in front of him," as his copilot once said.[10] They respected him not because of his rank but because of his ability to lead. The oldest of the crew members at thirty-five, he was from North Royalton, Ohio, and unmarried—that is, except to the air force.

He was also anxious to get on with the mission. Chester had called back to Clinton-Sherman AFB three times earlier in the week expressing his agitation about the assignment being scratched due to the cold and cloudy weather in Wichita. When Friday arrived, their mission canceled yet again on account of weather, they were now four days behind schedule. Chester—trying to avoid further delays and salvage the mission—called again at noon and obtained approval to run the mission on Saturday, January 16, at 8:00 a.m.[11] If the weather cooperated, his crew would finally complete their assignment and then recover at Clinton-Sherman. Chester was due home that Saturday.

Jeanine Widseth once told her mother she was going to marry someone who loved and respected her. When she eventually met Gary on a blind date on January 1, 1958, she knew she had found him. Tall and slender with clear brown eyes, Gary J. Widseth, the copilot, was twenty-six years old. He was born in Iowa and later moved to Minnesota, where he met Jeanine. As a child, Gary dreamed of flying and entered an aviation cadet program in 1958 before receiving his wings in September 1959. Gary was dynamic, jocose and very much a gentleman. He and Jeanine were married on September 2, 1959, and a good marriage it was. They adored each other. Always chivalrous, he once told Jeanine, "If I don't open the door for you, it's grounds for divorce."[12] He kept his promise.

Captain Czeslaw "Chester" Szmuc. *AP Photo.*

Gary was also skilled in his craft: aviation. He flew the propeller-driven KC-97, the predecessor to the upgraded KC-135 jet tanker, which he had now flown for two years and preferred over the much slower 97.[13] Jeanine made a hair appointment for that Saturday when she learned Gary was coming home after a long week of delays in Wichita. She couldn't wait for him to get back to her and their three children. Besides, she hoped he would arrive in time for them to attend a banquet that evening—an event well worth her trip to the salon. Gary was her "dream man," she would later say, remembering how handsome he looked in his flight suit, even though it was troublesome to iron.[14]

Captain Gary J. Widseth (fourth from left). *Jeanine Widseth.*

Captain Gary J. Widseth (back row, third from right). *Jeanine Widseth.*

Once, on the morning of November 22, 1963, when Gary was assigned to pick up some "important people" and fly them to Dallas, she labored tirelessly trying to iron wrinkles out of that awkward flight suit with all of its zippers and pockets—only to find out later her efforts were in vain when the mission to Dallas was canceled on account of President Kennedy's assassination.

"The 1960s were difficult times for our country," Jeanine expressed, but she never worried about Gary when he was out on his missions because he was in capable hands.[15] "They were a good crew," said Jeanine, reflecting on her husband and his team.[16] Gary was due home that Saturday.

Just returning from a temporary duty assignment (TDY) in Spain, not yet twenty-one years old, A1C Daniel "Danny" E. Kenenski was having the time of his life working as an assistant crew chief. He grew up in Harrisville, Rhode Island, and enlisted in the air force at eighteen after graduating from Burrillville High School in June 1963. Like many young men, Danny planned to put himself through college with the GI Bill and eventually become a pilot. As one friend described him, Danny "was very much on the ball...knew what he wanted and how to go about getting it."[17]

Athletically built, with light green eyes and a fair complexion, Danny exuded confidence, drawing the attention of any room he entered. He was a voracious reader, but his passion—as the many letters he penned told—was writing. Danny wrote home at length, at different times and in various places, speaking of the new world he had found outside of Rhode Island and his experiences in the air force. In a letter dated May 16, 1964, he wrote about a disturbing KC-135-B plane crash at Clark AFB in the Philippines. Examining the wreckage the next morning, Danny described the crash to his family back at home: "It was a sight I don't ever want to see again in my life...if one didn't know what a '135' looks like in detail he would surely not be able to distinguish this."[18]

Danny was also madly in love with his high school sweetheart, Carol Morgan, and planned to propose the following month on Valentine's Day. His mother, Wanda, excited for their bright future together, was holding on to the engagement ring until he returned.[19] Danny was due home that Saturday.

Airman First Class Daniel E. Kenenski. *Irene Hubar (Kenenski)*.

Left: Second Lieutenant Arthur W. Sullivan. *AP Photo.*

Right: Staff Sergeant Reginald Went with his wife, Vivian Bozeman. *Mark Carlisle.*

2nd Lt. Arthur W. Sullivan left behind the warm sunshine and clear beaches of Miami, Florida, to become a KC-135 navigator at Clinton-Sherman AFB in Oklahoma. Sullivan was clean-cut, witty and possessed the keen mind required to perform as a navigator on the KC-135—with its heavy emphasis on physical sciences, meteorology and mathematics—before GPS, inertial and other long-range navigation systems were commonplace. Now in the air force for two years, just starting his career at twenty-two years old, he was only one week away from welcoming his son Arthur Jr. into the world. His wife, Virginia, due to give birth back in Elk City, Oklahoma, was eagerly awaiting his return.[20] Arthur was due home that Saturday.

Among the others were SSgt. Reginald Went from Baltimore, Maryland, whose wife and child were expecting him home soon. Thirty-four-year-old Reginald was the second-oldest member of the crew and had the tedious job of operating the "boom," an innovative mechanical probe attached to the rear of the KC-135 used for refueling planes.

SSgt. Joseph W. Jenkins, twenty-nine, was a crew chief from Middlesboro, Kentucky, with five children and a wife waiting for him back at Clinton-Sherman. A2C John L. Davidson, twenty-one and single, grew up in

Philadelphia, Pennsylvania, and was an assistant crew chief. Both Davidson and Jenkins, along with Danny Kenenski, were the ground crew for the KC-135—responsible for basic maintenance.

With less than twenty-four hours to go, having spent nearly a week at McConnell, these seven men were ready to get back to the wives, fiancées, families and friends who were all anticipating their arrival. On Friday afternoon—to take their minds off the disappointing week and ease the melancholy—Sullivan, Widseth and Went headed for a movie in downtown Wichita. The glowing marquee above the Orpheum Theater at 200 North Broadway Street broadcasted the blockbuster movie *Goldfinger*, the third and most popular film in the James Bond series with a young Sean Connery portraying the suave MI6 agent.[21] Not up for a movie, Davidson, Szmuc, Kenenski and Jenkins relaxed at a private bottle club adjacent to their hotel.[22] With the first clear day of the week finally appearing on Saturday morning, they were rested, relieved and ready to complete their mission. They were all due home that Saturday.

2

A ROUTINE SORTIE

A light northeast wind chilled the morning air, rustling against their thin flight suits as they marched. Steamy clouds—created by steady breaths issuing forth from their lungs—surrounded them. The cadence of thick leather boots pounding the concrete ramp beneath them echoed down the flight line. Their rhythmic footsteps told the story of men who walked with purpose and resolve. Above them was an unblemished Kansas sky; behind them, a disappointing week. The hulking mass in front of them—their ride home—bore broad, black numbers, reading, "1442" on its tail. They were glad to see it.

Capt. Szmuc, Capt. Widseth, 2nd Lt. Sullivan and SSgt. Went, bags in hand, arrived at Base Operations well before 7:30 a.m. to begin the morning briefing and obtain weather reports. Having received a thorough briefing the day prior at Operations, this morning was only a refresher and took little time. By 7:50 a.m., the briefing had concluded. Foregoing the ten-minute wait before their scheduled 8:00 a.m. release time, Szmuc and his men chose to head toward 1442 and begin preflight inspections. "They elected to go to the airplane and stand by," said Capt. Buswell, the tanker scheduler assigned to 1442, "to give them ample time for preflight checks, et cetera."[23] Crew Chief SSgt. Jenkins, A2C Davidson and A1C Kenenski were already at the plane performing their own preflight inspections.

The steadfastness of the entire crew was evident that morning. Those who witnessed them in action described Szmuc and the others as being "alert," "confident" and punctilious in their behavior.[24] Though not a combat mission, the aerial refueling of a B-52 was not to be taken lightly. Their plane was, after

all, bloated with highly flammable jet fuel. The stately tanker was loaded with approximately thirty-one thousand gallons of JP-4 jet fuel for the mission, stored in six wing and four fuselage tanks.[25] In the days prior, the mission planners had already designated the amount of fuel, where it was going and how much was to be distributed. Now, the crew focused on meticulously inspecting the vessel that would carry them home—a tedious procedure requiring due diligence.

The technical orders carried by Jenkins, Davidson and Kenenski included an aircraft inspection checklist. It required them to examine the outside of the plane—brakes, wheel and tire assembly, paint—and to search for hydraulic leaks, corrosion of parts and rivets or anything that looked irregular. On the engines, they studied the rotor blades, looked for dents, breaks or bends caused by birds. Inside the plane, they inspected the oxygen systems, breathing regulators and checked the lights on the boom. Arriving after the crew chiefs, Szmuc, Widseth and Went performed their own operational checks, placing a second set of eyes on the plane—looking through the checklist forms for any discrepancies and performing a walk-around inspection of Raggy 42—ensuring it was mission-ready. Inspection took about an hour.

THE NINETEENTH MISSION

The proposed experimental flight was the nineteenth conducted under Operation Lucky Number. At first, when they received their orders the week before, it looked to be another routine mission: they were to "go up, make a hook-up or two" and return to base in a couple of days.[26] Clinton-Sherman had just received a safety award from SAC for six years without a flying accident. Nothing suggested this mission would be anything other than prototypical, like the previous eighteen had been.[27]

At 4:20 p.m. on Tuesday, January 12, 1965, the crew departed from Clinton-Sherman headed for McConnell. After a scheduled refueling in the Boothhill Air Refueling Area, they reached McConnell at 9:50 p.m. Boeing Operations handed them their flying orders shortly after arriving, and the men bedded down at a local Holiday Inn for the evening.[28] With nothing on the schedule for Wednesday, the crew rested.

But then, much to their disappointment, they were grounded due to weather on Thursday, January 14, and Friday, January 15. As is the case so often in Kansas, the caprices of weather could not be avoided. Subzero temperatures gripped the nation that week. Northern states—Minnesota,

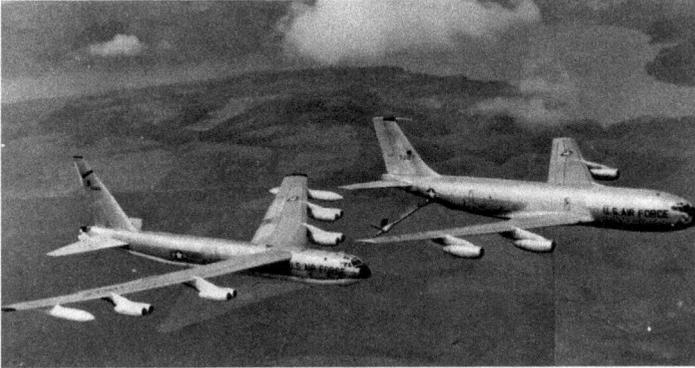

KC-135 refuels a B-52. *22nd Air Refueling Wing* (ARW) *History Office.*

South Dakota, Montana, Michigan and even Iowa—recorded freezing temperatures and snow. In Kansas, a cold front set in on Tuesday afternoon with winds up to forty miles per hour. "Partly cloudy and colder" became the weekly forecast for Wichita.[29] The crew would not see a clear sky until Saturday, and even then, temperatures remained algid.

On Friday, January 15, when Szmuc was calling back to Clinton-Sherman to gain approval to run the mission on Saturday, McConnell was busy activating a new air rescue detachment. The turbine-powered Kahman HH-43 B Husky—a portly helicopter with intermeshing rotors, used primarily for rescue and aircraft firefighting in proximity of air bases—was on alert "to rush to military and civilian plane crashes in the Wichita area."[30] The plan called for the Husky to "use rotor blast to help control fire and protect persons" after ferrying the rescue team to the crash site.[31] The rescue team, however, only went on alert when McConnell's F-105 Thunderchiefs were flying, not the KC-135s. Szmuc and his men would receive no such support from the newly formed aircraft firefighting unit.

THE LAST-MINUTE SWITCH

If it were a normal training mission and not a TDY, four airmen would have sufficed: two pilots, a navigator and a boom operator. But because they were completing this unique refueling mission, the additional airmen were necessary to help perform any maintenance the jet might need once they arrived at their destination.[32] The original orders, according to Chief Master Sergeant R. H. Grant, the noncommissioned officer in charge of the tanker flight line at Clinton-Sherman, were to fly to the Pacific for a fighter-refueling mission named "Flying Fish." However, because 1442 had

mechanical trouble with its boom, there was a last-minute switch, and they were reassigned to Wichita before they left Oklahoma. Grant later testified about why the switch occurred:

> *1442 had had trouble with his boom and he was still in the air on Thursday and we were told that 040 would take the "Flying Fish" mission [to the Pacific] instead of 1442 because of this boom trouble to make sure he didn't have trouble on this "Flying Fish" mission…[The] crew for 1442 took 040 on "Flying Fish" and the crew that was assigned to 040 took over 1442 while 040 was gone on the "Flying Fish" mission.*[33]

Despite the mechanical problems of 1442, the last-minute switch in crews (a common occurrence even today) and repeated delays in weather, the crew pressed on.

TAKEOFF

During preflight inspections that morning, the crew detected a problem with the number one engine on 1442 and technical problems with the autopilot. KC-135s, new as they were, often experienced such mechanical problems. The B-52 pilot scheduled to follow Raggy 42 on the mission, James M. Adams, commented, "I assumed if [Capt. Szmuc] got trouble we won't go; if he doesn't have trouble, we will go. He is certainly capable of isolating and treating his own problems properly."[34] The "trouble," in this instance, was only minor. Raggy 42's number one engine encountered a "hung start"—where, due to "icing of the burner pressure sense line," the RPM remained at a low value (in this case, 40 percent) instead of increasing to the normal idle RPM—delaying the flight for ten minutes.[35]

Once the delay was over, Raggy 42 rolled south out of its parking spot to begin taxiing down the runway. Adams recalled how Captains Szmuc and Widseth were going through their normal checks while taxiing and stopped at the end of the runway on the west taxiway. Adams parked about 150 feet behind them, awaiting takeoff instructions. At 9:18 a.m., Szmuc radioed to McConnell Tower, "Standing by clearance any time you receive it," and at 9:26 a.m., clearance was given: "[C]hange to departure control frequency 307.9 cleared for takeoff 36 left."[36] Raggy 42, its engines wailing, scuttled down Runway 36, picking up speed as it went.

The jet engines on Raggy 42, as with all KC-135s built at the time, were Pratt & Whitney (P&W) J-57-P-59W turbojet engines. They were extremely noisy, water-injected engines—sputtering out smoke and vapor but producing enough thrust

(approximately 10,000 pounds when dry and 13,000 when wet) to ensure the aircraft could get off the ground safely.[37] As the air force soon found out, however, "the capabilities of these engines imposed limitations on the takeoff maximum gross weight of the aircraft."[38] Climbing was difficult, and the weight didn't help. The nearly 31,000 gallons of JP-4 jet fuel carried by Raggy 42 was heavy, adding several thousand pounds to the plane, which, when fully loaded, would have weighed approximately 297,000 pounds (148.5 tons).[39] According to Boeing Control Tower operator Kenneth McKee, he was surprised at Raggy 42's struggle to climb during takeoff. He picked up his glasses and took a closer look:

> *The reason I picked up the glasses was the fact that he had lifted off what I thought at the time was pretty low. However, he maintained that altitude clear on through and executed his turn to the west or northwest and started his climb. So then I laid the glasses down and thought no more about it...*[40]

The FAA controller at the Municipal Tower, Delbert J. Massey, observed Raggy 42 departing as well and recalled, "Everything was normal. I tracked him out, and he went straight out on the runway heading. There was no deviation, and the takeoff roll was normal."[41]

The flight plan called for a left turn toward Hutchison, Kansas, after takeoff. Raggy 42 made its initial climb and went approximately four miles north before asking permission to start the left turn. When permission was granted, and Capt. Szmuc steered Raggy 42 into the left turn, all hell broke loose. The next—and last—communication was eerily grim:

9:29 a.m.	Capt. Szmuc:	"Departure 42, Are we cleared for a left turn[?]"
9:29 a.m.	Departure Control:	"Left turn climb on course. Stand by for hand-off to Kansas City Radar 4."
9:29 a.m.	Capt. Szmuc:	"Roger 42."
9:30 a.m.	Capt. Szmuc:	**"May Day, May Day, May Day, This is Raggy four two."**
9:30 a.m.	Departure Control:	"Raggy four two—ah—you're cleared to tower, you're seven northeast cleared back to tower, cleared to land, or if you can—eh—land municipal."
9:30 a.m.	Departure Control:	"What's ya trouble four two?"[42]

There was no response, only silence.

3
IMPACT

You know, it just seems the Good Lord must have looked the other way for a moment.
—*Cora Belle Williams, 1965*[43]

It was a cold, quiet morning. Little was stirring throughout the city. The sun peeped over the Kansas horizon at 7:43 a.m. but hardly warmed the frigid air. Steam billowed from chimneys atop small houses up and down Piatt Street, and icicles hung like pristine chandeliers from doorways. It was the "lazy kind of Saturday morning," one reporter remembered, "when even sapphire blue skies and dry streets could not tempt many people to brave the 11 degree chill."[44]

Cora Belle Williams was nestled in her favorite swivel chair and gazing out of her living room window at 2048 North Piatt, taking in the idyllic scenery. Joe Martin Jr., a twenty-five-year-old army veteran, was preparing to leave his home at 2031 North Piatt in order to drive his teenage brother, Gary, a junior at Wichita Heights High School, over to a friend's house. Clarence Walker had just laid out his clothes for the day and started running his bath water inside of 2101 North Piatt. Others were either asleep or just starting their mornings, too, in the close-knit, African American neighborhood. It was an ordinary Saturday, nothing out of the norm.[45]

Also stirring about that morning, the children inside of the House family residence were watching *Mighty Mouse*, an important part of their Saturday morning cartoon ritual. The strong aroma of bacon and eggs drifted from room to room. Sonya House, short and petite with a bright disposition, was wearing her muumuu dress and cozy house slippers. She had just cooked a

hearty breakfast for her nephew and son, who were enthralled by the cartoon mouse on the living room television. All was peaceful, calm. Sonya's father, the tall and sharply dressed Robert T. House—wearing a white dress coat, slacks and black-framed glasses—was returning from Razook's Thriftway Market at 2148 North Piatt, just a few yards away from their home. Robert, who was originally from the tiny town of Dover, Oklahoma, was a retired railroad worker and father of ten girls. He was running an errand that morning while his wife, Mary A. House, was out with one of their daughters.

The tranquil morning, however, was interrupted just before Robert returned home. Sonya was disturbed by what she thought was the roar of the television set in the next room. She could hear the noise from her bedroom and assumed, at first, that one of the children had playfully turned up the volume. As she approached the living room, it only grew louder. Troubled by the awful noise, Sonya remembered thinking to herself, "I better turn that TV off; it's going to explode!"[46]

She quickly discovered the roaring sound was not *Mighty Mouse*. It was coming from outside. Walking into the living room to turn down the volume, she saw the children's eyes were transfixed on the front window, observing a most horrific sight just beyond the glass. A thundering, giant gray object was overshadowing the tiny houses, coming closer with every second. The imminent terror cast by the seething mass was breathtaking. It was as if a colossal spaceship were landing in their neighborhood, like something right out of a science fiction novel. Panic ensnared Sonya's cheerful countenance, her face froze with fear.

As she neared the front window to get a better view, there was Raggy 42—engines screaming, going to pieces and plummeting toward the earth at several hundred miles per hour with its ill-fated crew aboard. She then saw her father, Robert, desperately running toward the house, terrified by the heinous sight behind him. For those in the immediate vicinity of the distressed KC-135, Sonya realized with dread that there was no escape. Alone next door, Mrs. Fred Balenton could only watch in horror as the massive shadow bore down on her home. "It was a terrific noise," she recalled. "I just hollered out and said, 'It's going to hit the house!'"[47] They were trapped.

SHOCKWAVE

Four miles away, at a cathedral near the intersection of Central and Broadway Streets, Larry McDonough was about to marry his fiancée, Kathy Angley.

23

Suddenly, the priest burst from his office and called the congregation's attention to a north-facing window. The scene outside the window "looked ominous," Larry remembered.[48] A menacing plume of black smoke was rolling upward from north Wichita, spreading across the sky like a dark pall. It was a foreboding sight.[49]

Three miles away, Capt. Earl Tanner was relaxing on his day off from the Wichita Fire Department (WFD). Shortly after 9:30 a.m., his house shook abruptly, and his windows rattled. Then, his phone rang. It was Fire Chief Tom McGaughey, who told Tanner, "Hit the road...It's a big plane!"[50]

Two and a half miles away, at 13th and Waco Street, twelve-year-old Barbara Frederickson was sitting in class at Holy Savior Catholic Church when the children dashed toward the window, frightened by an awful roar outside. "I saw smoke trailing from the rear," said Barbara, "then the plane dropped out of sight. I saw a bright glare that hurt my eyes."[51]

Nearly a mile and a half away, a shopkeeper working at 21st and Market Street recalled the front door to his business being swiftly blown open with a gust of wind and his walls shuddering from a quick vibration.

Ruby Brown, who lived five blocks from the crash site, said she was awakened by a high-pitched "whistling and spitting" that sounded like a monster outside of her bedroom window. "It was just like an earthquake. The floor trembled beneath me. I've been in an earthquake before," said Ruby, "and that's just what it felt like." Ruby ran to her front door and discovered that "everything was all black as if somebody had blotted out the sun. The smoke had an awful smell, and it began to choke me, so I closed the door and watched from my window."[52] Just beyond the wall of smoke and fire, her neighbors were fighting for their lives.

Two blocks away, ten-year-old Victor Daniels was stirred by a terrible rumble overhead and the ground shaking violently. Running toward Piatt Street to find out what happened, he encountered chaos, panic and grisly images—Victor's father, grandmother and three cousins were inside of 2037 North Piatt, now consumed with implacable fire.[53]

Mildred Hill was working in her small carryout restaurant a block and a half away from the impact point. A thick, steel door located at the back of her business was thrust wide open by the vehement force of Raggy 42's collision. "I had a kitchen knife stuck in the door by the lock to help hold it shut. It snapped that kitchen knife in two like it was a matchstick," said Mildred. The heat wave that followed felt "just like you were standing right up against a hot stove...I had to hold the door shut to keep it out or I wouldn't have been able to stand it," she remembered.[54]

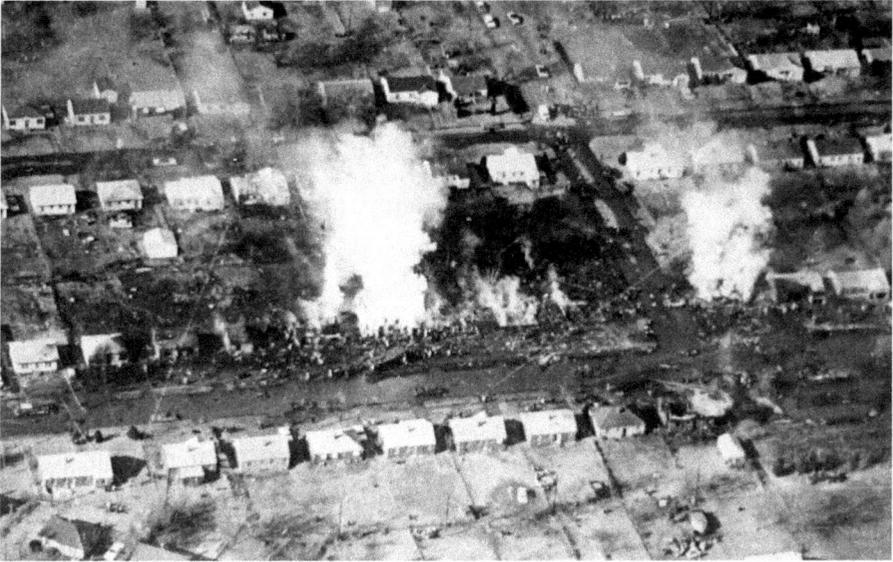

Aerial view of Piatt Street burning. *Kansas Firefighters' Museum.*

One block southwest of the impact point, at 1950 North Minnesota, Mrs. Edward Johnson was drinking her morning coffee in her kitchen when a three-foot-long slab of metal from Raggy 42 pierced the roof, nearly decapitating her.[55] One of the wings from Raggy 42 sheared off and cut the Allens' residence at 2065 North Piatt in two—slicing through the front room and bedroom but, amazingly, leaving the occupants unharmed.[56]

A sixteen-year-old boy, Stu Markey, working as a carryout only yards away at Razook's supermarket, described the terrifying scene he witnessed while putting groceries into a car:

> *I was walking back to the store when I happened to look up. I didn't hear anything, but I saw this huge plane barely above the rooftop. The plane was banking to the left, and smoke was pouring out of the midsection. I looked at it again and dived behind a car. The concussion was so strong it rocked the car. When I looked up again, it seemed as if the whole ground was on fire with flames shooting higher than I've ever seen. I ran back to the store.[57]*

Some thought it was an earthquake; others thought there was an explosion at the Derby Oil Refinery nearby. Many witnesses remembered hearing what sounded like a tornado just before the impact.[58] The heat

wave and concussion from the fallen tanker were far-reaching. Window glass on cars and houses instantly shattered for several blocks. The large display windows at Razook's supermarket burst almost immediately.[59] Automobiles were flipped upside down like pancakes, trees were uprooted and straightaway torched, lampposts became twisted metal wires and houses were violently pockmarked by flaming debris hurled from the wreckage. Homes once full with furniture and people were now scattered. "Stoves, refrigerators, hot water tanks, and even the bathing facilities...the bath tub, shower stalls and toilet stools, were completely blown clear out in the backyard," recalled witnesses.[60]

Fragments from the tanker shot out like missiles, ripping through walls and ceilings, while the shockwave carried by the explosion hurled residents from their beds and across their living rooms. As Cora Belle Williams at 2048 North Piatt remembered, "The explosion picked my chair up off the floor, tumbled me out of it and threw me across the floor." The window she had been peacefully gazing out of only seconds earlier was now in pieces. "I grabbed my daughter and ran out the back door, I tried to get into the front yard, but the heat was too much," said Williams.[61]

Ola M. Sanders, who was relaxing inside her home at 1627 North Ohio when the crash occurred, described the frightful morning:

> We were indoors, watching television, drinking coffee. All of a sudden there was a "whomp!" and the windows and doors bowed in and out, like they'd sucked in a deep breath and let it out. We ran outside to look, and to the north, we could see this huge cloud rising. We thought the Russians had dropped a bomb on us...we saw all the people standing around and the houses on fire. It was like everybody was in a state of shock, just standing there.[62]

Death and destruction claimed Piatt Street that morning. Few made it out alive. At 204 South Main Street, above Wichita's original 1892 City Hall Building, the lofty clock tower read the time: 9:31 a.m. Four minutes had passed since Raggy 42 departed the McConnell runway.

4
FIRE ALL AROUND

Scorched and flaming, fateful jet,
While upon a homeward flight;
Lost control, nosedived into the earth;
Leaving fuel clouds black as night!
—Ellen Anderson, 1965[63]

What many thought to be an earthquake or massive bomb exploding was in fact the earsplitting crash of Raggy 42 smashing nose-first into the area of 20th and Piatt. The plane buried itself fifteen feet—the height of an average one-story home—into the ground, leaving an enormous impact crater similar to that of a meteor strike. Over "300,000 pounds of steel, fuel and flesh" spiraled down all at once with tremendous force.[64] It crashed so quickly that most felt only the impact and then saw an eruption of red flames bursting in all directions. The thick steel structure of Raggy 42 crumpled like tin foil as it cut into the city street. The booming sound of oxygen tanks, pressure tanks and hydraulic lines exploding caused many to think ammunition had been aboard the aircraft (a rumor the air force would later dispel).

The worst part, however, was the fifty tons of jet fuel that erupted into a five-hundred-foot-high fireball, permeating the tiny homes on Piatt Street. Ten-year-old Sharon Johnson, who lived a half a mile away at 1842 North Pennsylvania, remembered seeing the gigantic fireball as she looked out her kitchen window. Watching the plane smash into the ground and then ignite into a monstrous inferno—covering nearly five acres—was too overwhelming for the young child. She fainted.[65]

Delwood Coles, thirty-four years old, had just climbed into his car at 2047 North Piatt to pick up a friend. But as he leaned forward in his front seat to turn the ignition, the KC-135 hit. The torrid jet fuel incinerated Delwood in his vehicle so rapidly that he was unable to react—a situation reminiscent of Pompeii in AD 79, when Mount Vesuvius erupted, scorching unprepared victims in place and leaving their bodies frozen in ash. Delwood was later found by firemen, in mid-turn of the key, his skeleton still leaning forward within the burned-out car frame.[66]

Clarence Walker, fifty-five years old, was preparing to take a bath inside his home at 2101 North Piatt when his living room exploded with fire. His wife screamed in terror as their television, pictures, furniture and family heirlooms melted beneath the scathing heat. They staggered about, frantically looking for a way out of what had suddenly become a death trap. Clarence darted back into the bathroom, trying to escape through the window, but found it sealed shut. "[T]hen the oxygen got so low I couldn't breathe," he remembered, "and I got down on my hips in the bathtub and said, 'Lord, here I am. I'm ready to go!'" Much to his surprise, Clarence was given another chance:

> Then a vision came to me and said, "You've got a few more seconds," then I saw the clothes hamper in the bathroom and I got up and rammed it through the bathroom window, and I followed immediately out the window.[67]

Cut severely by shards of glass as he leapt out the window naked, Clarence landed in a puddle of flaming jet fuel while his wife escaped on the other side of the house through the blown-out back door. Their entire backyard "was boiling in fire," and the engulfed home collapsed seconds later as they desperately ran from the sea of flames.[68] Twenty-two-year-old James Glover, asleep in the front bedroom, never made it out. "He was completely demolished," said Clarence. "I don't think he had ever got up considering the way they say they brought him out."[69] His remains were later found, still in his bed.

Robert Jackson, only twelve years old at the time, was walking to the grocery store just before the plane hit. Attempting to outrun the tanker bearing down on him, he quickly found himself rolling in the dirt to smother the flames that were melting his thin jacket onto his skin.[70] "I ran and ran and ran," said Robert, "and the plane came lower and lower and the engine got louder and louder." Hospital officials at St. Francis stated, "But for the synthetic fiber jacket, he would have received severe burns on his back."[71] Robert, although in the vicinity of the plane when it fell, had miraculously survived the crash. He was the exception.

The merciless hellfire scorched everything in its path—houses, cars, trees, front lawns, pets and human beings. No one was safe, and no one in the immediate

area of the gushing jet fuel was spared. It was, as one reporter noted, "like a small Hiroshima," with carnage, fire and smoke everywhere you looked.[72] The impact of the crash imploded windows in homes, allowing the flaming jet fuel to creep inside and burn the occupants to death. "We could hear our neighbors screaming," a survivor said. "[M]ost of them were still asleep or just eating breakfast."[73] A horrid lake of fire raged on as awful moans of agony shot out from those trapped inside the blue and orange flames. "No one tried to save any of the trapped," claimed a reporter first arriving on scene. "It was too late. Most of the homes had been flattened and all were burning."[74]

The small number that attempted rescues, such as the Reverend J. E. Mason, encountered ghastly sights. Mason ran through the thick smoke on Piatt Street trying to hustle disoriented neighbors out of the area. "I went into one house," he told reporters, "and saw a 5-year-old boy burn to death with his hands up in the air. There was nothing I could do at that house." As people were "crying and struggling to get into the burning houses for their relatives," Mason grabbed several hysterical victims and kept them from the futility and probable self-demise of entering the ferocious blaze.[75]

Entire families were swallowed up by the inferno (the Daniels, the Warmsleys, the Boldens, the Maloys), children were burned alive in their beds and others were incinerated trying to escape in their cars. The screams of men like Joe Martin, who lived at 2031 North Piatt, could be heard among the panic and chaos: "My boys in there! My boys in there!…Oh, my Lord, oh my Lord, both my boys burned up."[76] Joe was seen staggering about the neighborhood in a daze wearing only an unbuttoned shirt—the loss of his sons too great to comprehend.[77] Ellison W. Brown, an airman stationed at McConnell, was later found sobbing amidst the wreckage of what was once his friend Albert Bolden's home. Albert was to have been Ellison's best man at his wedding. The charred ruins and fumes of smoke were all that remained. Albert and Wilma Bolden, along with their nine-month-old daughter, Leslie, all perished inside.[78]

Some, too, would never forget the morbid sight of children on fire in their front yards like "stick[s] of wood."[79] The most accurate description came from a reporter a month later, who described the area of impact as looking like a "[t]ornado pushing fire ahead of it had passed through."[80] Destruction of this kind had never been seen before in Kansas.

For Sonya House—not yet thirty years old—who saw the plane crash sixty-seven feet away in front of her living room window, the sight was indescribable, too awful for words. Sonya recalled, "I didn't know what happened…It was burning like hell, and that's what I thought it was. That's all I could see was fire."[81] Her father, Robert, was violently thrown against the

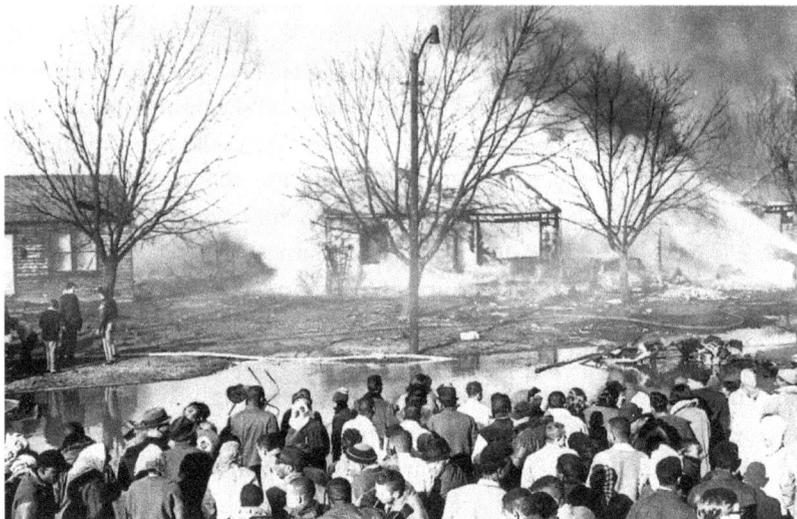

Piatt Street engulfed in flames. *Wichita-Sedgwick County Historical Museum.*

doorframe by the explosion as he desperately raced inside to help gather his family. Fortunately for some, the fire was so concentrated in the area of 20th and Piatt that it either killed the residents instantly or left them unharmed.

As Sonya rushed out onto her front porch, she saw what looked like a warzone. "The fire was everywhere, and it was rolling down the street. It looked to me like everything in the world was on fire," she recalled.[82] A wall of flames the size of a city block burned hundreds of feet high as frantic residents scattered in all directions. "It was burning up the grass under our feet as we ran," survivors remembered.[83] A lake of fire was all around. Some witnesses, like Bill Friesen, a civil defense director at the time, described the scene as "rivers of fire...running from curb to curb," with flames gushing like a "volcano" and "running down [gutters] to 13th Street."[84]

Fourteen homes were burning in a three-block radius, and sixty-eight others were riddled with damage. Thirty automobiles and countless personal possessions—everything that a person would acquire in life—were now gone.[85] The greatest loss, however, was that of human life. Nearly half of those killed on the ground were children under the age of twelve. Hundreds of onlookers stood "motionless, their eyes fastened on the blazing wreckage of homes," while others sobbed, gazing in shock.[86]

As the piercing sirens of fire trucks and police cars drew closer, the horrors—concealed just beyond the thick, black smoke—would soon be discovered by those heading into the tempest of flames.

5

GOING INTO HELL

…[I]t should have been titled "Twenty-five Minutes of Hell for Wichita Firefighters" because, gentlemen, that is exactly what it was.
—Tom McGaughey, Wichita Fire Chief, 1965[87]

For rescue workers entering the fray, the horrors came in three: the smell, a pungently noxious stench of burning flesh and debris mixed with jet fuel; the sound, piercing sirens and a crescendo of agonizing screams and cries for help within the flames; and, most dreadful, the sight, the charred bodies of human remains, the fire-engulfed homes and the weary, tearful faces of helpless onlookers. The Piatt Street crash tortured the senses, as well as the memories, of all who encountered its fury.

The video footage captured by *KAKE News* shortly after the fire contained vivid scenes of panic and bewilderment. Ghostly images of firemen, their faces smeared with black soot and fatigue, emerged from smoldering wreckage carrying out lifeless bodies. Cars were burned down to their frames, leaving nothing but seething shells. Pools of thick, green jet fuel were scattered here and there. Flame-gutted houses were rubble and ash. Stiff corpses—still smoking and simmering from the intense heat—lay beneath blankets in an open field, marked only by makeshift cardboard tags with the house number from which they were recovered. Victims staggered like disembodied zombies, their hands stretched out in front of them, feeling their way through the dense smoke and tripping over debris, airplane parts and bodies as they went. Just a few steps from the impact point, a tattered officer's garrison cap with lieutenant bars—a

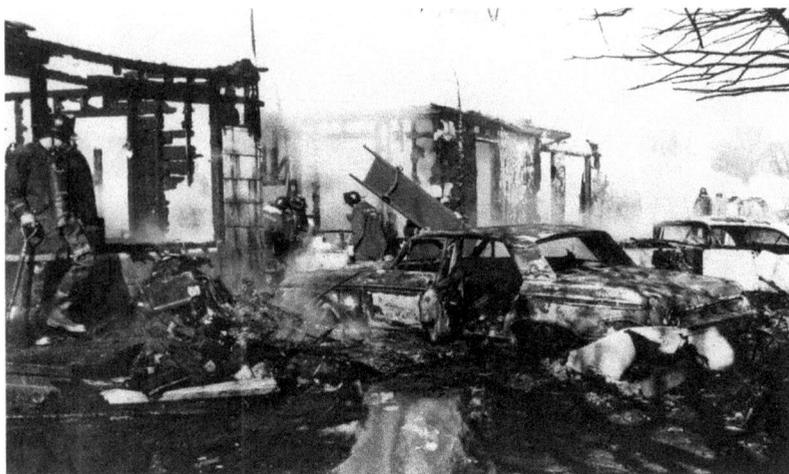

Rescue workers search the remains of a home, looking for victims. *22ⁿᵈ ARW History Office.*

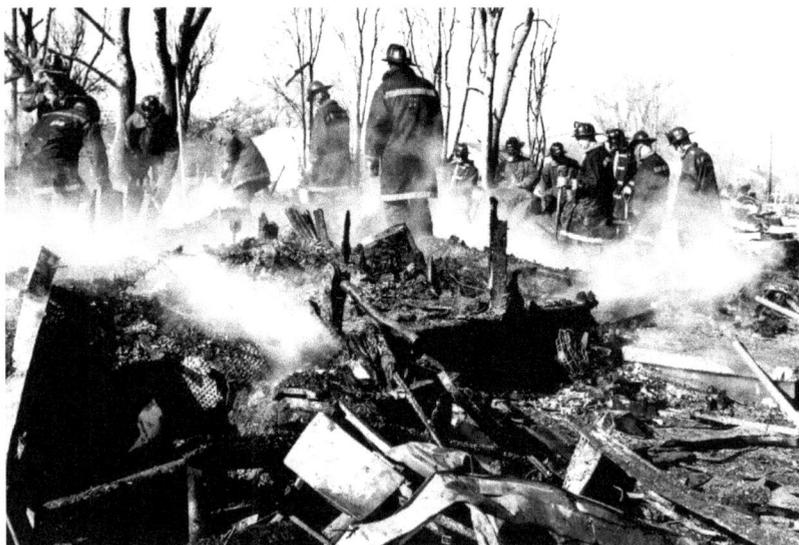

Firefighters search through burning wreckage for victims. *Larry Hatteberg*, KAKE TV.

gruesome reminder of the airmen—was found beneath the scorched remains of a tree.[88] For those directly touched by the disaster, it was as close to hell as one could come on earth.

CHIEF MCGAUGHEY

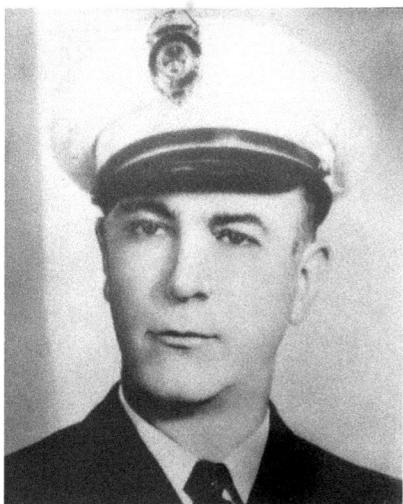

Fire Chief Tom McGaughey joined the WFD in 1933 and became its chief in 1960. He was described by those who knew him as a "fireman's fireman," "first-rate," a man who not only led but also led by example.[89] He pushed for pay increases for firemen, encouraged his men to pursue their educations and meticulously studied firefighting techniques to better train firemen and save lives. A hardworking man like his father, he labored on railroads during the Great Depression for one dollar a day and was a part of the "Greatest Generation"—which persevered through drought, deprivation, crime and war. He suffered serious burns to his shoulders and back in 1936, when the roof at McClellan's Store on East Douglas Street collapsed on

Wichita Fire Chief Tom McGaughey. *Kansas Firefighters' Museum.*

him during a fire. He nearly drowned trying to save a victim at the bottom of Sante Fe Lake, east of Wichita, in 1937. By 1965, when he was well into his fifties, he was still charging into fires alongside the rookies; he was the first in and the last out.[90] He had iron in his soul; his men adored him, and there was no question that he was in charge.

But Chief McGaughey's greatest test was about to begin that Saturday morning. Unaware of the chaos the day would bring, he had intended to play golf with his friend, Deputy Fire Chief Bob Simpson. Realizing it was much too cold out, Chief McGaughey canceled his plans, choosing to stay home instead.[91] The relaxing Saturday he envisioned never came. Speaking to a large audience at a Fire Department Instructors' conference in Memphis, Tennessee, sometime after the crash, Chief McGaughey entitled his speech "Fire from the Sky Over Wichita," but as he quickly explained to his audience, "Perhaps it should have been titled 'Twenty-five Minutes of Hell for Wichita Firefighters' because, gentlemen, that is exactly what it was."[92]

That day, Wichitans would realize, if they hadn't before, the true meaning of a firefighter as they watched dozens of Wichita's finest hurl themselves into the flames to preserve life, limb and property. Sonya House put it bluntly, "I learned what a firefighter was. They were fighting the fire, and that fire

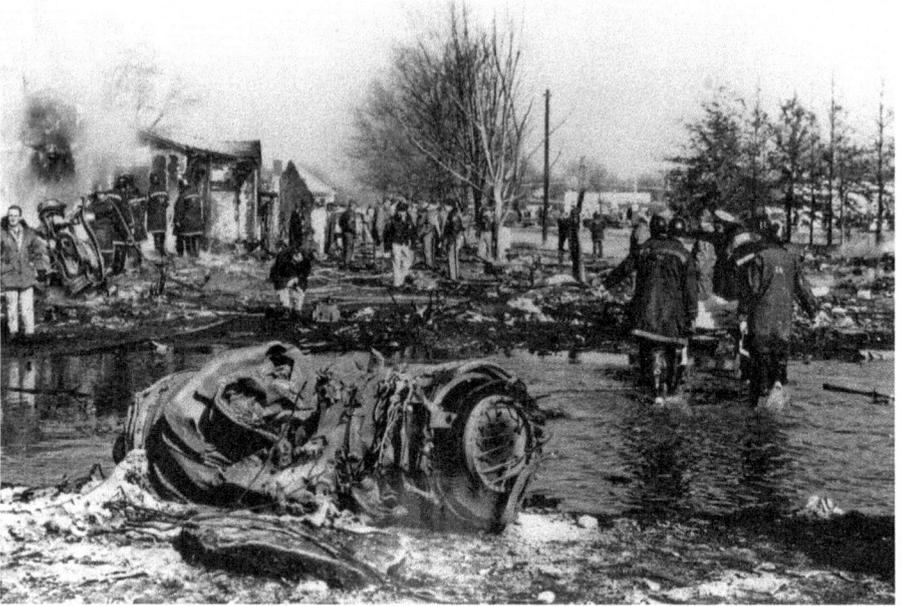

Firefighters carry a crash victim from the accident site. *22nd ARW History Office.*

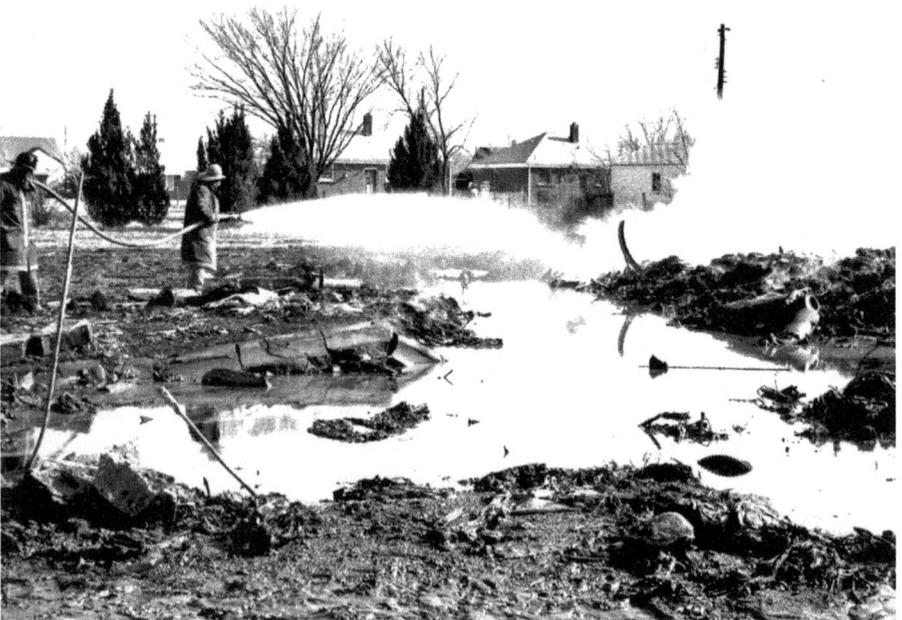

Firemen spray flaming wreckage. *Larry Hatteberg,* KAKE TV.

was fighting them back."[93] Chief McGaughey—arriving nine minutes after the plane hit—described the pandemonium:

> *All hell broke loose when the plane exploded upon impact—scattering fuel mixed with mud like napalm bombs over homes as far away as two thousand feet with the force of the blast. The speed and weight of the aircraft sent one of the motors crashing through the asphalt concrete street and six feet of soil to rupture an eight-inch water main and a three-inch natural gas line at the bottom of a crater approximately ten feet in diameter.*[94]

The firemen and emergency responders heading into the blaze, without question, faced a warzone.

Disaster Plan

When it was confirmed that the emergency responders had a catastrophe on their hands, on a scale never before seen in Wichita, the disaster plan went into effect. According to Chief McGaughey, the first company arrived at 9:32 a.m. and radioed back to the firehouse, "There's a block and a half of houses burning; you had better make it a double."[95] The first alarm came in at 9:30 a.m., the second at 9:32 a.m. and the third at 9:38 a.m.—which alerted the off-duty firemen to respond as well. Chief McGaughey also called for all of the available ambulances and the coroner to head to the scene, while checking with dispatch to make sure the disaster plan was initiated.[96]

The initiation of the plan meant that all police and fire reserves were activated; the American Red Cross was notified; hospitals, ambulance crews and medical personnel were put on standby; second alarm companies were sent out; and the Heavy Rescue and Fire Reserve were alerted.[97] The Boeing and McConnell Fire Departments were already rushing to the scene after they were notified of Raggy 42's mayday call and saw the smoke billowing from northeast Wichita. Meanwhile, calls from frantic citizens began to light up the switchboard reporting the inferno.

Nearly two hundred homes were blacked out by power loss when the plane hit. Wichita firemen—a few blocks away at 17th and Grove Street—quickly discovered they were trapped inside Fire Station 10, the heavy garage doors immobilized by the power outage. They had to pull the pins on the giant doors and lift them manually just to get the engine out.[98] Arriving in the area

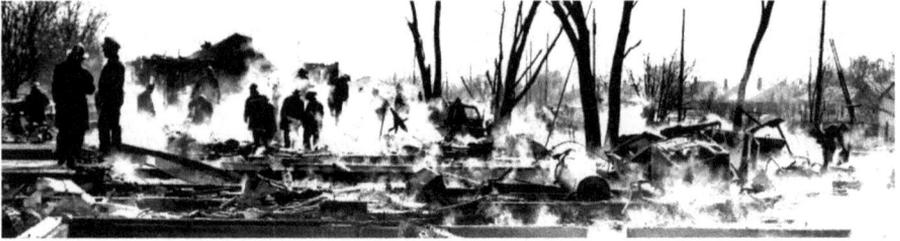

Firemen search rubble. *Larry Hatteberg,* KAKE TV.

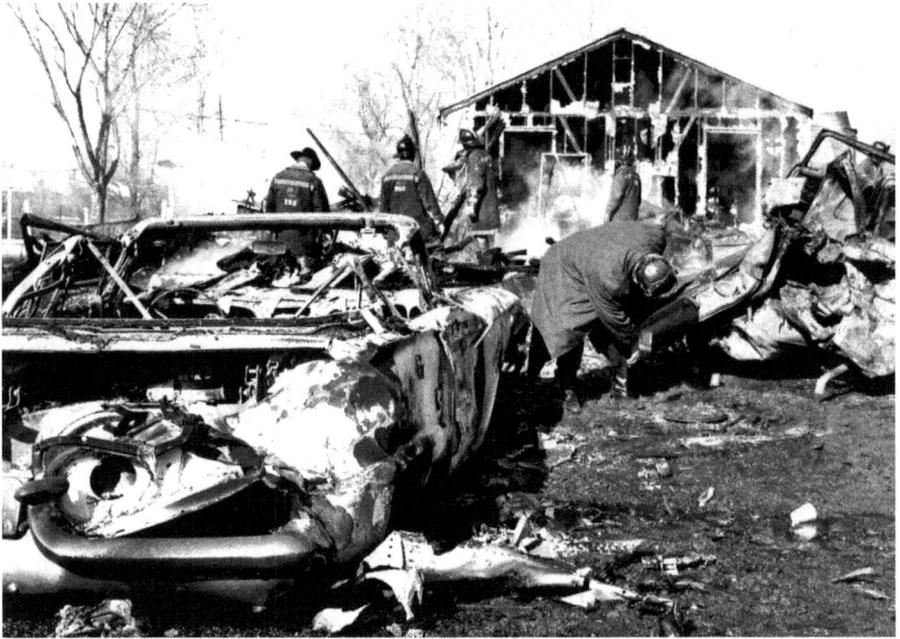

Firefighters search through wreckage. *Larry Hatteberg,* KAKE TV.

a few minutes later, they faced the lake of fire on Piatt Street caused by broken water mains and burning jet fuel floating on top. The blazing liquid extended for nine hundred feet in the immediate area, making it nearly impossible for the firemen to access homes. The debris of four houses, scattered across Piatt Street, further obstructed the path of the fire engines.

To add to these obstacles, downed power lines electrified many of the wire fences surrounding backyards, shocking anyone who touched them. Firemen became "jumping jacks" as they straddled the fences and were jolted with electricity.[99]

Residents hastily retrieving their cars, sightseers and crowds blocked other ways of entry. Those left alive who were suffering from burns, lacerations from flying debris or shock were treated by the emergency responders.

After the impact, the force of the explosion was pushed southwest of the 20th and Piatt intersection. Most of the homes there were constructed of wood, which fueled the consuming fire. As Chief McGaughey explained, "[A]ll homes on the west side of the street were wood frame; homes on the east side were all brick veneer," which allowed the flaming jet fuel not only to swiftly torch the exterior but also to push its way inside "as if from a giant atomizer," melting the interior.[100] The firemen dousing the five-hundred-foot-high flames noted how, when they breathed, "it almost tasted like [they] were drinking jet fuel."[101] Deputy Chief Simpson, remembering the conflagration, commented:

> *I have never seen so much fire in so many places. It just licked every place up and down the street. There was no way of telling just how many houses were on fire. It appeared to me that the fire was in the houses, burning from the inside out, rather than so much fire on the outside of the houses. I guess this is because the fuel was sprayed into them, and, of course, the contents of the building had ignited.*[102]

The homes in the impoverished neighborhood, most of which cost no more than $10,000, never stood a chance.

RESOURCES

In 1965, twenty-seven companies located in thirteen fire stations made up the WFD with approximately 100 firefighters on duty each day. One district chief oversaw three response districts. Wichita firefighters worked sixty-six-hour workweeks then, alternating between twenty-four hours on and twenty-four hours off.[103] Chief McGaughey called in as many men as he could to do battle with the fire along with their hulking equipment. The WFD used a total of "11,000 feet of 24-inch hose, 2,000 feet of 13-inch hose, 42 on-duty personnel and 136 off-shift firemen" to address the warzone at 20th and Piatt.[104] Equipment response included: seven engine companies from WFD, including one aerial company and the emergency bus that was used as a command post; one engine company from Fire Reserve; two engine companies from the County Fire Department; five units from Heavy Rescue;

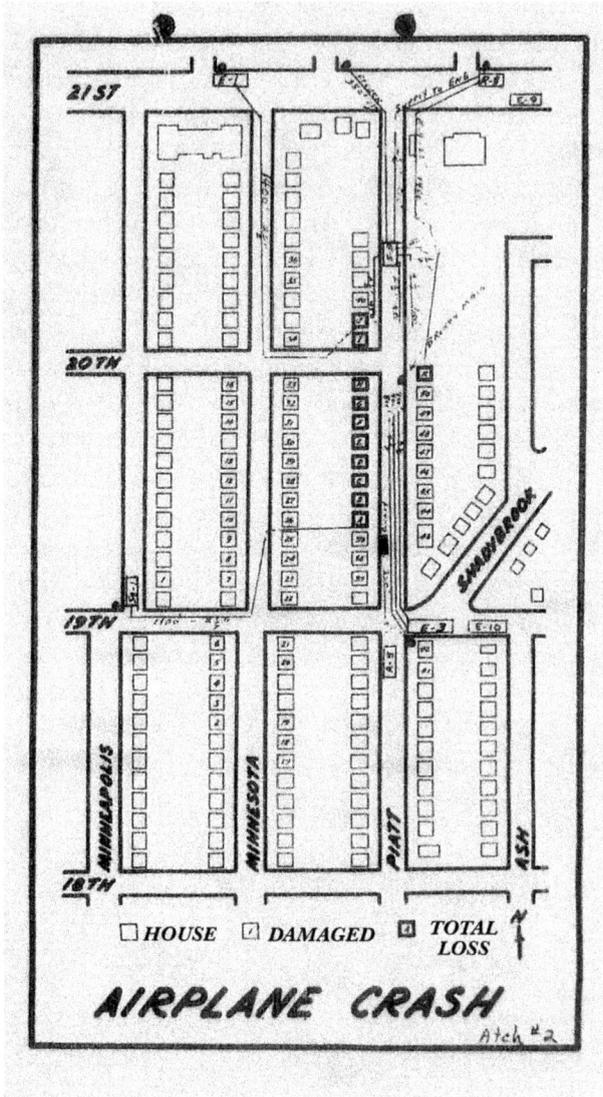

A 1965 map of the Piatt Street crash showing damaged homes (retyped for clarity). *U.S. Air Force Safety Center, Kirtland Air Force Base, New Mexico*

a tanker and foam truck from McConnell Fire Department; and one Boeing semi-trailer tanker that produced foam from two blabbermouth nozzles mounted on top of the unit.[105] It took an army of men and equipment to combat the blaze, and the determination of the firefighters was nothing short of amazing.

Chief McGaughey and his men made their attack from the perimeter and marched toward the center of the fire. It was a portrait of combat—with the chief leading his men in a coordinated strike against a ferocious enemy. They waged war on the blaze from all directions in a synchronized effort to jostle the flames "back toward the impact point," recounted Chief McGaughey, so that they could start drenching the burning houses. When the McConnell and Boeing equipment arrived, they blasted the fire with foam, while county pumpers swept the adjoining streets and area, putting out "grass and roof fires caused by flaming chunks of mud saturated with JP4 (much like napalm)" that had been blown over the entire area. For the firemen, it was warfare.[106]

The community also fought against the fire. Two off-duty captains and firefighters who lived in the area of 20th and Piatt assisted from their homes to direct the incoming firemen. Volunteers helped clear victims from the area, and neighbors assisted in manning hose lines, causing Chief McGaughey to realize that, "although many people were in a state of shock, we had so much citizen help that 24-inch hose lines were moved about as if they were booster lines [much smaller and lighter hoses]."[107]

The citizens in the immediate area who were not assisting the firemen were moved back by the police for their safety. Fourteen Wichita police officers initially responded, just minutes after the plane hit. That number quickly ballooned into hundreds of law enforcement personnel, including the Wichita Police Department (WPD), Sedgwick County Sheriff's Office, Kansas Highway Patrol, McConnell military police officers, National Guard and Army Reserves. Chief E. M. Pond, of the WPD, dispatched one WPD officer for every three military police officers from McConnell. The first perimeter established by the WPD stretched south from 21st Street to 13th Street (one mile) and from Hydraulic Street east to Grove Street (one half mile).[108] Although there was a need for crowd control to prevent onlookers from contaminating the scene or removing evidence, no arrests were made on January 16. Chief Pond would later praise how "local residents participated in traffic control and lessened spectator congestion, easing the difficulties of apparatus in getting to the scene."[109] Cooperation between the community and law enforcement was seamless.

CONTAINMENT

The enormous firestorm was under control by 9:55 a.m., twenty-four minutes after it began.[110] In forty-five minutes, electrical service was restored, thanks

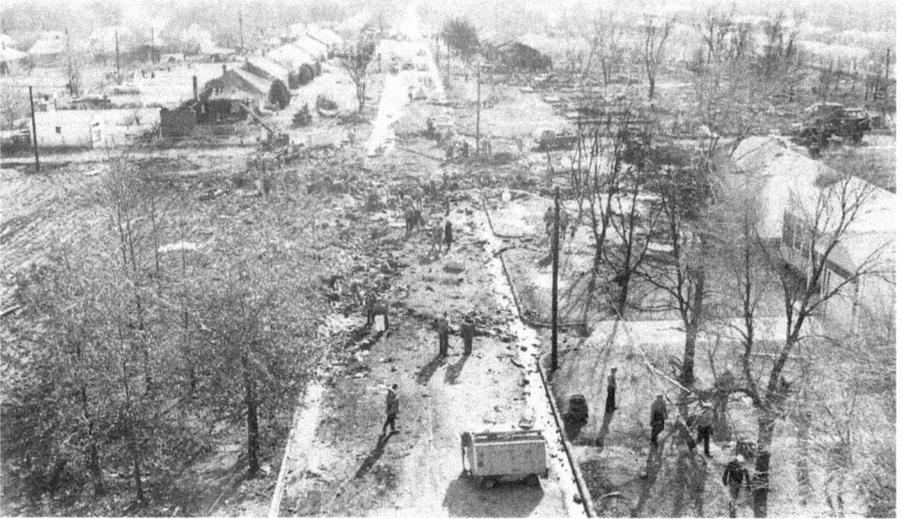

Aerial photo of crater. *Wichita-Sedgwick County Historical Museum.*

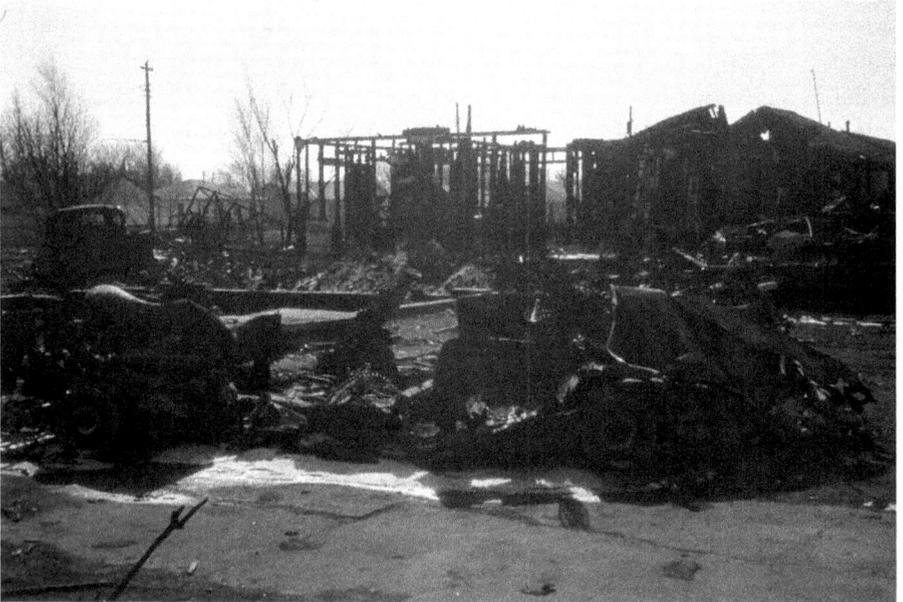

Burned-out car frames and houses on Piatt Street. *Kansas Firefighters' Museum.*

in part to utility companies that labored intensely to restore electrical and gas service, recover downed power lines and seal off an eight-inch water main severed by the plane on impact.[111] Although firemen would continually soak the wreckage for several hours after the crash, it was at least contained at that point by the steady flow of foam and water pouring out from fire trucks in all directions.[112]

Because of the potential for such a disaster in the "Air Capital"—nicknamed because of the many aircraft corporations founded there in the late 1920s and early 1930s—all of the fire departments that responded were trained in unique rescue procedures involving military aircraft crash firefighting. Having been trained in these special types of hazards, they were efficient in extinguishing the fire in a timely manner. Despite an initial lack of communication among the departments concerning location and placement after arriving on scene (later criticized by Chief McGaughey), these intense training sessions, as McGaughey commented, "paid off…knowing what to do and how to do it…"[113]

In the end, this miraculous effort of disaster containment was made possible because of the unparalleled, quick response of firemen from Wichita, Boeing and McConnell. The ability of the community to bind together and aid the emergency responders, however, was also a large factor in the success of the firefighting efforts. Everybody pitched in. Extinguishing a fire of that magnitude, that quickly, was a superhuman feat. Of course, it took equipment, proper training and one and a half million gallons of water, but the actions of the brave men and women who selflessly assisted the firemen saved many lives.[114] It was a collective community effort in an otherwise segregated community, something rarely seen in 1965.

6
THE KC-135

Peace Is Our Profession
—*USAF, Strategic Air Command Motto, 1946-1992*

The rationale of military necessity has provided fodder to countless heated debates. And three days later, on January 19, 1965, the *Wichita Beacon* posed the inevitable question that lingers on to this day: "whether the plane should have been flying over a congested urban area when it was loaded with nearly [thirty-one thousand] gallons of highly volatile jet fuel."[115] There is no simple answer.

The conception of airpower theory, the purpose of the KC-135 and the vision of an Italian artilleryman—a vision that was birthed before World War I and later matured under SAC following World War II—provides, to some degree, an insight into why Operation Lucky Number not only existed but was also necessary.

THE ITALIAN

He was laughed to scorn for several of his ideas. He was considered irrational, insubordinate, a charlatan, a caviler, a loon, a far-fetched dreamer—who was eventually court-martialed for his criticisms of the Italian army, imprisoned, vindicated, released, promoted to general and then retired to

write the world's first theory of air war in 1921: *The Command of the Air*.[116] He then became a visionary, the father of modern air warfare, a man who theorized the strategic use of the airplane within barely a decade after its invention. Although it was once considered preposterous to use an airplane as a strategic weapon in warfare, he knew better.

Giulio Douhet, the Italian general and great airpower theorist of the twentieth-century, said, "Victory smiles upon those who anticipate the changes in the character of war, not upon those who wait to adapt themselves after the changes occur."[117] Douhet was of the belief that "airplanes, like warships and armies, should be massed against the decisive point" in order to defeat the enemy.[118] The only problem with this theory was that it had yet to be seen or tested, since the technology needed for some of Douhet's anachronistic theories did not exist. Nonetheless, Douhet, though highly criticized and considered controversial, successfully developed a doctrine for the strategic use of airpower in the 1920s that would soon revolutionize warfare.[119]

JET BOMBERS

Twenty years later, while America was fully engaged in World War II, the use of strategic bombing—Douhet's "irrational" idea—was now being deployed. Posthumously, Douhet was vindicated, again. Following the strategic bombing campaigns on Germany and Japan in World War II—which led to the economic breakdown of the Axis powers, the detonation of two atomic bombs and essentially ended the war—U.S. military leaders came to realize the need for planes with capabilities of flying greater distances to bomb the enemy and then return home. Jets needed to become efficient ordnance carriers in order to match the range and payload capacities of propeller planes.[120] This would soon be the case.

Created in 1946, SAC's mission was to "conduct long range offensive missions in any part of the world."[121] With the beginning of the Cold War and the looming threat of a Soviet attack following World War II, the subsonic B-52 (Stratofortress) heavy bomber was the jet-powered strategic bomber military commanders were looking for. Becoming operational during the period of 1955 to 1962, the B-52 had a range of 10,000 to 12,500 miles and was fully capable of aerial refueling. It was adept at carrying multi-megaton free-fall bombs or two deadly "Hound Dog" missiles (earning their

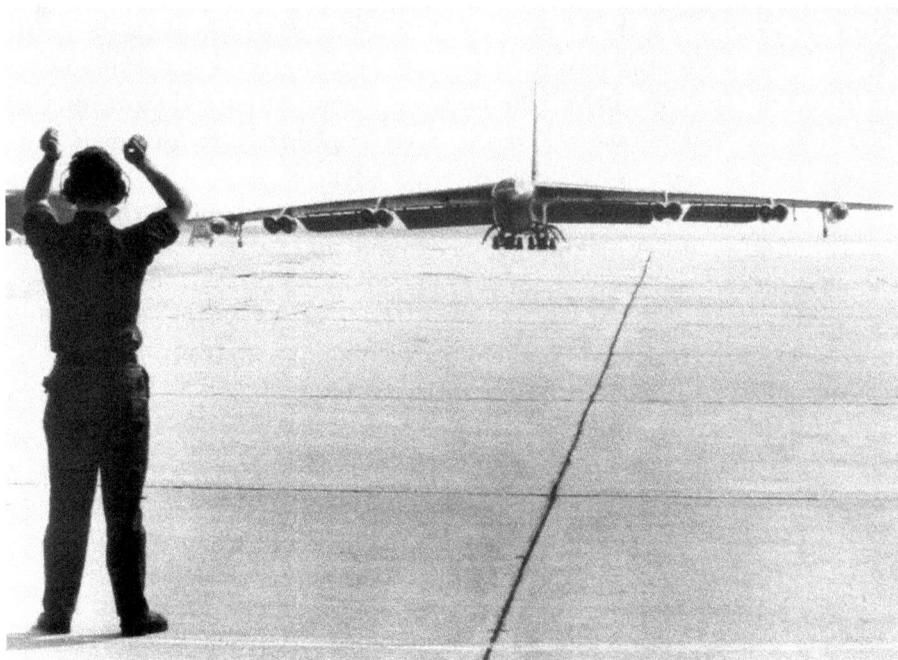

B-52 taxiing. *22nd ARW History Office.*

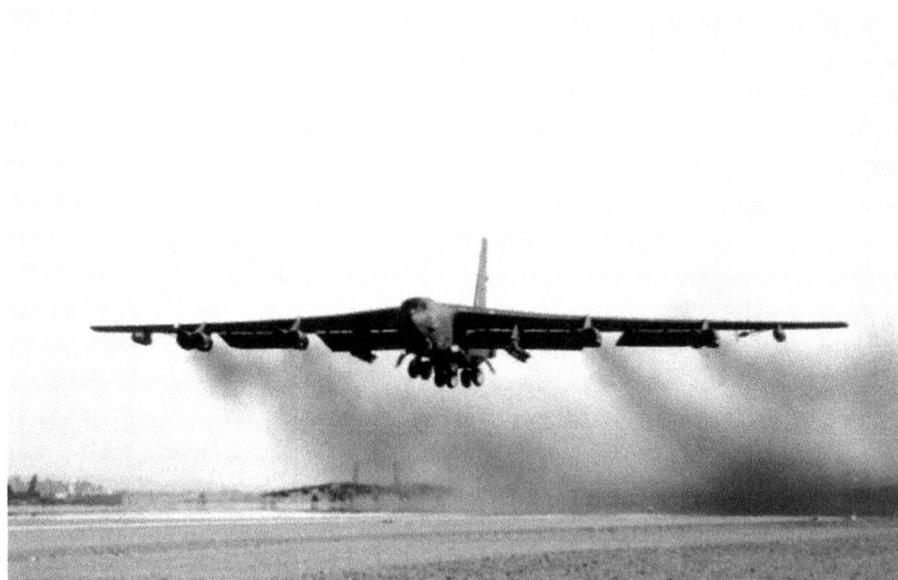

B-52 taking off. *22nd ARW History Office.*

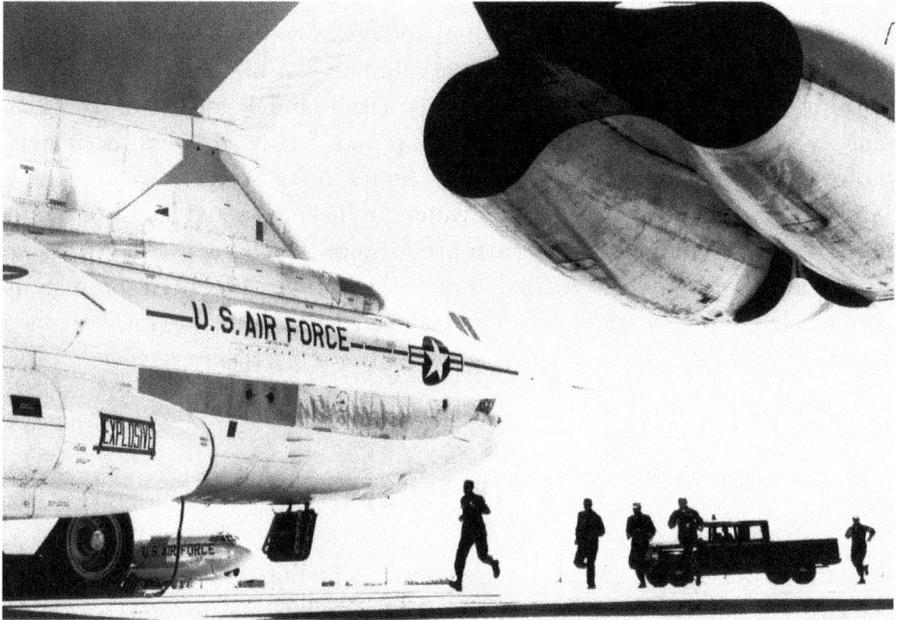

B-52 crew running "on alert." *22nd ARW History Office.*

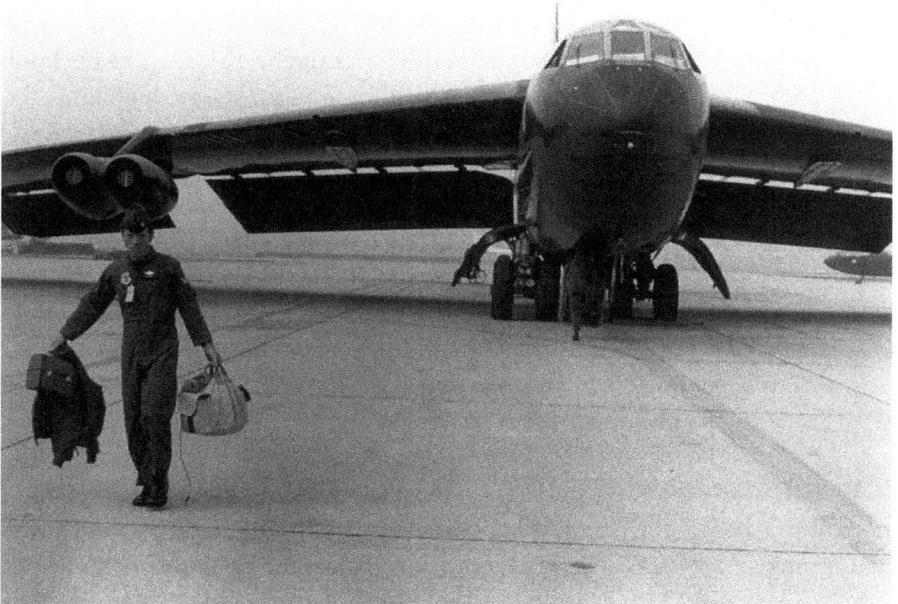

B-52 on ground. *22nd ARW History Office.*

nickname from Elvis Presley's hit song) and could travel up to 600 miles per hour at fifty thousand feet.[122] It was the ultimate war machine.

During the 1960s, the B-52 made up a substantial portion of the U.S. military's strategic bomber force and was a proud display of American military prowess. "A B-52 can fly from the United States to the Soviet heartland with a 10,000-pound bomb load and return without refueling," noted Jeremy J. Stone, an expert in foreign policy and former president of the Federation of American Scientists, in a 1964 article entitled "Bomber Disarmament."[123] Accordingly, if the U.S. deterrence-oriented military policy failed and the Cold War developed into a hot war, Stone's assessment might have become a reality.

A New Tanker

Superior bombing capability required aerial refueling, and the B-52 needed a colossal tanker to replenish its fuel.[124] Originally, the air force had been using the KC-97 tanker to refuel its B-47s, Boeing's first jet bomber. But the propeller-powered KC-97 was slow and had a low operational altitude, which created multiple problems with the refueling operations. The faster, jet-powered B-52s had to lower their flaps and rear landing gear just to slow down enough to be refueled by the KC-97.[125] Eugene Rodgers, in his book *Flying High: The Story of Boeing and the Rise of the Jetliner Industry*, highlights the various problems that arose with the aerial refueling of jet bombers:

> *The most compelling need was for jet tankers. Flying together in a refueling operation was difficult for the jet B-47 and a propeller-driven tanker; there was a serious mismatch in speeds. The highest speed that the tanker could fly was not much more than the slowest speed that a B-47 could fly without losing lift. The situation would be even worse when the Air Force started flying bigger, faster B-52s in a few years…the Air Force would soon see the necessity for hundreds of jet tankers.*[126]

With the "Jet-Age" fully underway after World War II, there was an obvious need for a new jet tanker. Abandoning the more cumbersome and time-consuming procedures for aerial refueling, Brigadier Generals Clarence S. Irvine (SAC) and Mark E. Bradley (Air Materiel Command), along with Cliff Leisy (Boeing), developed a new method for aerial refueling called the "flying boom."[127] The flying boom completely transformed in-flight refueling. The

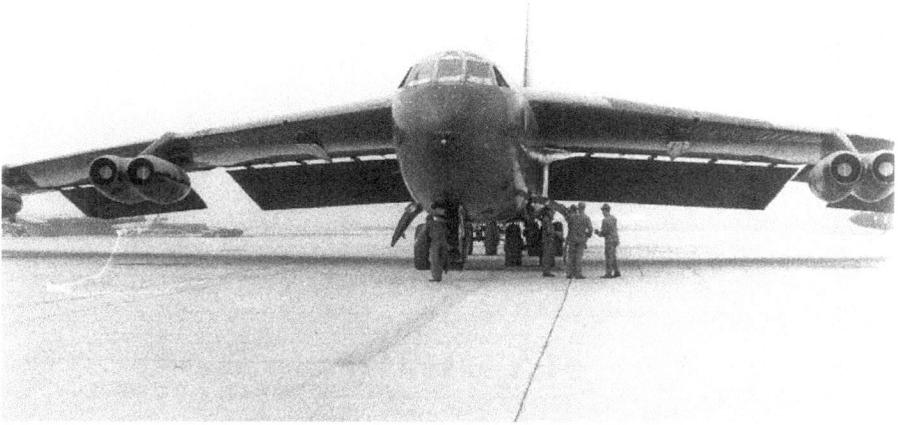

B-52 on flight line with crew. *22nd ARW History Office.*

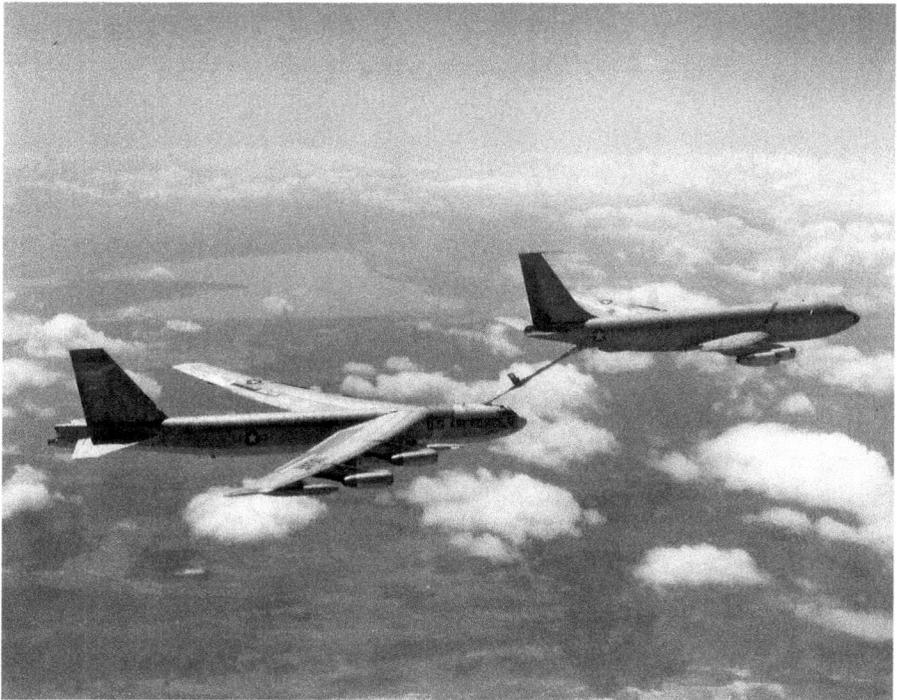

KC-135 refuels a B-52. *22nd ARW History Office.*

revolutionary new flying boom system was described by air force historian Walter J. Boyne in *Beyond the Wild Blue* as consisting of "a long telescoping transfer tube with two V-shaped control surfaces, called 'ruddervators.'"[128] The process for refueling, according to Boyne, meant that the refueling plane would fly, "above and in front of the receiver, which flew in close formation, permitting the boom operator to fly the boom into the receiver's receptacle."[129] The flying boom allowed jet fuel to be transferred expeditiously because of its high pressure, greatly reducing refueling times. This would later become the standard method used throughout the air force in the 1960s.

THE UNVEILING

On Saturday, May 15, 1954, just two days before the historic *Brown v. Board of Education* decision was handed down by the Supreme Court, desegregating public schools in America, the Dash-80 was unveiled by Boeing Aircraft Company at its factory in Renton, Washington.[130] The air force had expressed an interest in a jet tanker, and the Dash-80 was the prototype for the commercial 707 and the KC-135. After its first flight on July 15, 1954, by test pilot Tex Johnston, it was clear that the Dash-80 prototype was going to be a success.[131]

With the end of a brief contract dispute concerning which company would be allowed to build the new tanker for the air force, the Pentagon finally announced it would give the contract to Boeing in March 1955. The air force ordered three hundred KC-135s to be built at a total cost of $700 million.[132] At last, the air force would have the jet tanker that could meet its future and present needs. A commanding sight, weighing 297,000 pounds, the massive KC-135 had four P&W J57 turbojet engines with 13,750 pounds of thrust, a wingspan of 130 feet and ten inches, and a top speed of six hundred miles per hour with a range of approximately five thousand miles. It could accommodate four crew members and eighty troops with its large cargo deck. But most importantly, the KC-135 could transport more than thirty-one thousand gallons of jet fuel (double what the KC-97 tanker ever could) and deliver it with its telescoping flying boom.[133] It was the most efficient and capable refueling machine ever made up to that point, an impeccable force multiplier. As historian Steven L. Rearden noted, when SAC gained the advantage of acquiring three hundred KC-135 jet tankers to refuel the B-52s, it "could claim a *truly* global reach."[134]

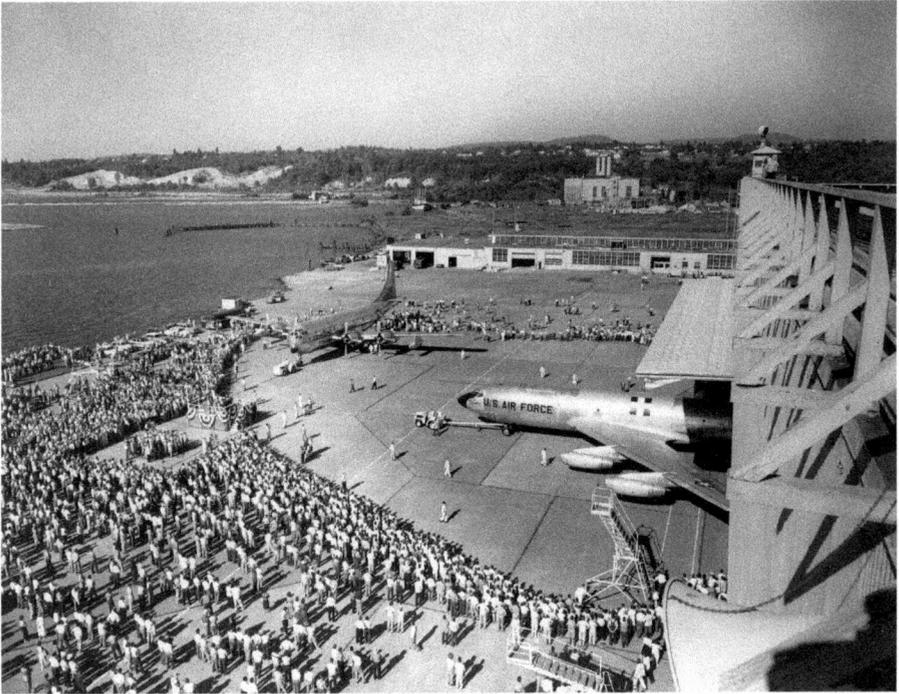

Aircraft 55-3118 (the first KC-135) rolls out of the Boeing plant in Renton. *22ⁿᵈ ARW History Office.*

COMPLICATIONS OF AERIAL REFUELING

Despite the advances in technology, airborne refueling was, and continues to be, a dangerous task. It is a meticulous operation requiring a high level of skill from both the pilots and the boom operators. Boyne went on to describe the many variables when attempting aerial refueling:

Consider the case of the KC-135 and the B-52. The KC-135, cruising at 250 knots indicated and weighing some 300,000 pounds (of which perhaps 150,000 was highly flammable jet fuel), was physically connected, by a tube that averaged about 40 feet long, to the B-52, itself weighing more than 450,000 pounds, flying at the same speed, and perhaps carrying a number of nuclear weapons. Add to this picture of mass and momentum such factors as the dark of night, turbulent

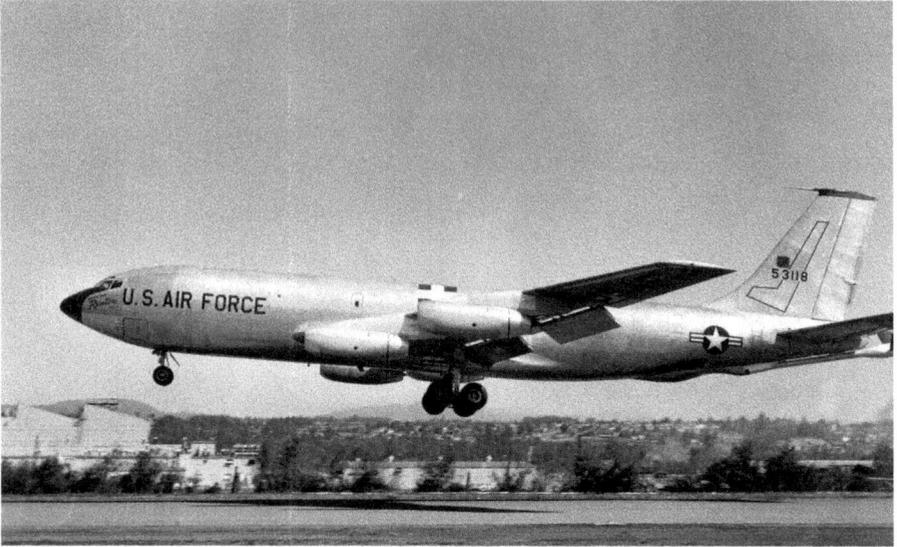

Aircraft 55-3118 taking off. *22nd ARW History Office.*

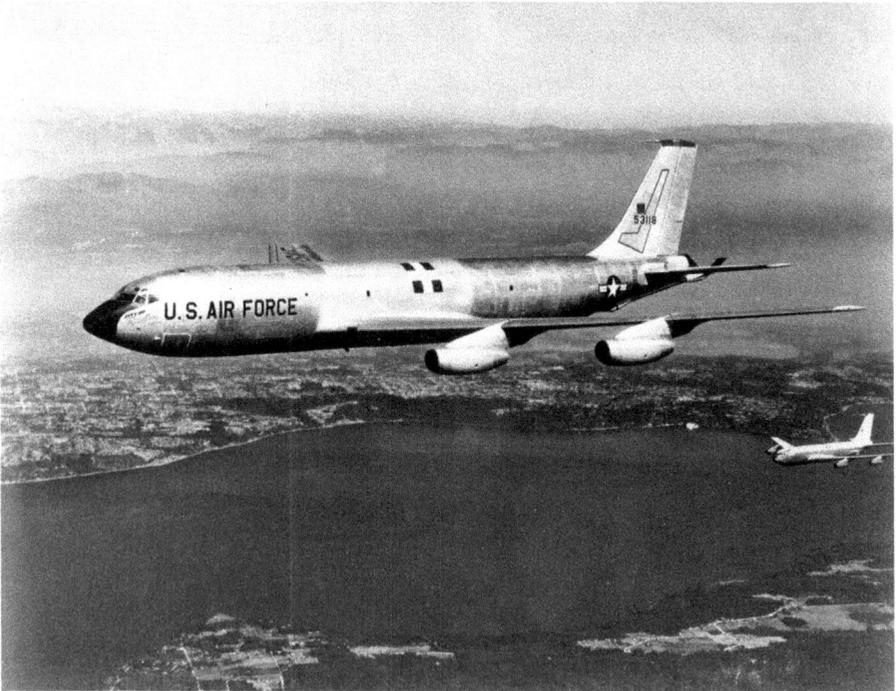

Aircraft 55-3118 in flight. *22nd ARW History Office.*

weather, and the prospect of combat, and you have all the elements of a
genuine white-knuckle drama.[135]

Aware of the dangers, Boeing worked tirelessly to ensure the success of its effective and lucrative machine. Perfected from its prototype, the Dash-80, the KC-135 jet tanker first took flight on August 31, 1956, and was assimilated into SAC the following year.[136]

Boeing produced a total of 820 KC-135s (732 of which were KC-135A models) before it closed production in 1966.[137] From then on, the primary mission of the KC-135 was, as it remains today, to refuel long-range strategic bombers. Operation Lucky Number, though ending in misfortune, was a byproduct of that mission. It epitomized the necessity of military preparedness, the challenges of mastering this new technology and the heavy toll it could inflict—on both civilians and military members—when fulfilling that need.

The symbiotic relationship between the City of Wichita and the air force existed long before the Piatt Street crash. When Rock Road—now a bustling, paved thoroughfare in Wichita—was little more than a "rock road," it existed. When aviation manufacturing in Wichita exploded with the onset of World War II, it existed. When the air force first considered establishing a base near Wichita Boeing facilities, in February 1951, it existed. And when the City of Wichita received a $9.4 million check from the U.S. government for it to acquire the Wichita Municipal Airport the following year—which later became McConnell AFB—its presence was cemented.[138] The air force needed Wichita; Wichita needed the air force. Nothing has changed.

7
INSIDE THE COCKPIT

All I could think of was that poor pilot is going down…
—O. B. Hill, Eyewitness, 1965[139]

The engines cried out in agony from the heavy load. The metal fuselage groaned and creaked, stressed under the tension of the skyward climb. Stiff jerks, created by turbulence, shoved the pilots around the cockpit. The flight felt uncontrolled, unfamiliar, unresponsive and violent. Staying in the air seemed impossible. The needle on the altitude gauge refused to rise. Warning bells and alarms blared from the control board. Rooftops, cars, trees and city streets—normally tiny objects when in flight—were plainly distinguishable. The pilots began draining the fuel to increase lift—causing a thick, white vapor trail to cut across the Wichita sky, outlining the dying plane like chalk on a blackboard. Screams of "Mayday!" shrieked into the ears of aircraft controllers back at McConnell. Then the KC-135 turned belly up and headed for a nose dive at 20th and Piatt. Just four brutal minutes would change the history of Kansas forever.

At first, Wichitans, going about their normal routines that Saturday morning, would have hardly noticed a sight so common—another KC-135 ascending into the sky. One such onlooker, Colonel James Trask, the Commander of McConnell AFB, remembered, "It was a clear, windless day…I thought it was a wonderful day to fly."[140] Nothing looked unusual. The climb appeared ordinary—speed, altitude, flap retraction, gear up—but somewhere between five hundred and one thousand feet, three minutes

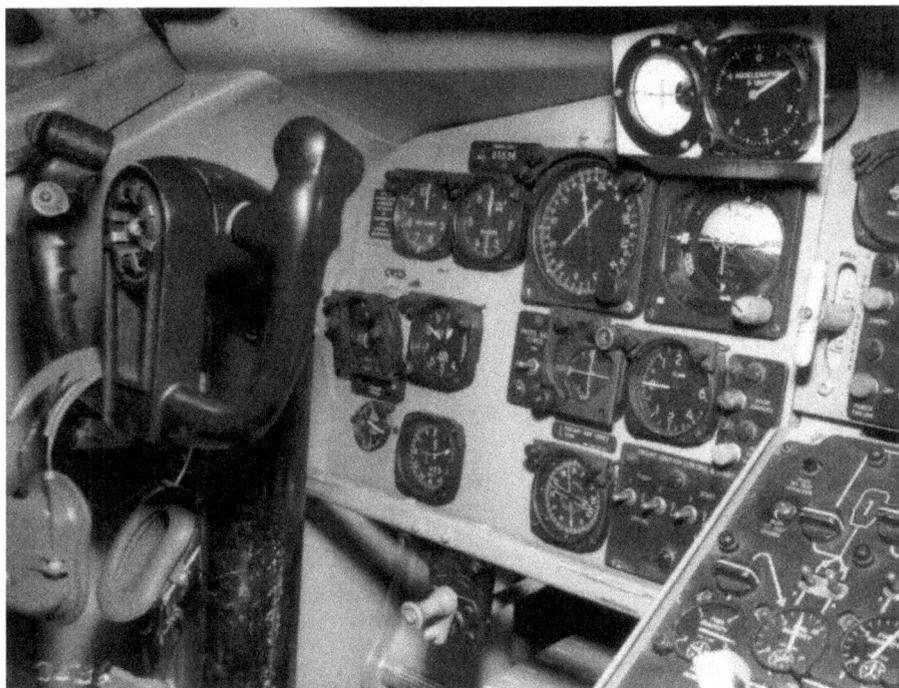

Left side of a KC-135 Model A cockpit. *22nd ARW History Office.*

into flight, Captains Szmuc and Widseth were warring with the doomed plane. Raggy 42, loaded with jet fuel and skimming very low, soon created panic just above the heavily populated area of northern Wichita.

A 707 commercial airliner—almost identical in appearance to its military counterpart, the KC-135—departed Wichita Municipal Airport only minutes before Raggy 42. The 707 was carrying one hundred passengers. The first reports of a crash subsequently caused many to believe that the 707 went down, confusing it with the KC-135.[141] That misinformation was quickly dispelled, though, because several witnesses, many of whom were pilots, recalled seeing a plane lift off from the McConnell runway and begin a left turn before crashing. Within minutes, every SAC base in the United States knew Raggy 42 had crashed. Lieutenant General David Wade, the Commander of the Second Air Force, received word of the crash at his office in Shreveport, Louisiana. He boarded an air force jet and was in Wichita one hour later.[142] Boeing investigators, too, were on scene before one hour had passed.

FUEL JETTISONING

On the evening of January 16, 1965, the *Wichita Beacon* recorded numerous eyewitness accounts of the plane's bizarre behavior after leaving the runway—behavior for which we now have an explanation. With over seven hundred flying hours as a pilot, Thomas Klem ascertained that Raggy 42 was indeed displaying some unusual behavior. Klem had just taken his son to wrestling practice at Wichita Heights High School and was driving south on Oliver Street when he observed a contrail from Raggy 42. Puzzled, Klem wondered, "Why was there a vapor trail at an altitude of one thousand feet?"[143] The reasoning soon became apparent. As the plane jerked violently back and forth, the crew made the conscious decision to begin jettisoning fuel. There are two reasons pilots make such a decision: to lighten the plane in order to gain lift or to lighten the plane in order to avoid an overweight landing.

When a plane lands with its gross weight in excess of its maximum design (as it pertains to the structural design and landing weight for the respective plane), it is considered an overweight landing. According to Rick Colella, a flight operations engineer for Boeing, "A pilot may consider making an overweight landing when a situation arises that requires the airplane to return to the takeoff airport or divert to another airport soon after takeoff."[144] Raggy 42, for reasons unknown at the time, declared an emergency shortly after takeoff. This led Delbert J. Massey, a controller working at the FAA Tower that morning, to believe that "there was some small malfunction and [Capt. Szmuc] was going to come back" to McConnell. Massey, upon hearing the distress call, cleared Szmuc to come back and land at McConnell. As Massey stated, "I thought he might swing around and land at Municipal, which the runway is capable of handling." According to Massey, "My first thought was to recover the airplane and get him back, but this never did come to pass."[145]

After the mayday call, Capt. Szmuc was attempting to either head back to McConnell or the municipal airport to land. But given the plane's low altitude and heavy weight, they first needed to abandon the excess fuel in order to return. General (Gen.) Murray M. Bywater, who headed the crash investigation for the air force, told the press the day after the crash, "[Capt. Szmuc] was dumping fuel because of his heavy load." Gen. Bywater noted how the fuel gushed out of the KC-135 as a conspicuous, "thick stream of white vapor"—which indicated that Raggy 42 was facing engine or control difficulties of some sort.[146] Indeed, Klem reported a vapor trail "pouring out of the aft fuselage," but "[t]here was no fire."[147] By Klem's estimate,

"[Capt. Szmuc] put the plane in a steep bank and appeared to be headed for Municipal for a possible emergency landing."[148]

EYEWITNESS ACCOUNTS

By all accounts, the giant KC-135 was desperately jettisoning fuel. The plane began spilling out the heavy fuel over Wichita State University (WSU) while attempting to make the 180-degree turn back in the direction of McConnell and the municipal airport.[149] A WSU security officer later reported fuel splashing on his face and police car as he watched Raggy 42 fly over.[150] Another veteran pilot, O. B. Hill, was driving east on 21st Street near Waco Street when he saw Raggy 42. Hill remembered that it was a bright, clear morning, and he could see the dense vapor trail flowing from the plane. According to Hill, the pilot tried to "give the left motors a blast and get the plane up in the air. As he blasted the engines, the tail appeared to go straight up, and the ship went into the ground."[151]

Most reports that day were nearly identical. Bob Kirkpatrick, who watched Raggy 42 from his office at WSU, recalled, "I turned to a man in my office and told him the plane was too low" and then saw how it "banked steeply and went straight down without being completely turned over." Sedgwick County Sheriff's Deputy Gilbert Roman, who was also on the WSU campus, reported that Raggy 42 was "in a bank at the time." Roman estimated the plane was "flying at less than 100 feet and losing altitude all the time" and "[a]t about 2500 and Grove [Street], or so, something metallic dropped from the tail of the plane, and a white vapor was coming from the tail." In the final moments before the crash, according to Roman, "it seemed as though the engine cut off. Then it went into a steep bank and nose-dived…Then there was a terrific boom and a huge ball of fire."[152] Other witnesses repeatedly declared, "The tail end went up and the nose straight down. The plane hit like a ball of fire."[153]

ESCAPE

One other emergency procedure taken by the crew just before the crash involved blowing open Raggy 42's escape hatch, located directly underneath the nose of the plane.[154] A witness remembered, "I saw something that looked

like a large piece of cloth whip out of the plane. And then something about the size of a mattress flew out."[155] This was a personnel parachute. Parachutes were removed from the KC-135s for cost and timesaving initiatives in 2008, but they were mandatory equipment in 1965. An article marking the end of onboard parachutes for the KC-135 fleet noted, "It is difficult to find a crew member who would grab a parachute and jump out of a KC-135 in trouble. It is statistically safer to stay with the aircraft, especially when flying over enemy territory."[156]

This was not the case aboard Raggy 42. One of the airmen did try to escape out of the hatch but was later found half a block away, in the backyard of a residence. None of the remains were identifiable to determine which crew member it was.[157] Author Joseph Heywood, who served from 1965 to 1970 as a KC-135 navigator in the 46th ARS, recorded his experiences while flying aboard a KC-135 in the 1960s in his book *Covered Waters: Tempests of a Nomadic Trouter.* Heywood mentions a crash that occurred on July 30, 1968, in Northern California when a KC-135 took off from Castle AFB on a refueling training mission. According to the records, "[T]he crew was conducting a practice emergency descent from FL390 to FL230. After a sharp turn, the vertical stabilizer separated, and the airplane crashed in a timberland forest on Mount Lassen."[158] All nine crew members were killed. Although it is not known if the crew members attempted to escape the plane, Heywood provided some insight into the futility of parachutes aboard the KC-135:

> *Only two people have been able to safely parachute from a KC-135 in its 13 years of military service. Our tankers do not have ejection seats. We have to unstrap from our positions, stand, and drop down an escape chute to be free of the bird. If the plane is in an unusual altitude, the G-forces keep you pinned in place and there is no way out. We all know that bailing out of a tanker is a poor option, but nobody talks about it.*[159]

According to the air force investigators, Capt. Szmuc, "in conjunction with his Mayday call...evidently instituted bailout procedures," and at least one of the crew members tried to escape the sinking ship.[160] But, as Heywood notes, escape is somewhat futile, especially if the altitude and position of the plane is abnormal, as it was on Raggy 42.

Taken together, what both procedures—the jettisoning of fuel and the escape hatch activation—suggest is that Raggy 42 was doomed and, despite all efforts, was going to crash. The flight was unsalvageable. Losing speed, unable to gain altitude and incapable of escaping, the crew was left with only one option: to brace for impact.

8
RECOVERING VICTIMS

There was no rescuing to be done. Everybody knew that.
There was only recovering.
—*John Husar,* Wichita Eagle, *1985*[161]

Despite their readiness, no amount of training could have emotionally prepared the emergency responders for what terror lay just beyond the drenched piles of rubble. "Everywhere you walked," said one reporter, "there were scenes of horror. Near the center of the tragedy, the ground was littered with roasted chunks of human flesh."[162] Recovering the remains was a challenge, not only because victims were buried beneath the rubble, but also because of the crowds of media personnel and law enforcement who converged on the site to more closely examine the holocaust. "There were so many reporters, photographers, firemen, and law enforcement officials grouped around leaders," according to one account, "that an Air Force sergeant asked members of the group to move because they were standing amid pieces of bodies."[163]

The air force personnel focused on recovering the bodies of the crew members in the deep crater left by the plane while firefighters concentrated on removing bodies from the houses along Piatt. A family acquainted with a majority of the victims was enlisted to help firemen identify those who had lived in the homes that were now being searched. Crews worked tirelessly from both intersections of 20th and Piatt, encountering ghastly discoveries as they went. Reflecting on the horrible images years later, Dennis McBride, a

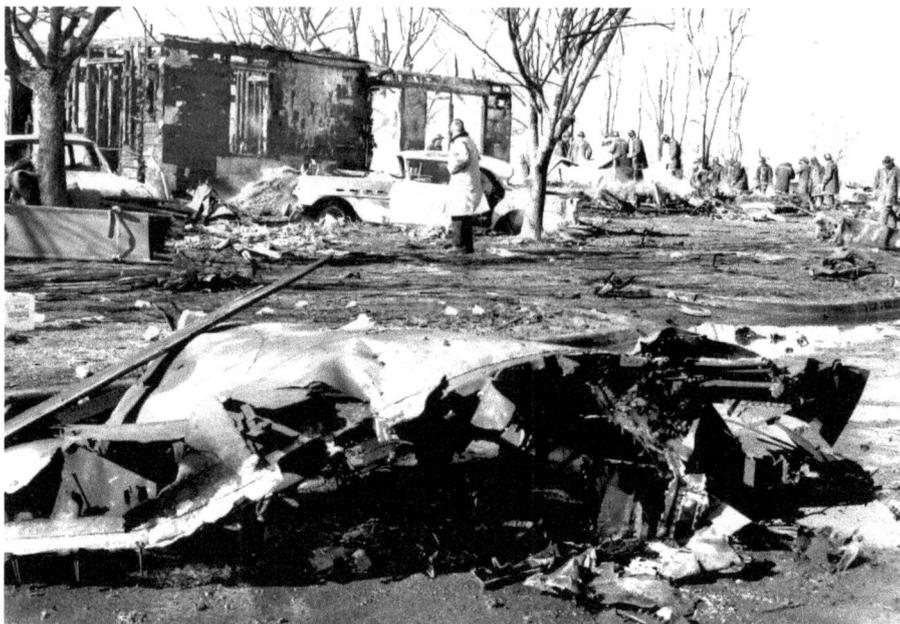

Wreckage from the KC-135. *Larry Hatteberg,* KAKE TV.

medic from McConnell and one of the first responders to the scene, detailed the grotesque findings:

> *The thing I cannot get out of my mind is this person starting his car—you know how you lean forward to turn the key when you start your car. This person was in that position. But instead of a person, it was a charred skeleton. We found the same kind of thing later on with a person who was stepping out of a bathtub.*[164]

The houses that had been standing only hours before were now in ashes, and responders had to take their time digging out corpses from amongst the ruins. This was the point at which civilian help finally waned. Deputy Chief Simpson recollected, "[T]hey said they had to get back. They had had enough…they didn't want any part of removing bodies. I don't mind telling you, it bothered me, with all my years of experience."[165]

Capt. Raymond L. Wert with the Salvation Army later reminisced on the eerie quiet that occurred upon the discovery of corpses: "When they came across a dead body. I was struck by that, you could hear a pin drop; the men

may have been joking and talking about each other, but when they came to a dead body, it was so quiet and so hushed. Nobody spoke."[166]

One of the firemen recalled pulling out what he thought was a piece of rubber from the heap of plane fragments. Much to his surprise, it turned out to be a scorched human stomach instead.[167] Rescue efforts went on throughout the day as more and more bodies were found among the wreckage. Reporters watched and recorded while firemen and members of the air force used "long grappling poles to retrieve the torn and mangled remains of the crew from the muddy water and fuel-filled ditch in the street."[168] It was not a job for the squeamish. These sights would not be easily forgotten. And yet, the worst sight to endure was the finding of small children. Fire Capt. Lawrence E. Black, a twenty-year veteran with the WFD, described one image that would haunt him for the rest of his life:

> *There was a house that had been burnt to the foundation, I would say, and I saw two small children that were burned…this type of thing I don't ever get over regardless of how long I have been on a job, or how long I will stay…But these two small kids looked like they might have been dolls that had burned. One of them looked like the head had exploded, the other like the stomach. I mean, this is the type of thing we looked at.*[169]

Fire Capt. Earl Tanner was one of the first to arrive on the scene. He vividly recalled a house he and his men approached on Piatt where Raggy 42's boom, torn off by the collision, was lying in the yard. In front of the torched home, there was a man sitting dead in a vehicle. The man to whom he had been speaking only seconds before on the front porch was dead, a woman inside the kitchen was dead and two children in the backyard, still on their tricycles, were dead—all burned alive instantly and simultaneously by the intense heat. Tanner, now eighty-seven years old, adamantly declares that no fire before or after the Piatt disaster in Wichita ever compared to that of January 16, 1965.[170]

Litter bearers made continual trips from the rubble to the field behind Razook's supermarket where the bodies were collected. Once tagged, they were sent to a makeshift morgue in the auditorium of the City and County Health Department at 1900 East 9th Street. Some were underneath blankets, others were in rubber bags. During one trip, a reporter asked the man carrying a litter how many bodies were beneath the smoldering blanket. The man replied that he "could not tell."[171] The intensity of the explosion left most bodies burned beyond recognition. Only charred flight suits helped to identify the airmen from the civilians.

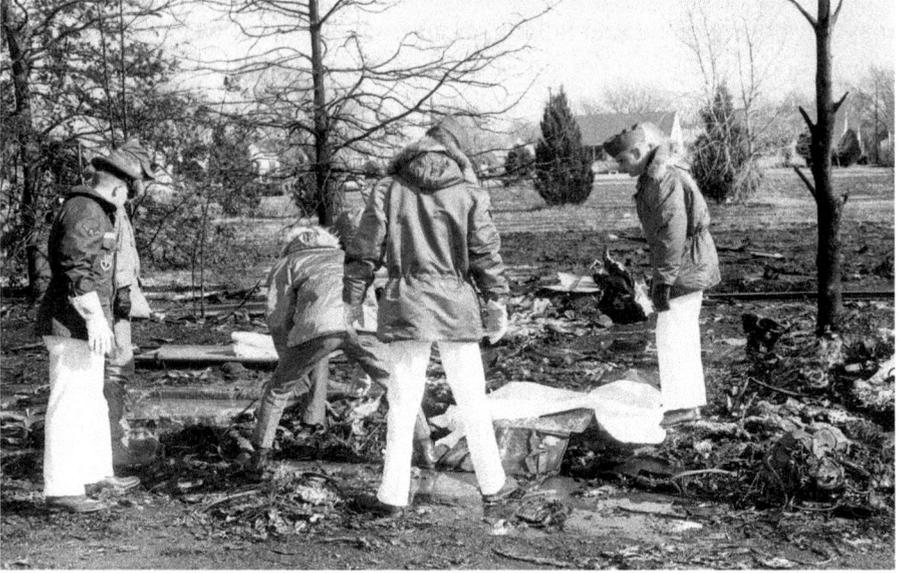

Air force investigators search for human remains. *Kansas Firefighters' Museum.*

The Reverend Thomas Heffernan, a young priest who worked as a chaplain on McConnell, was a familiar face at the scene. Firemen gladly hunched over and carried the reverend on their backs, wading through the knee-deep water, foam and jet fuel, so he could give the last rites to victims. But, as a reporter commented, "[r]arely did he find a whole body."[172]

Orange markers were placed on bits of tissue and bones until the markers were "as thick as trees in a forest."[173] Twenty-three of the bodies were sent to the morgue while six of the airmen were sent to another facility. Dr. Robert Daniels, the Sedgwick County coroner at the time, had a full crew of pathologists and dentists working on the recovered bodies in an attempt to positively identify them. When the next of kin arrived at the morgue, hoping to identify their family members, Dr. Daniels lamented, "There [were] only four or five bodies we could show. There's just nothing to see."[174]

ALL DAY AND ALL NIGHT

Recovery efforts were organized quickly and effectively by the federal, state and local authorities swarming on Piatt Street. But amidst the recovery efforts,

the scene was far from calm. People of all ranks and titles were searching through backyards, and fire trucks were moving hastily along the streets. Bulky, pot-bellied water trucks made continual passes, spewing out water in an attempt to dilute the jet fuel as much as possible, while ambulances hurried in and out of a crowded field near the impact point, their doors swinging open in anticipation of human remains for transport.

As the ninety-year-old Winston Churchill lay dying in London, England, after suffering a stroke, reporters from the *London Times* were calling police headquarters in Wichita, Kansas, to find out information about the crash. Inquiries came in from nearly every U.S. state. It was as if, at least for the moment, the world had paused outside of Kansas, and all eyes were on the mayday over Wichita.[175] Indeed, Churchill's famous words, "I have nothing to offer but blood, toil, tears and sweat," would have resonated with rescue workers as they wearily carried on in the fourteen-degree weather throughout Saturday night—raking through the last pieces of rubble.

Beneath the full moon and amidst the grisly remains, members of the Red Cross and Salvation Army provided coffee and refreshments to the exhausted workers as they pushed forward to recover the last of the bodies. A total of 500 cups of hot chocolate, 1,410 bowls of soup, 1,695 sandwiches and 3,700 bowls of chili were distributed by the Red Cross and Salvation Army that day alone.[176] Later, writing about his experiences after the crash, Capt. Wert recounted that from January 16 to January 22, when the Salvation Army left the scene, nine tons of food had been donated to feed the fatigued searchers and, now homeless, survivors. These tons included: "canned goods, bread, donuts, chili, hot chocolate, coffee, cakes, pies, milk, orange juice, soups, cups, napkins," and other miscellaneous items. An astounding 46,486 cups of coffee were handed out in seven days.[177] Wert also praised Mrs. Wilder of 3845 North Clarence, who baked over forty pies and ten chickens and sent plenty of "home-made chicken noodle soup, that was 'out of this world.'"[178] The efforts of the Red Cross, Salvation Army and Wichitans to supply the recovery workers were extraordinary.

FINAL TOLL

When Kansas Governor William H. Avery arrived at the scene of the crash, he called it the "[s]econd worst disaster in Kansas in his experience."[179] Avery stated that "it [was] second only to the Udall Tornado" of May 1955,

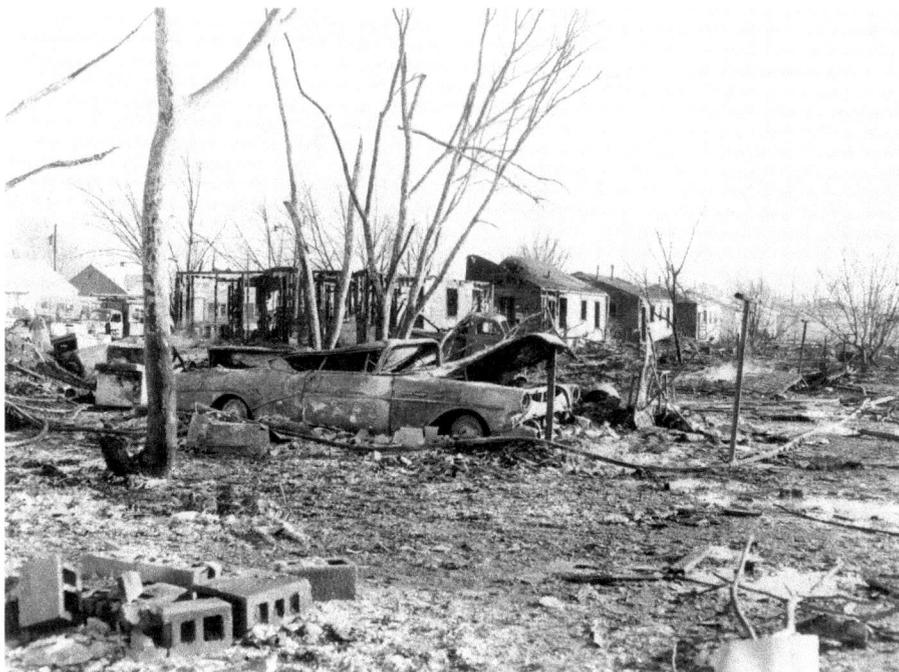

The KC-135 inflicted severe property damage. *Kansas Firefighters' Museum.*

which killed eighty people.[180] Despite the death toll of the Udall tornado, the Piatt Street plane crash was the worst non-natural disaster Kansas had ever seen, claiming many lives and causing the destruction of an entire neighborhood. The final toll taken by the WFD recorded fourteen houses instantly obliterated, sixty-eight others damaged, thirty vehicles demolished and thirty people killed—including the airmen.[181] Twentieth and Piatt Street now marked the most overwhelming catastrophe in Kansas history. Nothing before it, or in the decades that followed, would compare.

No one was blaming the air force, Boeing or the pilots—yet. In the time immediately after the crash, the issue at hand was the question of where to go from there and how to cope with such horrendous losses. A man leaving a nearby grocery store an hour after the crash occurred put it best. He said, "I don't know what to do now, but I need a drink."[182]

9
PICKING UP THE PIECES

*We ministers changed our subject for the Sunday sermon…My sermon was,
"You'd better get ready—it comes like a thief in the night."
—Reverend Joseph E. Mason, 1965*[183]

E ven the following day, a sea of onlookers and souvenir-hunters lined the
streets outside the crash site—each one gawking incessantly. Trucks,
cars, bicyclists, pedestrians and cameramen were everywhere. The whole
world, it seemed, wanted to see and photograph the worst disaster in
Wichita's history. Such a catastrophe—killing so many, so quickly, in Wichita,
of all places—was unthinkable. The alarming news rang out from church
pulpits that Sunday; corner diners and coffee shops hummed with gossip;
and local radio and television stations, newspapers and telephone lines all
carried the grim details to frightened, concerned and stunned residents.
Ominous headlines in the *Wichita Eagle* and newspapers across the country
told the dreadful story: "DEATH TOLL CLIMBS TO 30," "JET DEATH COUNT IS
30," "WICHITA TANKER CRASH TOLL RISES TO 30," "14 RESIDENCES WIPED
OUT: SCORES HOMELESS."[184] The congestion was so thick that one reporter
remembered, after asking an officer directing traffic how many cars he
thought were surrounding the crash site, the officer snarled, "How in the
hell do I know? Every damned car in town is trying to get in here."[185]

There was very little space within a six-block radius that was not filled with
either a vehicle or a spectator. From 21st Street to 13th Street, and everywhere
in between, cars were jammed bumper to bumper. Local law enforcement

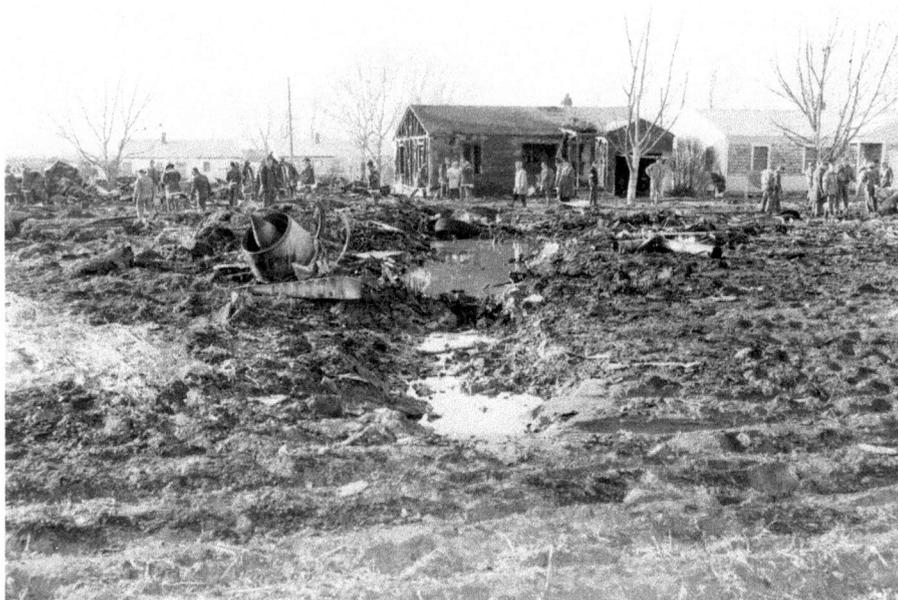

The impact crater left by the KC-135. *Kansas Firefighters' Museum.*

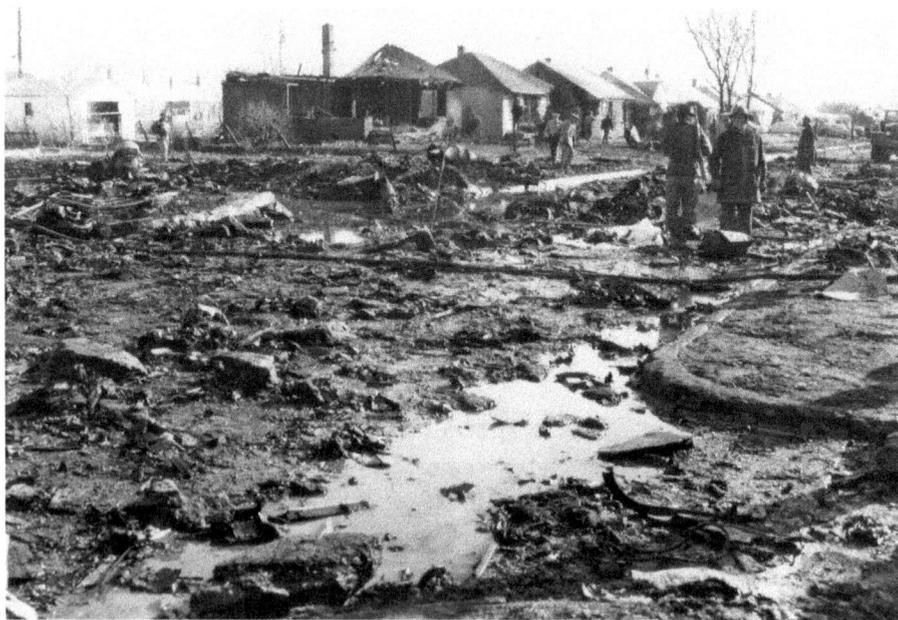

Near the impact crater. *Kansas Firefighters' Museum.*

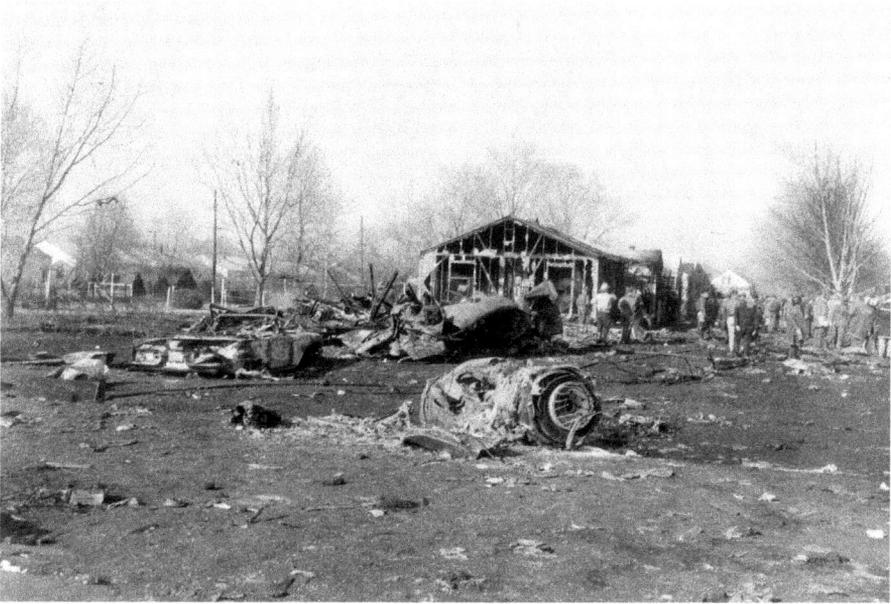

One of the KC-135's engines. *Kansas Firefighters' Museum.*

was hard-pressed to keep the thousands who had congregated out of the roped-off area. Unfortunately, this often included the very residents who lived there and were just trying to return home.

Few could blame the rubberneckers who strained to catch a glimpse. It was an unnerving site. When investigators began combing the murky scene at dawn on Sunday morning, one of them said quietly, "My God, it looks as though a bomb had hit."[186]

Property damage estimates started at $150,000. A few days later, they increased to $500,000. And by the end of the week, a loss of $3.5 million had been calculated—the largest portion of which was for the KC-135, valued at $3 million.[187] The area surrounding the deep crater where the tanker plunged into the ground was completely destroyed. The gross stench of jet fuel combined with burnt flesh still lingered. Blackened outlines marked where houses once stood. Copious piles of smashed vehicles and metal scrap mirrored those found in a junkyard. Trees were uprooted with their branches torn off. Grass was completely scorched. The only sign of life was the fifty-man team of air force investigators scouring and recovering the pieces to determine why the plane crashed.

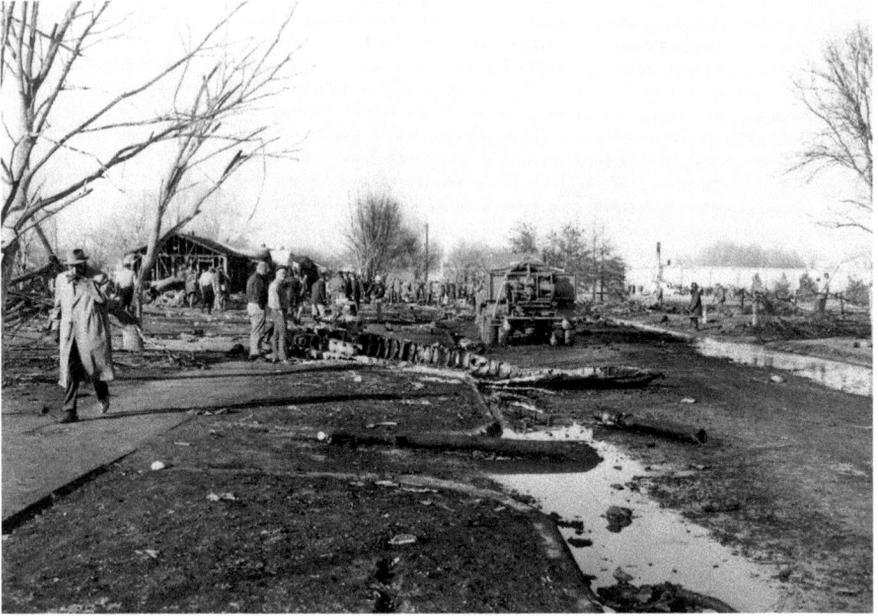

A scene of devastation on Piatt. *Larry Hatteberg*, KAKE TV.

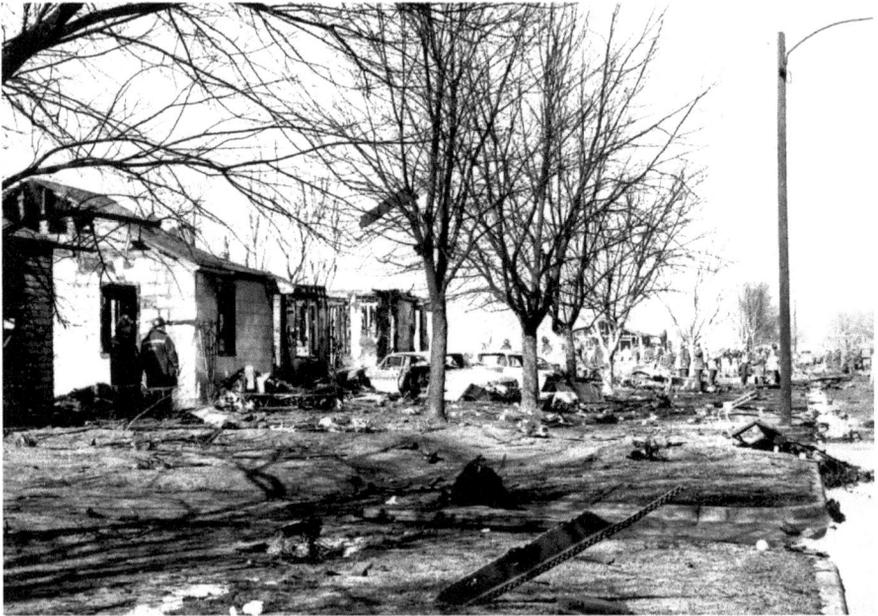

Destruction row on Piatt Street. *Larry Hatteberg*, KAKE TV.

Meanwhile, cranes and semi trucks with flatbed trailers from McConnell sifted through the area, scooping up anything resembling a piece of the KC-135. Reporters on the sidelines noted, "No part of the wreckage, no matter how small, escaped the scrutiny of investigators."[188] It was all to be taken to a nearby Boeing hangar and studied. The investigators were disappointed, however, as they soon realized little remained of the once giant Raggy 42.[189] A Boeing engineer later stated, "There was so little left of the plane that I was unable to identify the plane even though I was familiar with Boeing procedures, part numbers, etc."[190] When an inquiry was made about obtaining a photo of the reconstructed plane (a normal procedure in aircraft investigations), the air force replied, "The degree of the destruction to the aircraft structure and the components prevented investigators from reconstructing the airframe. Therefore, such photos do not exist."[191] Despite scarcity of evidence, they pressed on.

PREPAREDNESS

While investigators meticulously searched the crash site, members of the Wichita Disaster Committee assessed their own response and recovery efforts. The crash could not have occurred in a more prepared city. The extensive annual disaster planning in Wichita greatly affected the outcome. A city without a disaster committee, or perhaps, a less-prepared group of emergency responders, would not have fared as well. A study of the performance of Wichita's disaster plan in comparison to those of other cities, conducted by the Disaster Research Center in 1969, found that "[h]igh-ranking organizational officials immediately set up command posts at the disaster sites, and thus insured [sic] overall control and command of disaster operations."[192] The study concluded that the preplanning and organization for how to respond to such disasters in Wichita was up-to-date, and therefore, the catastrophe went about as well as it could have, given its magnitude. "Typical of any disaster, this crisis drove home to all of us the value of preplanning," said Bill Friesen, Director of the Civil Defense Program, years later. "Thank God we were organized then, but we are even better prepared now to cope with such a situation."[193]

In an interview conducted two days after the crash, Pat Kelley, with the Sedgwick County chapter of the American Red Cross, expressed relief that the disaster committee, which included "the police chief, fire chief,

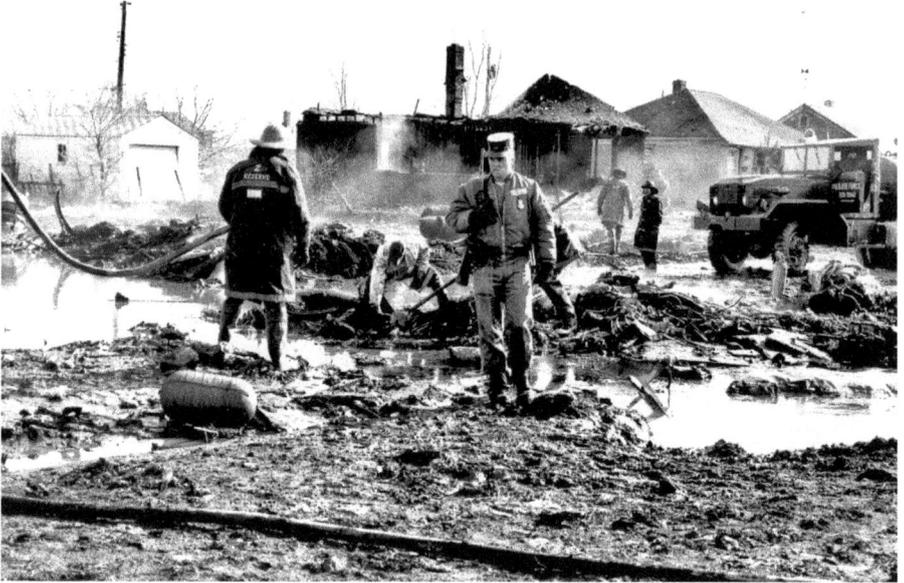

Military police and firemen walk among the wreckage. *Larry Hatteberg,* KAKE TV.

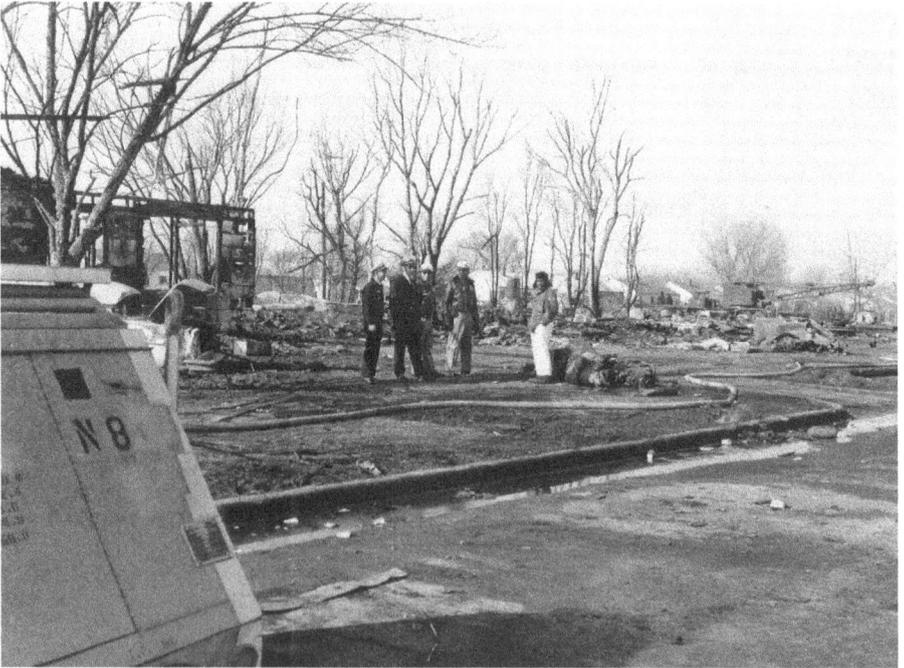

Air force investigators standing amidst wreckage. *Kansas Firefighters' Museum.*

ambulance and hospital people, the air force and others," had just met the week before on Monday to discuss in detail "a master plan of operations in the event of an air crash in the city."[194] According to Kelley, "We talked about having a test of the plan in March. It came sooner than we expected, but our planning served as an assist to the work carried out today."[195] These were the "most massive, swiftest, and most cooperative efforts" law enforcement had ever seen in Kansas. And for all the crash's fury, the operation went smoothly. Some claimed they had "never seen a smoother-working operation."[196] The plan worked, and it worked well. Capt. Gene Starr of the Highway Patrol observed that "it was an excellent effort," while Fire Chief Tom McGaughey rightly concluded, "They all did beautiful jobs…from the newest recruit to and including the deputy chief. They really put out; especially the off-shift men."[197] It was an incredible endeavor and display of readiness. Other communities almost immediately began implementing identical plans.

THE INJURED

Oddly enough, Wesley Hospital reported five women going into labor at the exact same time that victims from the plane wreck were being brought in. When asked about this phenomenon, hospital officials replied, "Some probably went into labor because of all of the shock."[198] Ultimately, shock and severe burns became the most common ailments for which dozens of residents received treatment. Hospitals were taken off of disaster alert by noon on January 16 but continued treating survivors for myriad injuries: twelve-year-old Robert Jackson of 1831 North Piatt had first-degree burns on his back; twenty-seven-year-old George Meyers and his wife escaped 2027 North Piatt with excruciating burns on their feet; forty-four-year-old Cora Belle Williams was treated for multiple abrasions after fleeing 2048 North Piatt; forty-seven-year-old Joe Martin, who watched his young sons, Gary and Joe Jr., burn to death at 2031 North Piatt, was treated for shock and burns to his face and hands; fifty-five-year-old Clarence Walker and his wife, Irene, barely escaped their home at 2101 North Piatt before being scarred with multiple burns and lacerations; and sixty-year-old Alvin T. Allen, who lived at 2060 North Piatt, suffered first-degree burns to his face.[199] Many other victims were treated and released from local hospitals—most of them, if not all, thankful they walked away from Piatt with their lives.

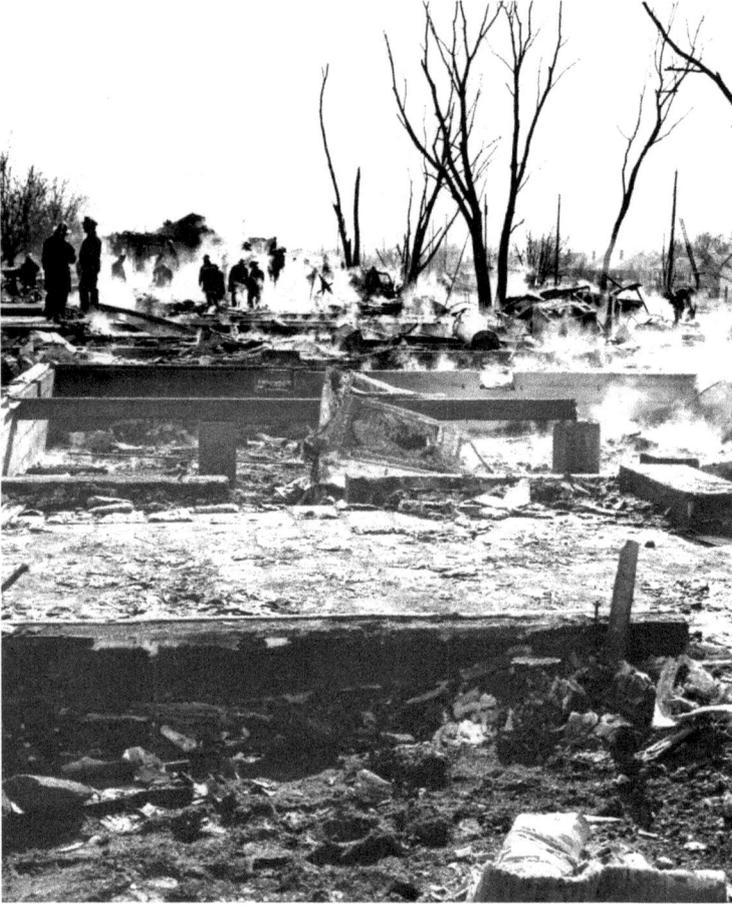

Homes burned down to their foundation. *Larry Hatteberg,* KAKE TV.

COMMUNITY SUPPORT

A comforting gesture following the crash was the amount of community support the victims received. The racial barriers between blacks and whites were seemingly nonexistent on January 16 and 17. It was not yet an African American tragedy or an air force tragedy; it was a Wichita tragedy. One builder, who promised to provide finished homes to those displaced by the event, captured the general feeling: "We know these people need the help. They're Wichitans and we're going to take care of our own. Now we can prove that Wichita has a heart."[200]

As the flatbed trucks began to haul away remnants of the KC-135, and the sunlight peered down on the charred trees, homes and twisted pieces of metal on Sunday morning, the Wichita community was at work making arrangements to aid those who had suffered from the crash. Operation Holiday took up a disaster relief collection, and Wichita residents almost immediately began donating. The offices were quickly inundated with "everything from Turkish towels to pajamas to children's shoes."[201] Wichitans gave in abundance.

By midafternoon, many of the victims had gone to temporarily live with friends and family. But for those who still needed shelter, additional space was provided. Dozens of Wichitans came forward, opening their homes to the victims. The Federal Housing Administration offered unoccupied homes to residents. One generous housing developer, Jim Garner, made one hundred apartments he owned available to the residents, reiterating that they could stay there for free "as long as necessary."[202] Over 150 volunteers, including Girl Scouts, members of the McConnell Officers' Wives Club, church groups, high school kids and all sorts of other individuals were laboring by noon on January 16, collecting and sorting the donations. Local department stores rushed out electric heaters for residents without power in the freezing temperatures, bake sales were crafted to raise funds and financial aid came from all directions. The Salvation Army and Red Cross were overrun with ample supplies of food and clothing rushed into their offices. By Sunday night, January 17, Capt. Ramon Wert with the Salvation Army was so astonished by the mountain of goods flowing in that he stated, "As it looks now, we will need no further donations until Wednesday."[203]

In addition to the recovery and cleanup efforts, the air force set up a command post in a vacant storefront building at 1919 East 21st Street. It began offering subsistence payments to victims whose homes were damaged or destroyed by the crash. Major G. H. Letarte, a legal officer under the SAC, told reporters he was "authorized to give or lend up to $1,000 per request."[204] But hours after opening on Saturday, he received only one damage claim for $250. Capt. William A. Martin, an air force lawyer from McConnell, remarked, "People don't seem to need the money right now. Apparently, they are being taken care of for the present."[205] However, there were also other reasons for why the seemingly generous $1,000 grant was rarely claimed—reasons that would soon be known.

10

RACIAL BARRIERS IN RECOVERY

In the years that followed the disaster, Wichitans began to speculate on what would have happened if the plane had crashed in a more affluent area of Wichita instead of in a socioeconomically disadvantaged section. A study conducted by the *Wichita Beacon* provided evidence that the African Americans in Wichita at the time were "socially, educationally and economically deprived in a heavily concentrated area."[206] This area, commonly referred to as the "ghetto," was located in the northeast section of Wichita, where "90 percent of the city's Negro population" lived.[207] Whereas, just down the road, the opulent College Hill neighborhood was one of the more prominent white suburbs in Wichita and had no such deprivations or derogatory monikers. Given the dissimilarities between the two neighborhoods, this juxtaposition was unavoidable.

Live-in servants were still commonplace in College Hill during the 1960s. With cobblestone streets and luscious, mature trees casting shade on them, homes in this area were a far cry from the $10,000 homes at 20th and Piatt. At only one square mile, the College Hill residential area contained some of the wealthiest properties in 1965. The neighborhood represented "an eastward city movement of upward mobility," in which resided "prominent families connected with the major industries of the city: livestock, grain, milling, railroads, lumber, petroleum, aviation, and financial institutions."[208] Piatt Street contained nothing of the sort.

Class Divide

The well-to-do in Wichita were once found in the downtown area near Central and Broadway Streets. By the turn of the nineteenth century, more and more wealthy families had started migrating to the suburbs from their downtown location, expanding College Hill. According to College Hill historian Jeff Roth, "The allure of getting out of the densely developed part of downtown with all the chimneys, burning coal, small factories, horse stables and blacksmiths and all that noise, dust and smoke" caused the wealthy to move into areas like College Hill. Roth went on to add, "Real estate agents could brag that in College Hill, you were up out of the teeming valley and on a hill where the view was so expansive that you could see as far away as Clearwater and Goddard."[209]

Hypothetically speaking, if the plane had crashed in the College Hill neighborhood, the residents who survived the crash might have instantly filed insurance claims to recoup their losses while checking into one of the nicer hotels in town. They probably would have called their family attorneys—who would have advised them of their rights and eased their concerns—purchased new comforts and awaited reimbursements from claims sent into the air force offices and insurance agents. The paucity of money and material possessions that plagued the victims on Piatt Street afforded them no such opportunities. Additionally, the housing restrictions, which corralled blacks in the northeast, certainly added barriers to the recovery process in the end.

The Veil Removed

Despite the amazing efforts of the community, local agencies and the air force, the issue of race could not be avoided for long. Relief workers were mostly white; the victims, mostly black. The Red Cross had no black board members (one, Jim Garmon, was recruited after the crash), and few blacks, if any, worked for relief agencies in Wichita. All Wichita banks set up disaster accounts in order to take in donations to help repair homes and relocate residents, but these efforts were never intended to override the housing restrictions that kept blacks out of white neighborhoods (though some hoped they would).[210]

The Red Cross did not wish to become entangled in the equal housing issues—so instead, it gained approval to allot ninety dollars a month in cash payments for rent to those still needing shelter. Rumors quickly spread that the majority of the houses offered were in the ghetto, and others were simply

uninhabitable. In an interview conducted by two Wichita high school teachers, Leonard Wesley and Frank Carpenter, on April 20, 1965, they spoke to residents about the generous offer from some property owners in Wichita to supply homes to those in need. Among those interviewed was Clarence Walker.

Clarence Walker was a tall, lanky man in his late fifties who incessantly smoked cigarettes. He wore a low haircut and full mustache and loved to have a conversation, even if he did the majority of the talking. He worked at the Boeing plant as a cook and was well liked among friends for his solid smile and good-humored personality. A combat veteran, he had witnessed friends die fighting in subzero temperatures during the Battle of the Bulge, one of the largest German artillery attacks of World War II. Ironically, it was only after surviving the horrors of Piatt Street that he would undergo psychiatric counseling for several months to cope with the trauma.[211]

Clarence and his wife, Irene, who barely escaped their home when the plane hit, quickly informed the interviewers about what actually occurred during recovery efforts:

> Let me correct you right now. That was one of the biggest frauds that ever came out. This fellow offered these homes. He had so many houses, and it come to find out that he didn't have nothing but some coops out there that had to be fixed up—just like my garage which is ready to fall down—and he offered them to us, and the Red Cross, well, we asked them to find us a home and they couldn't find nothing.[212]

Mrs. Walker went on to describe how the Red Cross found them some apartments for eighty-five dollars a month, but it would pay for only one month's rent. Not to mention, the apartments were located in a dilapidated area.[213] Those who had no choice but to stay in the apartments offered by the Red Cross called them "the filthiest place I've been."[214] The families affected, in many cases, were split up and forced to live wherever they could find shelter. Carpenter and Wesley later concluded in their study, "It is obvious that the Red Cross, while it offered food vouchers in several instances and rendered other amenities, misread the housing needs of the displaced persons."[215]

Victims also soon discovered that the clothes donated were mostly hand-me-downs, in odd sizes, which either needed repair or were so "on the fritz" that they were of use to no one. Furniture was "filthy" and missing pieces. Operation Holiday, which looked so promising just hours after the crash, was quickly discovered to be a "glorified rummage give-away" by most victims.[216] Moreover, few had the wherewithal to retrieve the donated

items or anywhere to put them. And despite the air force providing $1,000 in financial aid to individuals, it required proof of identity, property ownership and next of kin (if the victim had perished) before it would pay out any aid money. In many cases, the next of kin resided in other states, identification and property papers were destroyed in the fire and some blacks were understandably hesitant, even suspicious, about signing paperwork from what was perceived then as a "white" government.[217]

James Garmon, a former navy aviation machinist and Boeing employee who once ran for state senator, operated Razook's store just yards from the crash site and attempted to ease the difficulties for blacks dealing with the air force claims office.[218] Over 60 percent of his customers were the residents impacted by the tragedy. Garmon was also African American, and because of his intimate knowledge of the black community, the claims office asked for his assistance. According to Garmon, "You couldn't get the people to sign a claim," especially since "attorneys and the ministers were instructing them never to sign any papers whatsoever."[219] The majority of uneducated blacks living in this area feared this was some type of final settlement. This, coupled with the air force's requirement of signatures and various forms of proof, drastically delayed the entire process.

The $1,000 grant was also, in reality, much closer to an average of $250 per claim. Five months after the crash, Carpenter and Wesley reported that only *one* family, the Meyers, received a $1,000 grant. This happened only "after much persuasion from their attorney, G. Edmond Hayes."[220] Carpenter and Wesley concluded that the major source of hesitation by blacks to receive their claims "came from the inertia developed by long frustrating previous struggles with whites. Always under the surface of interviews was the idea, by implication, that 'We're in another situation where we might get taken again.'"[221]

There was also an overwhelming feeling that the $6,992.03 reported by the Red Cross in April as its total expenditure on the disaster "filtered out into higher salaries" because it failed to match its performance, given the substantial contributions received.[222] Race was, indeed, a factor, as it had been in almost every area of life in Wichita—even in disaster.

Racked with anxiety and uncertainty, the victims of the Piatt disaster could only speculate how this tragedy might have unfolded differently had Raggy 42 fallen just a few blocks east. An unidentified woman in a taped radio interview at the crash scene aptly surmised the dichotomy between the two neighborhoods: in other neighborhoods there were resources, but in the ghetto, "I guess we just have to make do."[223]

11

A DIVIDED CITY AND COUNTRY

One hundred years of delay have passed since President Lincoln freed the slaves,
yet their heirs, their grandsons, are not fully free.
—John F. Kennedy, 1963[224]

The mayday call by Raggy 42 on January 16, 1965, was not the only distress signal ringing that day. Hundreds of feet below the turbulent KC-135, the city—and, indeed, the country—was sending out its own cry for help. America was in trouble; Americans were divided. By the time 1965 was underway, one of the greatest hopes for the progress of civil rights, President John F. Kennedy, was slain; Dr. Martin Luther King Jr. was planning what would become the most famous march for equality in Alabama from Selma to Montgomery; American soldiers were entangled in an expanding and deadly Vietnam War; the Civil Rights Act of 1964 and the Voting Rights Act of 1965 were signed into law by the first southern president to be elected in over a century; black homes, churches and businesses were bombed and burned in the South; violent race riots broke out in Watts, California, later that year; and Americans everywhere were pushing for the integration of segregated establishments across the United States.[225]

Racial equality had reached an impasse. Neither the passage of laws nor federal troops could fix the problem. As President Kennedy observed, "[L]aw alone cannot make men see right."[226] Once again, mirroring what took place one hundred years prior, Americans were in the midst of civil war.

Martin Luther King Jr. at the White House with Lyndon B. Johnson, March 18, 1966. *Lyndon B. Johnson Library.*

It is not possible to fully understand the impact that a massive KC-135 aircraft, laden with jet fuel, has when it crashes into a primarily African American neighborhood in 1965 without first bearing in mind the context of what was taking place in the city of Wichita and in the country itself. When this tragedy befell Wichita, it did so during one of the worst periods of social upheaval in American history: at the height of the Civil Rights Movement. The crash and its effects, which divided the community, were a microcosm for the larger conflict at hand—a conflict that burned brighter as the decade progressed. How the nation arrived at this point, the role of Kansas in the Civil Rights Movement and the African American experience in Wichita during 1965 are crucial points to consider when encapsulating this tragedy.

KANSAS: A BRIEF RESPITE FROM THE SOUTH

A seventy-year-old coffin maker from Tennessee led the biggest impetus for free blacks to enter Kansas in the 1870s and 1880s. He had experience placing the bodies of dead slaves who "got out of line" into their graves. He knew all too well the cruelties of slavery and the oppression of blacks in the South following the Civil War.[227] Benjamin "Pap" Singleton—who had a stern face, a strong jaw and piercing brown eyes—was a rough, disciplined man. He had seen his share of life. Born and raised in slavery, Singleton led so many blacks out of the South that he once boasted, "I am the whole cause of the Kansas immigration!"[228] Few could argue to the contrary.

Singleton, through his immense work and tenacity in leading blacks from former slave states to Kansas, would eventually become known as the "father of Kansas black immigration."[229] Singleton wrote numerous letters to the Kansas governor asking for help with the exodus and he traveled extensively back and forth to Tennessee, over hundreds of miles, leading thousands of blacks to establish settlements in Kansas. In his twilight years, he declared, "I have taken my people out in the roads and in the dark places, and looked to the stars of heaven and prayed for the Southern man to turn his heart."[230]

Not only did migration to Kansas give blacks new freedoms and opportunities, but Singleton also surmised that, by removing blacks from the South, he could create a labor shortage to remind southern whites not to mistreat the people they depended on for production. Granted, the mistreatment of blacks by southerners did not cease, but many oppressed laborers went elsewhere to states like Kansas.

Benjamin "Pap" Singleton. *Kansas Historical Society.*

78

Exodus handbill.
Kansas Historical Society.

MIGRATION

Men like Singleton and Henry Adams, another well-known organizer of black migration, were a part of the movement following Reconstruction that brought the first black families to Kansas. After years of bloodshed to determine whether Kansas would become a slave state or free state, in the vacillating conflict known as "Bleeding Kansas," it finally entered the Union as a free state on the bitterly cold day of January 29, 1861.[231] With the passage of the Homestead Act in 1862, settlers soon crossed the threshold, making Kansas their home. Eight years later, when the first flour mill was established in the city of Wichita to support what had become a thriving wheat industry, the first black family settled there in 1870.[232] The next family arrived in Wichita in 1871, followed by four more in 1872, two in 1874, one in 1875, five in 1876,

three in 1878 and 1879 and four in 1880. By 1880, nearly two dozen black families were living in Wichita.[233] These numbers continued to grow over the decades as more migrated to Wichita in search of employment and freedom.

BURGEONING WICHITA

African Americans made up 5.5 percent of the Wichita population in 1880. This number crawled to 7.8 percent by 1960—eighty years later.[234] And at a quick glance, Wichita appeared to be the ideal American city in 1965. Located one hundred miles south of the capital city of Topeka and just over fifty miles north of the Kansas/Oklahoma border, Wichita was every bit the cow town it so proudly claimed to be—as well as the "Air Capital of the World." With its endless miles of flat terrain, clear skies and abundant farmland, Wichita flourished in two areas: aviation and agriculture. Promotional maps and posters throughout the 1900s boasted that Kansas was "First in Wheat," a "Shrine for Education," lived by the "open road" and offered "a great and promising future in America."[235] Wichita was home to a booming aircraft industry with Boeing, Hawker Beech and the newly built McConnell AFB in 1954.[236] This came as no surprise considering Wichita produced "one-fourth of all commercially-built planes in the U.S., with over 25 aircraft companies" just twenty-five years after the Wright brothers first took flight.[237] Apt to take part in Wichita's booming economic industry, the African American population further increased in the 1950s as Wichita expanded and more blacks established residence in the city.[238] With a total population of 24,671 in 1900, Wichita had swelled to a whopping 254,698 residents by 1960—19,861 of whom were African Americans.[239]

RESIDENTIAL SEGREGATION AND THE CREATION OF WICHITA'S NORTHEAST "GHETTO"

According to a 1960 census, there were nearly twenty thousand African Americans living in Sedgwick County. Of this group, 97 percent were living within the city limits of Wichita, mostly in the area of "21st Street and east to Hillside" in what was referred to as a "tightly segregated" community.[240] In fact, Wichita was one of the most compactly segregated cities in America in regards to residence, with

"95.3% segregated residentially."[241] As evidenced in a report prepared by the Kansas Advisory Committee to the U.S. Commission on Civil Rights concerning police-community relations in Wichita and Sedgwick County, it was understood that African Americans in the 1950s and '60s, usually not by choice, lived in their own distinct area of Wichita. The report found:

> *Racial isolation was perpetuated by the real estate industry, which during the period after 1955 allowed black families to move only into neighborhoods contiguous to the original black community. The Wichita Real Estate Board never answered a petition from local groups asking for its help to end this practice.*[242]

What's more, this area of Wichita, where African Americans resided in mostly $10,000 homes, was by no means considered an affluent area of the city.[243] The northeast section contained malodorous stockyards, packing plants and refineries, which pelted foul-smelling odors into the neighborhood every time the south wind blew.[244] But blacks had few options in prime real estate.

THE WRECKING BALL

Urban Renewal began as a concept within federal housing legislation in 1949. This was a host of federally funded land redevelopment projects that adversely impacted Wichita's once-thriving black community in the 1960s.[245] The best example of Urban Renewal's dislodging effects is the Calvary Baptist Church, located at 601 North Water Street. Built in 1917 in Neo-Classical Revival architecture by Josiah Walker—who was referred to as a "plasterer and architect"—Calvary Baptist Church was once the largest African American church in Wichita with a congregation of over five hundred members in the 1920s.[246] But by the time the 1960s ended, it was one of the last buildings earmarked for Urban Renewal's wrecking ball and today is one of only two original buildings left standing in what was formerly Wichita's historic black business district.[247]

Before Urban Renewal, the flourishing black community encompassed a fifteen-block radius for over half a century, stretching from "West Third Street north to West Ninth Street, and Main Street west to Waco."[248] This area was the booming center for religious, cultural, social and business activities in the black community, with various shops, restaurants, hotels and offices. But when Urban Renewal came in the early 1950s and '60s, many

blacks were displaced. So, too, were their buildings. As a result, Calvary Baptist Church and the Arkansas Valley Lodge building (also designed by Walker) at 615 North Main are the only remnants of that era. Calvary was placed on the National Register of Historic Places in 1993 after Doris Kerr-Larkins, an active member at Calvary, led several initiatives to help preserve the church.[249] Many other historic structures failed to escape demolition.

The construction of a new county courthouse in the heart of the black business district, the building of Interstate 135 and "block busting"—a practice in which real estate agents frightened white homeowners into believing their neighborhoods were being infiltrated by African Americans, thus causing them to vacate in order to sell the homes back to minorities at an inflated price—compelled many African Americans to move from the area of North Main and Water Street into the north and east sections of Wichita.[250] Countless blacks were affected by Urban Renewal. Business owners left the district, taking their businesses with them. The once prosperous center was demolished. New buildings and parking lots for city and county workers now cover the site. Today, Calvary Baptist Church, refusing to surrender, is the Kansas African-American Museum—besieged by the Sedgwick County Jail built around it. A clearer picture of Urban Renewal's impact, there is none.

RESTRICTIVE COVENANTS

Evident, too, in Wichita during the 1960s were the racially charged restrictive covenants, which kept black families isolated in the northeast, creating an all-black neighborhood seemingly overnight. A study by Angela Miller for the Kansas African-American Museum in 2000 contained several interviews of African American residents in the northeast who remembered well the restrictive covenants and their lingering effects. One such interviewee, Duane Nelson, whose family was one of the first to move into an all-white neighborhood north of 13th Street (a racial boundary line at the time), recalled the state of affairs:

> *A black family couldn't buy a house in a white neighborhood. They wouldn't sell you the land…There was always one* [real estate agent] *who put profit over anything else, who would over-price the property, sell it to a Black and that immediately started white flight. Everybody started running.*[251]

Another lifelong Wichita resident, Jackie Lugrand, commented:

Before 1958, we lived on Seventeenth and Grove and we had two white families left but they were changing, all of them were trying to get out of there as fast as they could; and they would sell their homes to Blacks, and of course, selling to Blacks, they would up the price, get more money, and then they would move south or move out west to get away from Blacks… before you know it, it's an all-black community.[252]

Some grew tired of the many barriers and difficulties faced when trying to integrate into white neighborhoods and gave up. Others refused to succumb to threats, which required great fortitude and perseverance. Holding one's ground was not easy, but some did. Duane Nelson's first home was rigged with dynamite by the Ku Klux Klan and blown up.[253] He pressed on. Chester I. Lewis promptly received a burning cross in his yard, explosives in his mailbox and bricks through his windows after he solicited a white friend to purchase a home in an all-white neighborhood and then assign ownership to him and his wife, Vashti.[254] The fiery and determined Lewis, who was the head of the local NAACP and a prominent attorney in Wichita, refused to move from his home.

Several other intimidations and heinous attacks occurred in Wichita (as in the rest of the nation) during this period, urging black families to remain in their neighborhoods and not to venture into white territory. In his illustrated book entitled *Wichita: The Magic City*, historian Craig Miner explained how "Wichita was in the 1960s, and had been since the 1890s, one of the most tightly segregated cities in housing in the United States."[255] The Fair Housing Ordinance passed in Wichita during 1965 "had no teeth," said Miner, "other than threat of publicity."[256] Moreover, there were but a few blacks in positions of authority who could stand up to such harsh treatment. Statistically speaking, "50% of black families in Wichita in 1960 fell below federal poverty guidelines in income, and 20% made below $2,000 compared with 6% of whites at that level," found Miner.[257]

In her book *Dissent in Wichita*, civil rights historian Gretchen Cassel Eick noted how, when compared to white neighborhoods, black neighborhoods in Wichita during this period were extremely diverse socioeconomically. According to Eick, "In the same area lived doctors, lawyers, dentists, veterinarians, teachers, porters, janitors, cooks, and the impoverished, underemployed, and unemployed."[258] And for the rest of Wichitans, there was "a sense of you don't go into that part of town if you're white," which was "fed by real estate agents and common culture," said Eick.[259] The

segregation in Wichita at the time was very real and unmistakable.[260] Miner would comment, "It was also evident that there was housing discrimination, and that the 'ghetto' was real" as well.[261]

Ultimately, the socioeconomic diversity observed in the African American neighborhood was due to residential segregation rather than choice of residence. African Americans who wanted to move outside of these areas into white neighborhoods were denied mortgages or, worse, forced to pay much higher costs than whites after being charged inflated interest rates and exorbitant down payments.[262] Some, such as Chester I. Lewis, who earned enough money to make it out of black ghettos, were truly the exception. The majority of black Wichitans struggled in unskilled jobs that offered only meager wages in the 1960s. Wichita's employment inequality could be surmised by the National Urban League's study in 1965. This study described how "jobs of Negro workers were in classifications requiring less skills than those of white workers," and in many occupations where whites were employed, "there were no Negroes."[263] Of the twenty-six employers who participated in the survey, the data collected revealed how 80 percent of blacks employed were working "in semi-skilled or unskilled capacities."[264]

Despite the efforts of the local NAACP and of prominent African American leaders in the community—like Chester I. Lewis and Hugh Jackson—little could be done to close the gap of dismal job prospects for African Americans. A staggering 90 percent of black federal workers "were in Grade 5 or below," and "only a few were in upper grades," said Warren M. Banner in his *Review of the Economic and Cultural Problems of Wichita* for the National Urban League, published in 1965.[265] With the destruction of the black business district, aside from manual and unskilled labor, employment opportunities were almost nonexistent for African Americans living in Wichita in 1965.[266]

The barriers in housing and employment for blacks during this period were vast. Some broke through the roadblocks, but most did not—especially those living on Piatt Street. Tract Number 7, where the plane fell, contained the poorest housing and two-thirds of Wichita's unemployed; the lowest achievement records for schoolchildren; the highest birth and illegitimacy rates; 20 percent of all criminal arrests; and very few community leadership positions.[267] As the executive director of the Wichita Urban League, Hugh Jackson, found, "[t]he segregation of and discrimination against the Negro" was the primary problem in Wichita.[268]

An article written a few months after the crash in the *Beacon* offered "solutions" to the housing and employment quandary faced by many blacks. The pejorative comments put forth, however, only exposed the racial

barricades, bigotry and apathy that fomented civil unrest in Wichita. The article was ironically entitled "How to End Prejudice":

> [Employment] *You see, it isn't that whites object to Negroes as such living next door to them, at least in most of the North. What they object to are obscure Negroes. Almost everybody is willing to accept a famous Negro.*
>
> *What we have to do, obviously, is to initiate a crash campaign among Negro pupils—to get them to concentrate on two fields, entertainment and athletics. Junk like History, English or Math won't help them a bit finding a better place to live…The only problem now is how to turn every Negro boy and girl into an Ernie Banks, a Lena Horne, a Harry Belafonte, a Jimmy Brown, a Willie Mays, an Ella Fitzgerald.*
>
> [Urban Housing]…*The whole urban housing problem could be solved in practically no time if the mass of Negro children would only concentrate on tap dancing, trumpet blowing, throwing forward passes, stealing bases, and strumming a classic guitar. (And if they could manage to look a little more like Lena Horne or Harry Belafonte, it wouldn't hurt either.)*
>
> *IT'S REALLY NOT the Negroes we whites are prejudiced against. It's the unsuccessful ones. The obscure ones. The ones who have the same problems and frustrations we have, only more so. What we dislike is failure—and where can you find more of it to dislike than in the black ghetto?*[269]

Most disturbing, perhaps, is the complete, yet sincere, delusion with which the article was written—further evidence that a social and economic moat, fortified with racism and ignorance, conspicuously divided Wichita in 1965.

12
WHY IT CRASHED

THE RUMORS

They said they were trying to kill a bunch of black folks in here; that was the rumor.
—Sonya House, 2012[270]

A vagrant arrived in Wichita a few days after the crash claiming he was going to deliver all the victims from their troubles. He was an odd-looking man with peculiar habits. Large and gangly, some described him as resembling "Frankenstein" or a "beatnick type of fellow"—comparing him to those who rejected the norms of conventional society and clung to the social movements of the 1950s and '60s.[271] He was a vegetarian, wore a full beard, spoke eloquently and, for all intents and purposes, conveyed his ideas well. Beneath the façade of concern and good intentions, however, there was a darker side to the stranger. And in the opinion of those who had direct contact with him, he was a deranged man.

Of the many conspiracy theorists emerging after the disaster, none was as eccentric or irritating as Samuel D. Coleman. He meticulously scoured the crash site, holding solo prayer sessions in the ashes, prowling through the neighborhood and repeatedly harassing residents about what happened. To make matters worse, barely a week after arriving, Coleman burst into Razook's confectionary store waving a small bag of miscellaneous "airplane" parts, insisting he was the brother-in-law of one of the pilots. Coleman swore the parts were from the destroyed KC-135, somehow "overlooked" by the air force. Those who remembered Coleman especially recalled his various claims about the cause of the crash: the plane had been sabotaged by

communists as part of a "larger plot"; a time-bomb was onboard and must have exploded, causing the crash; and, finally, it was a massive government cover-up. Probably the vilest rumor Coleman spread was that the airmen were intoxicated, and the reason they crashed was because the men aboard the KC-135 were inebriated.[272]

Coleman spouted his theories incessantly throughout the neighborhood, upsetting residents and increasing hostility toward the police after their relaxed presence in the area ended with the investigation. For weeks afterward, Coleman gladly offered his ideas to any ear that would listen, though most tried desperately to avoid him. He was hard to miss, wailing in prayer amongst the field of ashes, alarming passersby. If there was ever a profane, burlesque and abominable perversion of John the Baptist—the biblical prophet described as "the voice of one crying in the wilderness" who wore tattered clothes and ate locusts and wild honey—it was Coleman.[273]

Although abnormal, Coleman's behavior was representative of the abundance of rumors that arose soon after the crash. Wichitans, as well as the air force at the time, had no idea why Raggy 42 plummeted, but that did not stop the myths from spreading like wildfire throughout Wichita. With the onset of numerous wrongful death lawsuits against the air force and Boeing filed by the victims' families in the years that followed, combined with the lengthy investigation by the air force, rumors persisted.

RUMOR #1: IT CRASHED TO KILL "BLACK FOLKS"

A common assumption then, as it still is among some today, was that the KC-135 crashed at 20th and Piatt because it was a predominantly African American neighborhood. Wichita historian Craig Miner described how, over the years, rumors that the KC-135 "was aimed there [in the black neighborhood] after circling to avoid the rich eastern suburbs" began to spread.[274] Theresa Johnson, a former member of the Wichita City Council, commented on the horrible rumors she had heard as a small child attending Mueller Elementary School:

> *Some pieces from the plane had landed on some of my classmates' homes, so we discussed it a little. After that class, I overheard people saying it wasn't a big deal because it was just a bunch of niggers that had been killed.*[275]

The comments described by Miner and overheard by Ms. Johnson were not uncommon, nor were they isolated to any particular race. Malicious gossip about the plane striking the northeast section of Wichita propagated many unsubstantiated rumors, which were further exacerbated by the context of 1965 America. Blacks and whites in the Wichita community expressed that they thought the plane crashing in the African American neighborhood seemed in no way to be a coincidence. Many thought it was intentional. Sitting in the same house forty-seven years later, when asked about why she thought the plane crashed, Sonya House stated, "They said they were trying to kill a bunch of black folks in here; that was the rumor. Some people still feel like that was their motive." But she disagreed. She went on to clarify, "If that had been their motive, they would not have failed…Instead of putting it in the ground, if they had slid with it, how far would it have gone? Central? 13th Street?" At the end, she stated, "I just don't know why it crashed."[276]

There are certain key points in the statement by Ms. House that reveal, not only how much bitterness has remained in the community even decades afterward, but also how common sense overrides such frivolous theories. The only reason, perhaps, that this theory has perpetuated for nearly five decades may be just one thing: residential segregation.

A 2010 study on the development of Wichita's African American community by Deon Wolfenbarger of the National Park Service reiterated how racial boundaries, enforced by restrictive covenants, ran deep in Wichita during 1965.[277] One such covenant provides the perfect example. It reads:

No persons of any race other than the Caucasian race shall use or occupy any building or lot, except that this covenant shall not prevent occupancy by domestic servants of a different race domiciled with an owner or tenant.[278]

It must be noted, however, that the practice of residential segregation was not isolated to Wichita, nor was Wichita's the worst in terms of severity. For example, Levittown, New York, in the 1960s defined segregation. According to historian Mike Wright, in his book *What They Didn't Teach You About the '60s*, "Of the 82,000 who lived in Levittown, none was African American."[279] Wright stated, "The developers told black families outright not to bother trying to buy a home in Levittown. They were not welcome."[280]

Residential segregation received even more momentum in Wichita due to the social norms allowing such practices. Blacks were sent to the northern end of Wichita, out of white neighborhoods. Therefore, with 97 percent of African Americans living jam-packed into Wichita's northeast section,

no matter where the plane fell, it was going to be either a white tragedy or a black tragedy. It was unavoidable. Residential segregation made this an African American disaster, not the pilots, or the air force or some communist agenda—as Mr. Coleman insisted.

The pilots and their crew were not from Wichita, or Kansas or McConnell AFB, and neither was the plane. They arrived in Wichita only a few days before the crash. Because they were not Wichitans, they most likely had no detailed knowledge of the city or its residential segregation practices and were in all likelihood looking forward to a routine refueling mission before heading home. What's more, pinpointing a particular racial community while peering out of a tiny window on a plummeting aircraft, with seconds to spare, would be very difficult. The boisterous attorney Chester I. Lewis noted:

> Most people accepted it as a matter of fate…Particularly since there have been no crashes and particularly since we have McConnell out here since God knows when, together with Boeing, Cessna and Beech—and there have never been any crashes in any particular neighborhood and so I don't think initially—even the Air Force officials were perhaps afraid that since it did happen basically in a Negro community that it might arouse racial antagonism toward the Air Force…[281]

Factors were set into motion decades ago with the migration of African Americans to Wichita and the evolution of enforced residential segregation. The plane crashed. And it happened to crash in northeast Wichita.

Rumor #2: A Parachute Cord and Failed Engines

The Parachute

Although there was not much left of the KC-135 to signify that a plane had crashed, its mangled engines miraculously survived. The force of the plane driving nose-first into the ground sheared the wings from the fuselage, propelling the battered nacelles (an outer casing for the engines) throughout the scene. A reporter described the image of one charred engine nacelle protruding out of a depression in the ground as being "the only pieces of the wreckage recognizable."[282] The engines and a piece of the plane's tail section found half a block away gave some clues for the investigation team to work on, but very few.

A bulky semi truck with a long flatbed trailer hauled the engines to Tinker AFB in Oklahoma a few days later for examination. Most who watched undoubtedly wondered if engine failure was to blame for the crash. Much to the investigators' surprise, when the number one engine was cracked open, they discovered a piece of shredded parachute and its melted nylon cord in the "aft portion of the compressor section"—the area of the engine that takes in air.[283] The Oklahoma City newspaper quickly released a controversial photo of the parachute entwined in the engine, which only fed new rumors. It was believed to be a personnel parachute, the same kind as KC-135s at the time had on board. The cord had somehow been sucked up by the engine.

An escape hatch, which investigators later discovered to have been jettisoned at approximately four hundred feet in altitude, on Raggy 42 suggested that at least one of the airmen tried to make a last-ditch effort to escape.[284] Quickly dissolving the parachute rumor, a Tinker AFB spokesman explained, "[T]he engine apparently picked up parts of a parachute after the plane crashed and broke apart"—not before.[285] "Specialized parachute personnel" were brought in and identified the parachute to be a "part of the canopy of a personnel type."[286] The official went on to say the pieces of parachute and cord were "so located that it's evident it did not contribute to the accident."[287] Logic would dictate that an airman would not jump out of a plane if it was not already going down to begin with. The plane must have already been in danger, and therefore the parachute would have played little, if any, role in causing its demise.

The Engines

As Brigadier General Murray A. Bywater, head of the investigation team, indicated, the KC-135 could have flown fully loaded with just three engines. The plane, according to Bywater, "had been tested in flying at full load on three engines and had performed well."[288] Even if the parachute had contributed to the one engine malfunction, it would have been recoverable. Further dispelling the rumors, however, metallurgists and other aircraft specialists at Tinker AFB closely examined the condition of engine parts, which revealed the damage to be the effect of post-impact fire resulting from the crash. On the engines, they studied the oil system, fuel system, bearings and turbine section. They inspected the front compressor, rear compressor, combustion section and other miscellaneous parts. They looked for damaged or missing rotor and compressor blades and found many. Parts were excessively bent, torn and broken; some were missing.

Despite the badly damaged engines, the meticulous inspection of all four ended with two identical conclusions. The first, "[s]evere anti-rotational bending of compressor and turbine blades, shearing of the front compressor rear hub, turbine shaft and coupling and severe rotational scuffing on parts throughout the engine[,] indicated that subject engine was rotating at a high RPM when ground impact occurred,"[289] and the second concluded that "[n]o evidence of material deficiency or progressive failure on any engine component was found."[290]

Nothing was discovered during the inspection that revealed the engines were a contributing factor to the aircraft accident. Each one was functioning, as it should have, when Raggy 42 came crashing down.

RUMOR #3: A DROGUE CHUTE

Rumors also persisted that a drogue chute—a small parachute dragged behind aircraft to help with stabilization and deceleration—was left on the runway from another aircraft stationed at McConnell and had blown into Raggy 42's engine shortly before takeoff.

The F-105 Thunderchief and F-100 Super Sabre—both of which possessed drogue chutes—were highly active bombers in Southeast Asia, especially following the Tonkin Gulf incident in 1964. Moreover, the air force utilized both bombers extensively in the heavy bombing of North Vietnam called "Operation Rolling Thunder."[291] There were, in fact, F-105s and F-100s stationed at McConnell in 1965. F-105D, an active duty aircraft, was there from November 1963 through June 1972. F-100, an Air National Guard jet, was there from April 1961 through March 1971.[292] And although it is not inconceivable that a drogue chute could have been mistakenly left out on the runway or blown away by the tumultuous Kansas winds, none of the eyewitness accounts of those who watched Raggy 42 take off that morning chronicled any such occurrence. Likewise, there were no reports of a missing drogue chute following the crash, which would have been noted in the post-flight inspections. This rumor most likely developed only after the personnel chute was discovered inside one of the engines at Tinker AFB.[293]

As the evidence suggests, it is highly improbable that a nylon cord or drogue chute crippled the tanker into a spiraling death dive. An anecdote from the KC-135's inception offers proof of the durability, versatility and flying capabilities of the KC-135's engines. Boeing test pilot Tex Johnston, who first flew the Dash-80 (the prototype for the commercial 707 and KC-

135), made quite the spectacle when he sent the massive jetliner into a barrel roll in front of Boeing executives and would-be investors during a test flight at the Seattle Gold Cup Boating Competition on August 7, 1955. Johnston barrel rolled the gigantic plane, not once, but twice, to show both its proficiency and flexibility.[294] When the chairman of Boeing, Bill Allen, scolded Johnston afterward, demanding to know why he had performed such a ridiculous and dangerous stunt, Johnston replied, "I'm selling airplanes."[295]

Because the 707 and the KC-135 sold so well afterward, several believed Johnston's antics helped sell the jet plane as a solid, flexible and safe aircraft. The four 13,750-pound-thrust P&W J57 turbojet engines of the KC-135 were by no means invincible but were resilient for their time. Gen. Bywater most aptly addressed the parachute rumors when he said, "This is foolish."[296]

RUMOR #4: THE PILOTS AIMED FOR A VACANT LOT AND INTENTIONALLY NOSE-DIVED

The most common rumor retold in newspapers, letters and poems after the crash was that the pilots had aimed for a vacant lot. Even today, this apocryphal tale is still alive in the neighborhood where the crash occurred. To be clear, Capt. Szmuc was, without question, a superb pilot who commanded the respect of his crew. He was a devout patriot, having served for nearly a decade, and was every bit as heroic as any pilot serving in the air force. His copilot, Capt. Gary J. Widseth, and the rest of the men on Raggy 42 that day had nothing but admiration for him. The dutiful and intrepid reputations of Szmuc and Widseth are indisputable, and to call the vacant lot rumor into question is in no way an attempt to traduce their memory with falsehood or allegations. All the same, the "vacant lot" theory has consistently been retold by the media, survivors, Wichitans and many who possess only a faint knowledge of what actually transpired.

It is evident that if the plane had crashed a mile away at WSU, where it began jettisoning fuel; or four blocks away at the Derby Oil Refinery; or three blocks away at the Institute of Logopedics, filled with "many small children and adults," the casualty rate would have greatly exceeded thirty lives.[297] It is also plausible that, if the plane had not nose-dived into the intersection of 20th and Piatt but had instead slid down Piatt Street, consuming homes and Wichitans as it went, the death toll would have grown astronomically. The question yet remains how anyone could come to the conclusion that the

"FAITH, THEIR VICTORY"

Scorched and flaming, fateful jet,
While upon a homeward flight;
Lost control, nose-dived to earth;
Leaving fuel clouds black as night!

Upon a chilly, winter morning,
January, sixteen, sixty-five!
A city awoke to a busy day,
Vibrant, vigorous, and alive!

Then out of the sky, the big jet fell,
Releasing fire resembling hell!
Burning roofs and homes, and then,
Killing women and children and men!

A Chaplain Priest called to the scene,
Waded waters, murky and green;
Sick, at heart, and near to crying,
Said prayers for the dying!

Thirty dead so they account;
In the millions, the amount;
A hole where the plane fell 20' deep!
In the earth; where people still
 stand and weep!

Tonight, along the rows of light,
Bleak and desolate is the sight;
Of tents of helpers that were spread,
To take away the charred and dead!

All through the night, their lights
 burn bright!
A memory to the living hell!
That burst forth that tragic morning
When the jet plane tanker fell!

How many lives did they save?
As they bravely dug their grave?
They forced their plane straight to the earth;
As they nobly proved their worth!

Oh, Grave, where is thy victory?
Oh, Death, where is thy sting?
For, as these gallant men dived down,
Me thinks I heard them sing!

"Thanks be to God, through Jesus Christ!
Who soon will set us free!"
They kept the Faith, forgot the Death!
Faith is their victory!

On Fame's eternal landing field,
The silent tanker lay;
The slumbering souls of that valiant crew,
Await the judgment day!

 ---Ellen Anderson
 Copy. 1965

Poem by Ellen Anderson. *Irene Hubar (Kenenski).*

pilots purposely avoided other, more populated areas or had *any* control over
the plane at all.

Ironically, it was Gen. Bywater—who had so often squelched other rumors
about why the plane crashed—who actually initiated the first reports of the
pilots having aimed for a vacant lot. In an interview on *KAKE News* the day
of the crash, Bywater stated, "From the reports we have received it appears

Chester I. Lewis. *Kenneth Spencer Research Library, University of Kansas.*

that he made an effort at the last minute to avoid buildings, or knowing he was going to crash perhaps put the aircraft in the vacant lot."[298] Although Bywater was only going off of the reports he received (it is still unknown who delivered these reports), the rumor, nonetheless, trickled far and wide throughout the Wichita community. In the midst of so many debauched rumors, it was refreshing to have one that spoke of compassion and heroism—unfounded though it was.

Chester I. Lewis, who would later become the attorney for nearly half of the victims on Piatt, and who was himself a pilot, replied to the question of whether he thought Capt. Szmuc intentionally aimed for a vacant lot:

Nobody believes this hogwash! Because you can't put a KC-135 tanker in a two by four field, with it out of control, too—it just can't be done—that's like landing in a basketball court on the moon. Anyhow, this was said and I think this was an emotional reaction from the Air Force. Many people want to know what caused it. It's like an automobile accident, you want to know where the fault lies, who is the one who precipitated it. And knowing air crashes, being a pilot myself, something caused it, it just didn't happen.[299]

Indeed, to make the assumption that the pilots purposely chose the location of the crash not only perpetuates the myth of their control over the plane but also suggests they could have selected better locations, reawakening the rumors about their choice to crash in an African American neighborhood. A surviving victim, when asked about the vacant lot theory, mentioned how he thought the plane could have landed at the municipal airport or even made it back to McConnell but chose not to.[300] This sincere, yet misguided, belief lives on.

In all likelihood, the seven men onboard Raggy 42 had little, if any, control over where the plane crash-landed, the manner in which it crashed or the people whom it would drastically impact. The air force, it appears, prematurely expedited this rumor based on skewed witness testimonies, and it has stood the test of time. The inability to determine whether the pilots purposely nose-dived Raggy 42 does not imply that the airmen were any less patriotic or virtuous in their attempt to recover the doomed aircraft—lest we forget they lost their lives as well. As is the case with any good airman, they were merely serving their country and doing their duty when disaster struck.

After arriving in Wichita to begin the initial crash investigation, Gen. Wade made a statement to the media about the tragedy: "The cost of military preparedness has always been shared by both our citizen 'soldiers' as well as our military members in our efforts to maintain a semblance of peace in this world—and in Wichita today, a high price in human life has been extracted." He went on to add that the KC-135 "was staffed with a well-qualified combat crew. I know that they did everything within their power to avoid or prevent this tragic happening."[301] There is no reason to doubt Wade's statement as a genuine truth based on the airmen and their abilities. The rumors concerning whether or not the pilots had control over the aircraft and the actual cause of the crash, though, were far from being put to rest by Wade's statement. Others demanded more definitive answers in the months that followed. Ten months later, they received an answer.

13

WHY IT CRASHED

THE REPORT

The report, withheld from the public for months,
said the jet tanker's rudder was turned at a "severe" angle.
—Wichita Beacon, *October 3, 1965*[302]

In 1925, when Calvin Coolidge was still president of the United States, Wesley E. Brown began his undergraduate studies at the University of Kansas. Four years later, he worked his way through the Great Depression, attempting to find employment wherever he could. When America entered World War II the following decade, he joined the navy at age thirty-seven as the oldest lieutenant in his unit. Born on June 22, 1907, in Hutchinson, Kansas, Brown had finished law school, gone into private practice, worked as a bankruptcy judge and become a newly appointed federal judge by the time the Piatt Street crash occurred in 1965.[303]

Three years prior to the crash, in 1962, President John F. Kennedy had appointed Brown to the U.S. District Court. Though none could have guessed it at the time, he would go on to become the oldest practicing federal judge in U.S. history. Still active decades later, Brown was notorious for replying to critics of his age, "I was appointed for life or good behavior...whichever I lose first."[304] Well past his 100th birthday, determined as ever, he made the arduous climb to his fourth-floor courtroom to hear cases. Court clerks and lawyers who worked with Brown remembered the sprightly old figure walking by their office and asking, "Well, is justice prevailing?"[305]

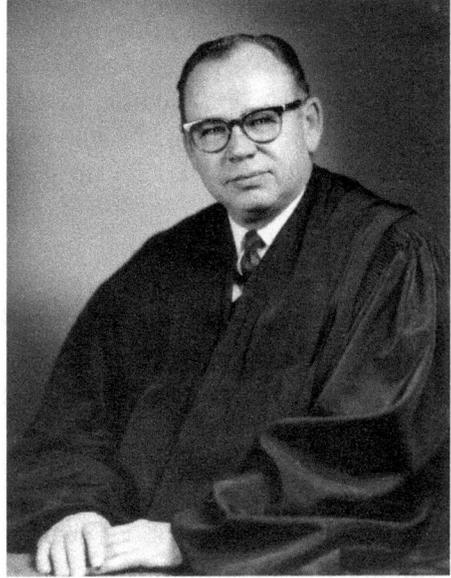

Judge Wesley E. Brown in 1962, when he was appointed to the bench by President John F. Kennedy. *Wichita U.S. Courthouse.*

Just three months shy of his sixtieth birthday in 1967, Brown made a controversial order concerning the Piatt Street crash. A headline in the *Wichita Beacon* on Tuesday, March 28, 1967, read, "Judge Removes Mystery Cloak from Jet Crash."[306] Brown felt the plaintiffs, who had recently filed wrongful death lawsuits against the air force and Boeing, deserved the right to see the contents of the "secret" air force investigation report, if it existed. Although the Collateral Investigation Board Report had been released a year prior to Brown's order, Terry O'Keefe, an attorney who spoke on behalf of the plaintiffs, called this "secret report"—supposedly different from the one previously released—the "crux of the case."[307]

O'Keefe was unsatisfied with the Collateral Investigation Board Report because it did not provide, as he felt, a definitive answer for what caused the crash. Alleging wrongful death, physical and mental injury and property damage, O'Keefe cited four main reasons why his clients needed a more detailed report of the crash: first, that everyone on board the jet tanker died in the crash; second, the area surrounding the crash site was cordoned off and guarded while air force and Boeing investigators retrieved the parts; third, the remaining parts, said O'Keefe, "could not have been examined by the plaintiffs after the crash even if plaintiffs had the available resources and technology"; and, finally, the plaintiffs were "indigent people of limited education" and had "limited funds to prosecute their claims."[308]

Most, like U.S. District Attorney Guy Goodwin, doubted if such a report even existed. Goodwin, in textbook manner, refused to "concede that such a report [did] exist," stating, "I have no knowledge that it does exist... therefore, I must deny it."[309] The plaintiffs, as they had since the day of the crash, would have to wait for the government to respond.

THE INVESTIGATION

The benefit for investigators probing crash scenes of commercial aircraft today is the recovery of the "black box," also known as the flight-data recorder (FDR). In reality, this box is painted bright orange and provides key details concerning how the plane performed just prior to a crash. The FDR records valuable information such as the time of the crash, altitude, control-column position, fuel flow, engine thrust, airspeed, vertical acceleration and rudder-pedal position.[310] As a military plane, KC-135s did not have such luxuries. The team investigating the Piatt Street crash had very little to go on for two reasons: there was no FDR on board Raggy 42 (since it was a relatively new technology at the time), and aside from mangled pieces of metal, four smashed engines and a crumpled tail section, there was not much left of the plane.

Their investigation, instead, would focus on maintenance records, the pilots' radio transmissions prior to impact and the charred wreckage at the bottom of a deep crater. The hardboiled air force and Boeing investigators lamented that determining the reason for the crash would require "considerable time but we are going to find the cause."[311] They knew privately, however, that determining a cause might be impossible, given so little evidence.

Moreover, neither the air force nor Boeing was likely to budge an inch when it came to assigning blame for the accident. Boeing, of course, would be expected to blame the crash on *pilot error* and not equipment failure or malfunction. The air force, in turn, would deny pilot error and attribute the crash to *mechanical failure*. The investigators, then, were left with the laborious task of finding the cause of the accident, not just to salvage the reputation of either party, but also to appease the victims' families, who grew more and more frustrated as time passed. Chester I. Lewis exclaimed:

> *It's been right at three months ago January 16 and many people want to know what caused the crash. Naturally, if you receive causation,*

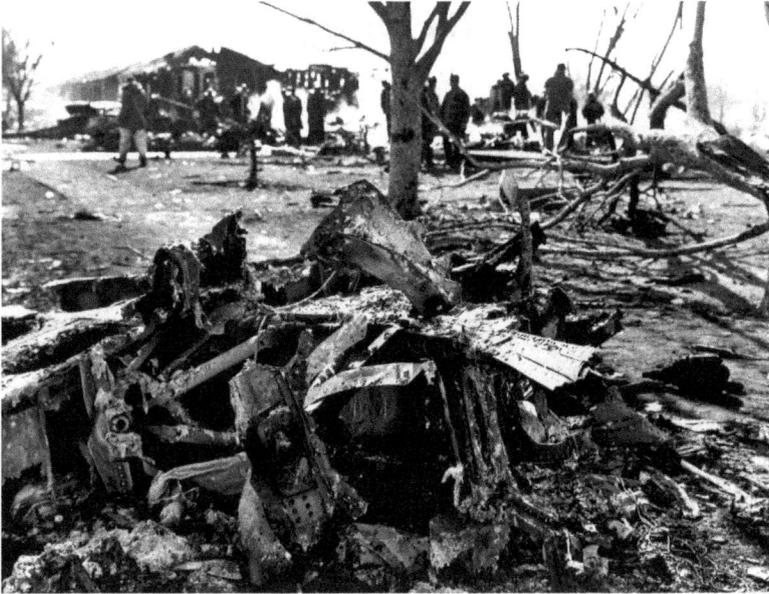

Close-up of wreckage. *Larry Hatteberg,* KAKE TV.

then one can suggest remedies. If they are overloaded, we can demand that they don't load [KC-135s] so heavily. If the personnel isn't experienced, we can demand that they recieve more training or the runway was too short for any reason. And many of the heirs of the deceased want to know what the cause was and I'm not sure the Air Force was going to disclose it. But I do know that they have these crack teams, they are about as expert and technical as any teams come, and I would think by now they would be able to render a report as to the cause...[312]

The longer it took to determine the cause, the more discontent and bitterness grew within the African American community. For the investigators, though, their job proved difficult. To assign a precipitous cause to the crash could have extreme effects on liability and the plane's safety record. Furthermore, they were fully aware that "KC-135s were involved in 15 accidents causing injury or death in the previous 7 years."[313] One such accident occurred just twelve days before the Piatt Street crash. Treading lightly in assigning a cause would have been in their best interest, as well as the victims'.

THE RUDDER

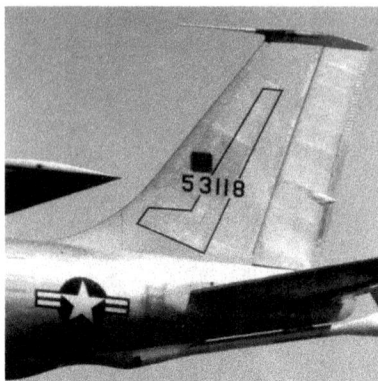

Close-up of a KC-135 rudder. *22nd ARW History Office.*

By 1965, the rudder was hardly a new invention. It had been around for thousands of years. The ancient Romans used large wooden rudders to help steer their ships, and centuries later, the Wright brothers quickly figured out their usefulness and functionality on airplanes after several failed attempts.[314] In aviation, the rudder is a vertically hinged structure on the tail of an aircraft attached to the vertical stabilizer. It helps to hold the plane straight, counteract crosswinds and control the nose of the aircraft. According to seasoned air force pilot Capt. Ben Jamison, who pilots the versatile B-1 long-range bomber, "The rudder is usually the largest control surface on the airplane, in terms of total surface area, and therefore requires only a small input to make a large aircraft movement."[315]

Pilots control the movement of the rudder with two rudder pedals, which they can depress to produce the side-to-side motion of the rudder. When it is deflected (pushed to one side, either right or left), it changes the amount of lift in the opposite direction. With greater rudder deflection to the right, for example, the force would cause the aircraft to yaw (move from side-to-side) to the left.

The rudder is, therefore, critical to keeping the nose of the aircraft on the proposed flight path.[316] Without the rudder, the plane would deviate radically from its set course. As the great aviation author Wolfgang Langewiesche stated in his 1944 publication *Stick and Rudder: An Explanation of the Art of Flying*, the rudder is "merely a device for counteracting the adverse yaw effect."[317] Langewiesche also warned, "The important thing to understand about the rudder pedals is that they are unnecessary; like your wisdom teeth, they serve no very good purpose but can cause much trouble."[318]

THE AUTOPILOT

The 1931 article "Inventions and Discoveries," written by Clark Tibbitts in the *American Journal of Sociology*, praised several new inventions reported

during 1930 that "were sure to change the world."[319] One such invention was the automatic pilot. Although the autopilot had been around several years by 1930 (first invented by the aviation genius Lawrence Sperry in 1914), the article detailed how the refined invention "keeps an airplane on an even keel in clouds or fog, the pilot merely having to guide right or left with his horizontal rudder."[320] Ironically, Sperry died in a plane crash in 1924, but his sons and other inventors continued to make autopilots smaller, more advanced and reliable as the years progressed. The U.S. Army Air Corps and Air Force would eventually adopt the autopilot system on their aircraft.[321]

The autopilot system on KC-135s, however, was far from perfect by 1965. Since its inception, the KC-135 had struggled with mechanical issues, the autopilot listed among them. The authors of *Airlift Tanker: History of U.S. Airlift and Tanker Forces* explain some of the key mechanical difficulties:

> *The KC-135 development program was not trouble free. When the aircraft caught on, and orders for its sister 707s began to flow in, Boeing and the Air Force had considerable disagreement over priorities. Unreliable Lear MC-1 autopilots plagued the early production models. Stator vane welds in the early J-57 engines were faulty and the fuel tank contamination, because of poor housekeeping at Boeing caused some additional difficulties…Other development problems involved hydraulic system overheats and a severe flutter in the rudder assembly.[322]*

Among the investigators' judgments, there is little doubt that the autopilot on Raggy 42 was malfunctioning. Based on eyewitness testimony and findings of the Collateral Investigation Board Report (finally released in October 1965), Captains Szmuc and Widseth experienced what is called "unscheduled rudder displacement," referring to an unexpected, sustained deflection of the rudder. According to the official air force report, cited in court papers and leaked to the media, a combination of the autopilot and rudder malfunction was the most likely cause for the crash:

> *The plane's autopilot apparently forced the rudder to turn despite the efforts of the pilot to keep the plane under control. The plane yawed, meaning it traveled in one direction while the nose was pointed in another. The yaw forced the plane to roll over. In trying to keep the plane level, the pilot lost too much height and speed to pull out.[323]*

The last four minutes of the flight, as recorded by eyewitnesses, corroborates a fatal flaw with the autopilot and rudder. Raggy 42 departed

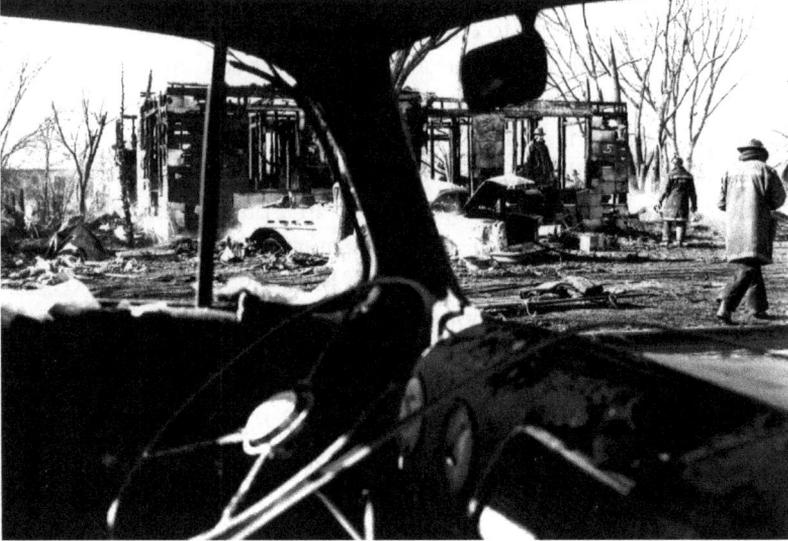

Piatt Street captured through the window of a burned-out truck. *Larry Hatteberg, KAKE TV.*

McConnell at 9:27 a.m. It began to yaw as it flew north over Oliver Street and then started a "flat shallow turn to the northwest."[324] Fuel was jettisoned over WSU as the plane banked hard to the left. Witnesses then recalled, "All of a sudden it looked like something snapped. A piece of the tail fell off. When it fell off, the plane rolled over on its side. Then it went into a nose-dive and crashed."[325] The time was 9:31 a.m.

Without question, unscheduled rudder deflection can be dangerous—even deadly. As Capt. Ben Jamison noted, having such a malfunction can quickly lead to a perilous situation for pilots:

> *The rudder is typically used to control the aircraft in the "yaw" axis, but when it is fully deflected, it can also cause a rolling motion in the aircraft. If the aircraft does not have enough roll authority, usually controlled with ailerons and/or spoilers, the aircraft will roll into an uncontrollable situation...the rudder is a critically important control surface...an un-commanded and uncontrollable full-scale rudder deflection would most likely result in the airplane departing controlled flight.*[326]

If a plane's rudder is severely deflected, the odds of salvaging the flight are dismal.

Maintenance Logs

When reporters asked Lieutenant Colonel Thomas J. Skiffington, a lead investigator in the Piatt Street crash, about the malfunctioning autopilot and rudder displacement theory, he replied, "Well, it is a case that gets real hard to prove, but you are right…we had a very strong suspicion that we had autopilot problems and the autopilot was the thing that put it into a yawed condition."[327] A survey regarding prior incidents of power rudder malfunctions on KC-135s, conducted by the air force from February 1963 to October 1964, revealed thirty-four write-ups, each one unique in terms of severity. And while minor maintenance issues are no doubt expected, some of the malfunctions—as indicated in the following tail number write-ups—were truly disturbing:

57-1442,	*October 23, 1963:*	*"Preflight found right rudder would only move 3 to 4 inches to right…Damper assembly lower rudder control tab…was installed upside down."*
59-1468,	*December 29, 1963:*	*"Right rudder locked on takeoff roll. Takeoff aborted. Investigation revealed rudder control damper was installed upside down. Aircraft had flown fourteen sorties since installation of unit."*
60-361,	*January 23, 1964:*	*"Autopilot engaged—aircraft pitched up violently—gained 400 ft before control was regained. Caused by malfunction of autopilot control amplifier."*
62-3532,	*April 10, 1964:*	*"Aircraft rolled to left at unstick…Control problems continued and aircraft diverted for landing…Investigation revealed that rudder trim tab had been improperly set to correct trim write-up from previous flight."*[328]

Adding to suspicion, five months before the crash, there were fifteen occasions in which the crews flying Raggy 42 wrote in the maintenance logs that the autopilot had malfunctioned.[329]

The most telling and possibly most disturbing evidence for these malfunctions is an excerpt from the radio traffic between Raggy 42 and a Boeing crew flying a B-52 (airplane 632) recorded on January 12, 1965. It provides a chilling premonition for what would soon lead to the demise of Capt. Szmuc and his crew just five days later:

Raggy 42:	*"632 this is 42, when you get into hookup give me a report and see if the tail is rotating around there. This power rudder seems to be acting up a little bit."*
Bomber:	*"Does it seem to be driving in a slow rate—one way, then another?"*
Raggy 42:	*"That's affirmative—left to right."*
Bomber:	*"Yes, it's doing it."*

<div align="center">Interval</div>

Bomber:	*"Yes, we have something wrong with this auto pilot now."*
Bomber:	*"Try it again."*
Bomber:	*"Did you get to pitch and porpoising in there?"*
Raggy 42:	*"Just the same type of movement we have been getting before—just swinging left to right."*

<div align="center">Interval</div>

Bomber:	*"Let's try a turn and maybe this auto pilot will work in a turn and we'll head back toward Hutch."*
Bomber:	*"Are you getting a lot of yawing during your turn there?"*
Raggy 42:	*"I was trying to regulate the turn but I got a real touchy turn knob here—at about 15 degrees it gets real touchy."*
Bomber:	*"It seemed like your tail got to going back and forth there and the yawing back and forth at the beginning of your turn made it a little difficult."*
Raggy 42:	*"Did you notice that all the way through—at the beginning I only had about 10 degrees of bank."*
Bomber:	*"It seemed to be okay at about 10 and when you went to about 15 it seemed to be getting a little wild."*[330]

Later that evening, when Szmuc's crew landed at McConnell, they requested the Boeing mechanics take a look at the autopilot and repair it. Nevertheless, Boeing's contract with the air force allowed it to fix *only* minor maintenance problems, and since the autopilot was more complex, Boeing was not required to do so. Therefore, when Szmuc and his crew departed McConnell on that fateful Saturday morning, the autopilot was still malfunctioning.[331]

An electronics equipment expert for the air force, Sam E. Taylor, testified before the investigation board that the autopilot malfunctions on Raggy 42

were "abnormal" and "way out of reason."[332] Although the air force had not grounded a plane for such cause before, it was clearly a problem and point of concern for the crews based on their complaints.[333]

Boeing, as expected, was less forgiving in its analysis of the pilots, denying any malfunctions on the KC-135 it built. Its general counsel, George Powers, stated, "…[T]hey went up at a low altitude and immediately started a left turn too sharply over the university. They started side slipping…and didn't have enough speed to make the turn. His left wing was too low and he could not pull it up. That's what happened and there was never any question about it. Pure pilot error."[334] Powers's statement would be refuted in time.

14

A SUBTLE KILLER

Decades after Raggy 42 came smashing down on Piatt Street, three
nearly identical crash investigations were headed up by the National
Transportation Safety Board (NTSB) in the 1990s. These investigations
provided a new perspective on why Raggy 42 and other similar aircraft
disasters occurred in the manner in which they did and what was to blame.
The search for answers included all the trappings of a police investigation,
with ardent detectives methodically chasing an elusive serial killer, who
strikes without warning and then disappears into the shadows, leaving no
trace. It took the NTSB ten years of fact-finding to locate the cause behind
these three occurrences, and since that time, numerous lives have been saved
because of the information it identified. There was one striking similarity
in the explanations that investigators finally gave as the root cause for these
crashes: unscheduled rudder deflection.

THREE FLIGHTS, THREE PROBLEMS

United Airlines Flight 585

The longest crash investigation in aviation history started with United
Airlines Flight 585, a passenger flight carrying twenty-five souls from Denver
to Colorado Springs, Colorado, on March 3, 1991. Four miles south, at 9:44

a.m., Flight 585 was coming in to land on runway thirty-five at Colorado Springs Municipal Airport. The plane was piloted by Capt. Harold Green and First Officer Patricia Eidson, both seasoned pilots, who had just been cleared by Air Traffic Control to make their final approach when disaster struck. According to the NTSB Aircraft Accident Report, a blood-curdling scream of "Oh no!" was heard on the flight voice recorder just before impact.[335] Those were their last words. Investigators determined through eyewitness accounts that, once the plane had completed its final turn and headed in for its approach, it "rolled steadily to the right and pitched nose down until it reached a nearly vertical altitude before hitting the ground."[336] The crash was extremely abrupt. Within ten seconds, the pilots experienced some minor turbulence, and the plane mysteriously spun out of control, turned upside down and spiked nose-first into the pavement, leaving almost nothing of the 737 to investigate.

An impact crater, much like the one found on Piatt Street, was virtually the only evidence. And because the plane did not skid upon impact, the fire was contained in a condensed area—also like Piatt Street. The five crew members and twenty passengers onboard, unfortunately, too, were immediately consumed by the inferno of jet fuel ignited by the crash.

Determining the cause of Flight 585's sudden catastrophe seemed nearly impossible. The defense of pilot error, it was later found, did not hold up. Both the pilot and first officer were experienced professionals, and investigators found no indications that they would have erred to this magnitude. Mechanical failure was also a difficult theory to substantiate, since the 737 had an impeccable safety track record, and indicator needles on the hydraulic pressure gage showed the plane's engines were running normally upon collision. Turbulent winds were present, but that theory soon dissipated as investigators determined that "too little was known about the characteristics of rotors [a horizontal axis vortex] to conclude whether a rotor was a factor in the accident."[337]

The flight controls were also examined. And although small metal chips were found inside the hydraulic fluid of the plane's power control unit (PCU)—a dual servo valve that disperses hydraulic fluid to move the rudder—investigators were still uncertain as to how this could have crippled the plane. Fresh out of clues, and unable to determine the cause of the accident, the NTSB was forced to give its final assessment on December 8, 1992. It regrettably stated that investigators "could not identify conclusive evidence to explain the loss of United Airlines Flight 585."[338]

US Air Flight 427

Three years later, on September 8, 1994, at 7:00 p.m., US Air Flight 427, also on a Boeing 737, was approaching Pittsburgh, Pennsylvania, carrying 132 souls on board. The plane, piloted by Capt. Peter Germano and First Officer Chuck Emmett, had made its final approach into Pittsburgh International Airport. All seemed calm when, suddenly, the jet rolled sharply to the left as if it had a mind of its own. The cockpit voice recorder transcripts captured the frightening last words:

7:03:07.5	*Captain Germano:*	*"What the hell is this?"*
7:03:14	*Control Tower:*	*"US Air 427 maintain 6,000, over."*
7:03:15	*Captain Germano:*	*"Four twenty seven emergency."*
7:03:19.7	*Captain Germano:*	*"Pull...pull...pull."*[339]

Then silence. All 132 lives were lost.

The plane slammed into a hill six miles northwest of the Pittsburgh International Airport near Aliquippa, Pennsylvania, leaving fractured pieces of debris and human carnage in its wake. The investigators were forced to don biohazard suits due to the shroud of human remains scattered along the hillside.[340]

Finding the cause of this crash was yet another mystery: very little was left of plane; both the pilot and first officer were skilled and had excellent track records; the 737's safety record gave no indication that mechanical failure existed; and the engines had been functioning properly prior to impact. The one thing the investigators could examine was the plane's tail section. Again, the investigators found small metal chips in the hydraulic fluid of the plane's PCU servo valve, leading them to believe that a problem had arisen whose cause was still eluding them. The PCU was disassembled and subjected to numerous tests. Still, they came up empty-handed. They were no closer to finding the elusive killer. And just like after the Piatt Street crash, public dissatisfaction grew as the investigation waned.

Eastwind Airlines Flight 517

Two years later, on June 9, 1996, Capt. Brian Bishop and his first officer were making their final approach to Richmond, Virginia, in a Boeing 737 with

fifty-three souls on board. In the official interviews taken after the salvaged flight, Capt. Bishop explained how, as they descended to approximately four thousand feet, "the airplane yawed abruptly to the right and then rolled to the right."[341] Attempting to correct the yaw to the right, the captain instantly stomped on the "opposite rudder and stood pretty hard on the pedal."[342] According to the first officer, the captain was "fighting, trying to regain control" while simultaneously "standing on the left rudder."[343] He also cut the yoke to the left and increased the right throttle to try to pull out of the deadlock. The plane, however, refused to budge and remained on its side for half a minute before releasing. Then it happened again.[344] Capt. Bishop told his first officer to "[d]eclare an emergency" with Richmond Tower and "[t]ell them we've got a flight control problem."[345]

Staring death in the face, the pilots did what they were trained to do: they started performing their emergency checklist—something the other pilots, with only seconds to spare, had had no time to do. Then, as quickly as it began, the rudder finally released its grip. The plane did not roll onto its side for a third time, and the pilots were able to land the plane safely at Richmond. The NTSB, Boeing and US Air investigators immediately secured the plane and the crew so they could determine why Flight 517 defiantly rolled over.

The investigation combined Flight 517's rudder issues, pilot testimony and what little knowledge they had gained from the prior accidents involving Flight 585 and Flight 427. At first, it seemed as though the investigation would again end in a standstill. But when the investigators began thermal shock testing with the PCU on Flight 427, they finally had a breakthrough.

Thermal shock testing uses "hot hydraulic fluid injected directly into a cold PCU to explore the effects of extreme temperature differentials on the main rudder PCU's operation."[346] They discovered that, if they soaked the PCU in dry ice and then injected it with hot hydraulic fluid, it jammed. When the valve jammed, it reversed. This meant that if the pilot tried to correct the yaw by pressing down on the rudder pedals, the rudder moved in the opposite direction autonomously. The mystery was solved. When the PCUs malfunctioned due to thermal shock, they jammed the rudders, causing Flight 585, Flight 427 and almost Flight 517 to crash.

The official investigation report from Flight 585, later amended, found that all three planes had experienced malfunctions due to unscheduled rudder deflection and had little time to recover from it.[347] The NTSB determined the probable cause of the US Air Flight 427 accident as "a loss of control of the airplane resulting from the movement of the rudder surface

to its blowdown limit."[348] The report concluded: "The rudder surface most likely deflected in a direction opposite to that commanded by the pilots as a result of a jam of the main rudder power control unit servo valve."[349] In light of the culprit, Boeing made changes to the valves following the tests. Subsequently, there have been no recurrences of that nature.

This is not to suggest that Raggy 42 experienced thermal shock that jammed the rudder. The KC-135 is a much different plane than the Boeing 737 involved in these three cases. Furthermore, these accidents occurred during landing and not during takeoff, when Raggy 42 malfunctioned. Even so, the three flights investigated by the NTSB provide another viewpoint on how a plane and its pilots respond to an unscheduled rudder deflection.[350] If highly trained pilots in the 1990s, nearly three decades after the Piatt Street crash, had difficulties with unscheduled rudder deflection, it is plausible that Captains Szmuc and Widseth, flying a relatively new jet plane in 1965, would have experienced similar complications for which they were not prepared.

"Pilots would be more likely to recover successfully from an uncommanded rudder reversal," said the Flight 585 accident report, "if they were provided the necessary knowledge, procedures, and training to counter such an event."[351] Chester I. Lewis offered his compendious judgment after reading the accident investigation report on Raggy 42: "Boeing neither in its flight handbook nor otherwise informed the [air force]…of the flight characteristics or procedures to be followed in actual flight if a power rudder has a severe deflection as it did in the case herein."[352] The findings of the Air Force Accident/Incident Investigation Report verified the slim chance the pilots had of recovering Raggy 42, saying, "To sustain flight with maximum rudder deflection at speeds approximating Raggy 42's would have required asymmetric power adjustment, flaps 20 degrees, and exceptional pilot technique."[353]

The best of pilots are stalled when trying to fight their way through this mechanical failure, which often attacks without warning—a subtle killer.

THE PRIMARY CAUSE

Although no "secret report" was ever uncovered, the Collateral Investigation Board Report, released by the air force ten months after the crash, contained three volumes, including 187 pages of testimony from forty witnesses, thirty-seven exhibits, autopsy reports and sixty-nine photographs. The main cause of Raggy 42's crash was made clear:

The primary cause of this accident was a rudder control system malfunction producing roll, yaw, and nose left skid of such magnitude as to compromise control of the aircraft and preclude proper interpretation and corrective action by the pilots in the short time available.[354]

Chester I. Lewis, who read the contents of the report, revealed his conclusions in a motion filed on behalf of the plaintiffs in October 1965. First, according to Lewis, the tanker "was of dangerous and defective design" and crashed "due to violent severe power rudder deflection."[355] Second, there were training issues in dealing with unscheduled rudder deflection. Finally, "Boeing failed to test and determine compatibility of component parts of the airplane."[356]

MISSING FACTS

As the renowned historian David McCullough once said concerning the difficulty of facts and evidence while interpreting history: "You can have all the facts imaginable and miss the truth, just as you can have facts missing or some wrong, and reach the larger truth."[357] In this particular historical tragedy, facts are undoubtedly missing. It is impossible to know what exactly took place onboard Raggy 42 during its brief, four-minute flight. The crew and the wreckage are long gone. The majority of individuals possessing knowledge of the investigation are now deceased (including Judge Brown, who died in 2012 at the grand age of 104). All that remains is the Collateral Board Investigation Report and the eyewitness testimony that was dutifully recorded.

Nonetheless, by combining the troubled mechanical history of Raggy 42— the broken boom that caused a last-minute switch in flight crews, numerous write-ups for autopilot malfunction, issues with the rudder and autopilot only days before—eyewitness testimony, the manner in which it crashed and the detailed report provided by the air force, a clearer picture emerges. All of these factors combined depict a failed autopilot, an unscheduled rudder deflection and two pilots fighting desperately to save a doomed plane headed into an upside-down nose-dive at 20th and Piatt.[358] Given the scarcity of evidence to the contrary, little suggests otherwise.

15

THE SETTLEMENT PROCESS

As you know, lawyers are natural procrastinators and when this is combined with
military paper shuffling the results can be most exasperating.
—*Russell E. McClure, Wichita City Manager, 1966*[359]

Shortly after the KC-135 nearly leveled the entire block of North Piatt Street, Lorenzo Pouncil—whose home was twenty-five feet away from the first house burned to the ground—received a check in the mail for one dollar. It was from the air force to repair a pole lamp. "If that's the way they want to do…that's all right," said Pouncil after deciding he would not petition the government for any money to repair his home. Overwhelmed with the mountain of paperwork, the confusing forms and the lengthy process to receive aid, Pouncil decided, "The Lord will take care of us."[360] He was not alone. The KC-135 crash not only destroyed many of the indigent families living on Piatt—in some cases as many as six family members all perishing together—but also the delayed, deficient and disproportionate settlements ensured only more grief to come.

Today's society is a highly litigious one. Lawsuits are abundant, frivolous or not, and lawmakers are more apt to place restrictions on the amount victims may receive from personal injury or death resulting from accidents. The subsequent harm from the Piatt Street crash, however, was a far cry from the examples of frivolous lawsuits and million-dollar settlements arising from tort cases today. Since the time of America's inception, individuals have accessed the courts to resolve disputes. And despite its many faults, the justice system in America today remains one of the best in the world. While it is true that

monetary settlements can never replace the loss of life, they do, in some cases, help families move on with their lives and pay for the many property, hospital and funeral bills that arise after disaster strikes. Nevertheless, the settlements received by the victims on Piatt Street provided very little comfort, if any.

RESTRICTIVE LAW

Part of the problem for the meager settlements awarded to the victims stemmed from the Kansas Wrongful Death Statute in 1965 (K.S.A. 60-1902 and 60-1905). In an article entitled "A Commentary on the Kansas Wrongful Death Act," published by the *University of Kansas Law Review* that same year, author Robert C. Casad wrote the following:

> *Kansas has a wrongful death act, but it is only effective up to the specified monetary maximum. In so far as damages in excess of $25,000 are concerned, it is as though Kansas had no statute. For that excess, it would seem not inappropriate to borrow the view of the states that have no wrongful death act and allow recovery for loss of future earnings.*[361]

Exacerbating the troubles for the victims on Piatt, the Military Claims Act, Section 2733, Title 10, United States Code, also placed a cap on the amount victims could receive. A letter written by air force Colonel Dwight W. Covell in response to an inquiry about the payment of damages caused by the KC-135 crash explained, "[T]he maximum amount which can be paid administratively by the air force is $5,000 and any award in excess of that amount must be reported to Congress for consideration."[362] Based on both laws, a hefty settlement on behalf of the victims was, therefore, highly unlikely, leaving only two avenues available to obtain relief: one, file a lawsuit under the Federal Torts Claim Act against the air force and Boeing; or two, wait for relief by settlement of the claims from the secretary of the air force.

Outraged by the proposed settlements and desiring to expedite the process, a congressman for the Fourth Congressional District of Kansas introduced a bill to remove the limit on claims the government could pay to the Piatt Street victims. Congressman Garner E. Shriver, a Republican, World War II veteran and graduate of Washburn University School of Law in Topeka, Kansas, found both the lapse in processing the victims' claims and the paltry amounts deplorable.[363] "I felt it was time I made a personal inquiry for the

processing of claims," he wrote to a friend in August 1965. "[A]s a duly elected representative of the people I have a responsibility to make inquiries in a calm and collected manner."[364]

Previous military plane crashes occurring in 1960 in Little Rock, Arkansas, and another the following year in Midwest City, Oklahoma, set the precedent for Shriver to do something about the limitations placed on the settlements.[365] With the support of Secretary of the Air Force Eugene M. Zuckert and many other constituents, on February 8, 1965, Shriver introduced H.R. 4546 in order to remove the meager $5,000 limit for administrative claims.[366] President Lyndon B. Johnson later approved the bill on July 7.

A matter of speculation, however, surrounded the majority of administrative claims that were dismissed and then refiled as lawsuits following the passage of Shriver's Bill. Guy L. Goodwin, assistant U.S. attorney, felt the path to litigation taken by the victims was chosen in part to increase the amount of money the attorneys could receive. After all, Shriver's Bill limited attorney fees to 10 percent:

> *No part of the amounts awarded under this act in excess of 10 per centum thereof shall be paid of delivered to or received by any agent or attorney on account of services rendered in connection with these claims.*[367]

But the Federal Tort Claims Act, on the other hand, allowed attorneys to receive 20 percent. With most of the lawsuits being filed after Shriver's legislation, not before, it gave the appearance that the attorneys would have, to some degree, encouraged their clients to pursue adversary litigation rather than settling for only 10 percent of the fees they were limited to under Shriver's Bill. In an unpublished letter written by Goodwin, he stated that it was "unusual that Mr. Lewis [who handled a third of the victim's claims]… would abandon administrative claims on behalf of his clients *before they had been acted upon*, in favor of lengthy litigation."[368]

Chester I. Lewis, however, asserted that he filed the suits because of the lack of response he received from the air force regarding the claims. He also expressed the desire to obtain the accident report in order to find out why the plane crashed and to assign liability. Wichita attorney Dale W. Bruce agreed, in part, with Lewis. In a letter dated two years later, April 21, 1967, to Congressman Shriver, Bruce stated:

> *We were informed that the lawsuits were filed because the claimants who had sued were fearful that if they sued within two years they would have no*

basis for recovery except by decision of the Secretary of the Air Force and
that there would be no appeal from a negative decision by him....Now that
the two year statute of limitations has passed, the pending lawsuits are the
only way of recovery for those who have sued apparently.[369]

Whatever the reason, it would take years before the victims on Piatt finally received restitution.

THE DELAY

"There is a lot of talk in sections of town," said Cornelius P. Cotter, a WSU professor, in a letter to Shriver, "...about the delay in the handling of the KC-135 damage suits, chicanery on the part of the air force, or delay in the handling of administrative claims against them, and so on."[370] Part of the blame for the postponement was the two-year statute of limitations that had to expire before the cases could be consolidated and set for trial.[371] The decision agreed upon by the victims' attorneys to forego the administrative claim process and take the matter to trial, moreover, caused further delays.

Additionally, the plaintiffs, in a search to prove the air force's negligence, petitioned the government to provide data on every KC-135 crash that had occurred since its introduction into the air force. Judge Brown briefly halted the lawsuits in 1967, ordering the government to produce all the data on KC-135 accidents for only the past three years. Brown claimed that the limited search of three years was more appropriate since the earlier KC-135 models had been extensively modified.[372] Thus, with the many obstacles and lapses occurring for various reasons since the first suit was filed in March 1965, an expedited settlement of the cases did not take place.

In the meantime, whether because of the encouragement of their attorneys, distrust of the government or fear that it somehow constituted a final settlement or loan, many of the victims did not take the emergency relief money provided by the air force. As a result, many went into debt trying to repair homes and pay hospital bills. "I heard shortly after the crash that the U.S. Air Force was offering loans of up to $1,000 to help," said survivor Clarence Walker. "I didn't want to borrow any money so I didn't inquire further."[373]

The Fair-Mark Committee

In 1967, after a lapse of two years, several members of the Wichita community took action. The Fair-Mark Committee (composed of church members from the Fairmount United Church of Christ and the St. Mark United Methodist Church) was formed to address what it saw as "the injustice of the treatment of Negro and poor white people by political, social, and economic forces that are predominantly white controlled."[374] Consequently, after hearing the dissatisfaction among survivors, the committee sought means for a "speedy" and "adequate" way for the victims to receive their settlements. It started by surveying 137 individual and family contacts affected by the crash, and then it compiled a thirteen-page report on its findings. Report in hand, it inquired of Congressman Shriver whether the secretary of the air force could settle claims quicker than litigation in court.

In a letter to Shriver, the committee asked, "Why has not or why cannot the secretary of the air force settle all of these claims without the trouble and expense and delay of all these lawsuits?"[375] Their inquiry led to several correspondences from Shriver's office to the secretary of the air force questioning the status of the claims. Although Shriver initially began his inquiry into the matter in 1965, H.R. 4546 allowed the air force to "report to Congress within 30 months after the enactment of this act" on claims submitted and settled under the bill.[376] When the time expired, Shriver was eventually provided a summary report on the claims from the air force on April 20, 1967, detailing what had been settled up until that point. The summary, however, provided little satisfaction to Shriver or the committee that the job was getting done. It would take another year of petitions, letters back and forth and time in court before the claims were finally settled.

16
FINAL SETTLEMENTS

*Laymen know and lawyers will admit that such delay effectively bullies injured
parties and their families to settle too soon and for too little.*
—*Fair-Mark Committee, 1967*[377]

Despite the lengthy process, the victims eventually received their settlements, though most were clearly disappointed. Cora Belle Williams of 2048 North Piatt, who was thrown across her living room by the impact of the crash, filed the largest suit for $235,000. Her claim was settled for $27,500 minus $5,500 for attorney fees.[378] George Meyers and his wife, Palestine, spent fifty-eight days in the hospital, suffering from burns after barely escaping their home with their two daughters: three-year-old Debbie and seven-month-old Donna. They became even more depressed, however, when they attempted to claim the full $1,000 in temporary relief allocated to them by the air force and received only $250 instead. Their attorney, G. Edmond Hayes, later filed an optimistic $132,000 lawsuit for damages. Three years later, they settled for $45,000, one of the largest settlements.[379]

Others, too, received less and lost much as a result of the crash. The amounts paid out showed little homogeneity. They were imbalanced and, as some felt, illogical. The largest amount awarded for a single death was $14,000.[380] The smallest relief granted for the death of a child was $400 and for the death of an adult, $701.33.[381] The loss of one's home or property, in most cases, paid more than the loss of a loved one.

Two adults and three children burned to death inside of 2053 North Piatt: Albert L. Bolden (twenty-two); his wife, Wilma J. Bolden (twenty-four); Denise M. Jackson (six); Brenda J. Dunn (five); and Leslie I. Bolden (nine months). The final settlement for the loss of the Bolden family was $28,059. Their attorney fees were $5,611.[382]

Harvey Dale lost his wife, their newly adopted two-year-old daughter and his home. He sued for $67,000, ending up with only $36,840.38—a ratio of fifty-five cents on the dollar.[383]

Laura Lee Randoph, Earl S. Randolph and Ethel McCormick handled the estate for Tracy Rachelle Randolph (five) and Mary Daniels (fifty-six), receiving a total of $18,175 for loss of their lives, property damage and funeral expenses. Attorney fees were $3,800.[384]

Six people died inside of 2041 North Piatt: Emmit Warmsley Sr. (thirty-seven), Laverne Warmsley (twenty-five and with child), Emmit Warmsley Jr. (twelve), Julia A. Maloy (eight) and Julius R. Maloy (six). A total of $28,557 was awarded for their deaths. This sum also included property damage and funeral expenses. Their attorney fees were $5,961.[385]

Henderson Kye, after losing his wife, Ella, when she suffered a stroke from the trauma of the crash, filed a claim for $25,215.40. Instead, he was given $2,500 for the death of his wife. His attorney fees were $500.[386]

Alvin T. Allen and his family received $8,000 for personal injuries and property damage. Their attorney fees were $3,300.[387]

Out of the thirty personal and property damage suits filed against the U.S. government and Boeing, Maxine C. Straughter received the lowest settlement of $100 in a suit originally asking for $2,500 in property damage. Her attorney fee was $20.

Margaret Daniels received $19,516.21 for the loss of her husband, Claude L. Daniels (thirty-two). Twenty-two-year-old James L. Glover, fast asleep when the KC-135 crashed and poured fiery jet fuel into his bedroom, probably never even woke up. His parents, James and Maxine Glover, residing in Detroit, Michigan, were awarded $14,985.53 for his death and other damages.[388]

Joe T. Martin, after suffering in agony while watching his two sons burn to death in their front yard at 2031 North Piatt, would find no comfort in his settlement. Although they filed a suit for $87,483, Joe and his wife, Lucile Martin, were given only $36,000 for the loss of their home and sons, Joe T. Martin Jr. (twenty-five) and Gary L. Martin (seventeen).[389] Joe was laid off from Boeing a short time later and was unable to "face the music," as he put it. The Martins eventually moved back to Boonsville, Arkansas, where they buried their sons.[390]

"Every time they burn down a shack in Vietnam they pay for it," said Clarence Walker. "I'm supposedly an American citizen, but they've made no restitution about my house."[391] Clarence and his wife, Irene, leapt from their burning home through a bathroom window and a back door—escaping death but sustaining multiple injuries in the process. They received $25,000 for personal injuries and property damage; $5,000 went to their attorney.[392] "My sores have healed, but I don't know when my soul will," lamented Mrs. Walker after the settlement.[393]

At last, on January 11, 1968, Congressman Shriver received a phone call from an air force colonel who conveyed the final settlement of the claims.[394] The thirty main lawsuits filed against the air force, seeking just over $1 million in relief and spanning over three and a half years, ended with the government paying $413,250 for loss of life, property damage, funeral costs, injuries and medical bills for all. There were also another 125 Wichitans who filed damage claims against the government outside of court that were settled for $212,000.[395] A claim of $14,138.83 by the Gas Service Company for damage to "gas meters, regulators and reimbursement for repair costs, labor and materials," and one of $12,936.04 by the City of Wichita for property damage, equipment, salaries and material were included in the final numbers.[396]

An alarming twenty-five out of the twenty-seven claims against Boeing, the codefendant with the U.S. government, were dismissed in 1968—with neither the U.S. government nor Boeing ever taking responsibility.[397] As was noted in the *Wichita Eagle*, "The government agreed to the settlements without admitting liability or fault in any of the cases."[398] Fault or no fault, these were considered final settlements, leaving no avenues for future lawsuits stemming from the crash.

In the end, several claimed the air force should have settled the claims quickly and for their maximum amount; a few claimed the air force deliberately delayed the process in order to decrease the amounts or to sidestep paying the settlements altogether; others claimed it was the court system that was at fault; some claimed that, if it were not for the courts, nothing would have been settled; many claimed the process might have gone quicker if the greedy lawyers had not wanted a larger percentage; and most were just plain angry. They didn't know who to blame, but no matter their opinions, one truth remained: all were dissatisfied. "No crash need leave the wake of dissatisfaction and the protracted disruption of lives," wrote Cornelius P. Cotter, "that has characterized the federal government's response to that which occurred in Wichita, January 16, 1965."[399] The final settlements were at best pyrrhic victories. Nobody won.

FAMILIES OF THE AIRMEN

Four widows, ten children and countless friends and family of the airmen would never see their loved ones return home that Saturday. And whereas the victims on Piatt Street would at least receive some relief, although not much, the same was not true for the families of the servicemen killed. On the morning of Sunday, January 17, 1965, Jeanine Eileen Widseth heard a knock on her front door at base housing located on Clinton-Sherman AFB. Grieving from the loss of her husband barely twenty-four hours before, she reluctantly answered. Standing before her was an air force colonel in his dress blues—pressed, polished and adorned with medals. He had visited her the previous day, accompanied by a doctor and chaplain, when they broke the heart-wrenching news of her husband, copilot Gary J. Widseth's death. Now, the colonel had even more tormenting news for Jeanine that she would never forget.

At first, he offered his condolences again and handed her a check for around $3,000. He explained it was to help pay her bills and make any adjustments that she needed to after the loss of her husband. But just before walking out the door, the colonel said quietly, "Don't even think about suing."[400] She never saw him again. Jeanine, as she remembered, was certainly not thinking about suing the air force at the time. Her world had just come crashing down, and as a widow with small children, she had much more pressing concerns. Forty-eight years later, however, she recalled how she thought it was a military rule that she could not sue the air force for her husband's death, so she never tried. Even worse, her husband's death remained an open wound in her life. Jeanine never remarried.

Irene Huber (Kenenski) came to loathe the insufferable memories of January 16, 1965, and the deafening silence afterward. She was nine years old when her brother, A1C Daniel E. Kenenski, assistant crew chief, died aboard Raggy 42. She recalled coming inside their house in Rhode Island after shoveling snow with her father that morning. As soon as she entered, she found her mother crouched down on the floor sobbing with the telephone in her hand. While the wet snow falling from her coat began to form melted puddles on the kitchen floor, she stood in shock, helplessly watching her mother cry over the news that Danny was dead. A Western Union Telegram from the air force carried the shattering news.

They were never told why the plane crashed and had "no information at all," said Irene.[401] And like Jeanine, their family was instructed that a lawsuit would not be an option.

The Kenenski family was notified of Danny's death via this Western Union wire sent by the air force. *Irene Hubar (Kenenski).*

Neither Jeanine nor Irene (and it can only be assumed, the other families), for reasons unknown, was ever given the Collateral Board Investigation Report that explained what happened to their loved ones—further proof that the tragedy, grief and dissatisfaction with the outcome of the Piatt Street crash extended far beyond Wichita. Families across the United States, divided by race, socioeconomic status and location, still mourn every January 16, as they have done for nearly half a century. Their afflictions were, and remain, many.

<p style="text-align:center">**17**</p>

THE LONG-AWAITED MEMORIAL

The only people it will die with will be the ones who watched it on the news.
—*Survivor, January 16, 1985*[402]

The victims of the Piatt Street crash would wait forty-two years before a memorial was named in their honor. In this case, justice took longer than the biblical account of the Children of Israel's exodus from Egypt, as they sojourned in the wilderness of the Sinai desert for forty years before entering into the Promised Land.[403] It took longer than the time needed to build the great Panama Canal, uniting the Atlantic and Pacific Oceans, which, after several attempts, was completed in nearly thirty-five years.[404] It even took longer than the decades needed for policies on race and equality to begin shifting in the U.S. following the Civil Rights Act of 1964 and the Voting Rights Act of 1965. When chatter began about the possibility of a memorial, blacks remained second-class citizens, and most U.S. establishments were still segregated. When the rhetoric finally ended, forty-two years later, an African American was preparing a successful run for the presidency of the United States. Time had certainly passed.

MORE TALK

There was talk of a memorial in the *Wichita Eagle* two days after the crash. A decade later, in 1975, people were still talking. On the twentieth anniversary

in 1985, people were still talking. And another ten years after that, people were still talking about the absence of a memorial. Frustration and separation between the races were perpetuated in the Wichita community as years passed, with no activity or efforts made by the city to create a memorial. Ron Thomas, who witnessed the crash, explained in a 1996 interview the general feeling of isolation and separation after the KC-135 fell in Wichita's black community:

> *It seems to me the city did not show much remorse, or enough remorse, outside of the black community. After the crash, and maybe because of the responses of whites, a lot of people in the black community really closed up. It became a black/white thing. People asked, "Why did all those people die here?" and the city never even put up a memorial or anything to acknowledge the loss of life.*[405]

Others in the community suggested possible reasons for this: "I think that because of where it was," said Brenda Gray, a longtime Wichita resident, "it was definitely not so important to the rest of Wichita."[406] The lingering silence and stagnation after such a tragedy had insidious effects: African Americans felt further excluded from the rest of the community; the crash seemed insignificant, easily forgotten; and the longer it took to do something, the more embedded the perception became. "…[I]t would be nice to see some kind of memorial over there," said a survivor five years after the crash. "It would be a good thing just to have any kind of marker to recognize all those deaths."[407] They would have to wait. Meanwhile, a seething undercurrent of anger and acrimony boiled just below the surface.

THE FIRST MEMORIAL

Thirty-six years passed before the first collective memorial service took place. The service was held at the McConnell Base Chapel on June 9, 2001. The relatives of Capt. Gary J. Widseth (copilot), 2nd Lt. Arthur Sullivan (navigator) and several others helped establish a stone marker and organize a memorial service to honor the memories of those lost. While bagpipes bellowed "Amazing Grace," the victims' family members and airmen in attendance carried stargazer lilies, each representing a victim, down the aisle in an orderly fashion. It was a truly touching service, and there was scarcely a dry eye visible. Mrs. Widseth described the service as "beautiful" and "orderly"—as only a military service could be.[408]

A McConnell Senior Airman lays a flower during the memorial service and monument dedication ceremony held in June 2001. *22nd ARW History Office.*

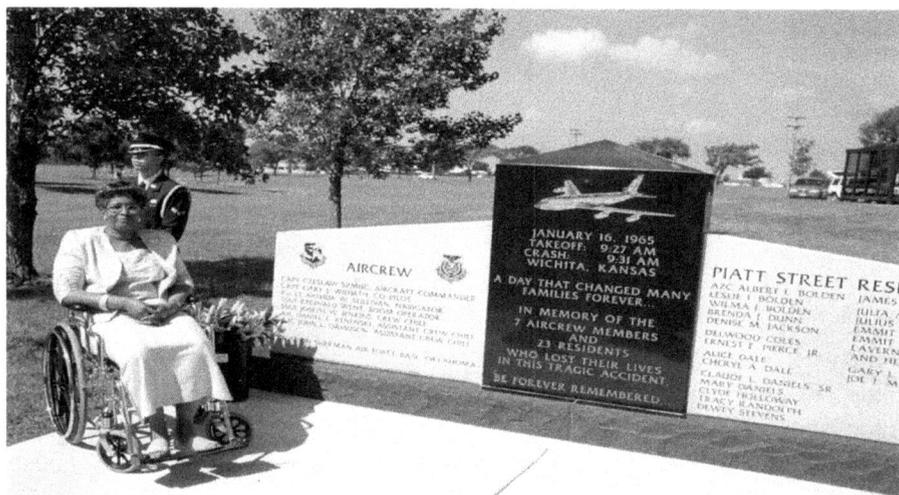

Erna Starnes-Winter lost members of her family in the 1965 crash. She is seen here with the memorial monument commemorating crash victims at its dedication ceremony. *22nd ARW History Office.*

It was long overdue in the eyes of many in attendance, but it finally marked the beginnings of acknowledgement and a bit of closure. On that day, the McConnell officials promised, "no one would be denied entrance to see the monument dedicated to the crew and civilians."[409] But that was a promise they could not keep.

A New Memorial

With the worst act of terrorism our nation has ever seen on U.S. soil occurring just three months later, on September 11, public access to the memorial via McConnell was limited. The relaxed security and open gates the public once enjoyed on military installations throughout the country vanished. Thus, a complaint in the years following the McConnell memorial was that its location was not readily accessible. Once again, it seemed the memory of those lost on Piatt Street would soon fade from public view under the shadows of larger events affecting the nation.

John Polson searched for a way to stop history from repeating itself. Polson, a white male in his sixties with no connection to the victims, was an unlikely candidate to generate interest in a disaster affecting Wichita's black community. Nevertheless, Polson was a lifetime resident of Wichita and a community activist who was always troubled by the fact that there was no memorial on Piatt Street to honor the victims. According to Polson, "In the middle part of 2005, things got going on the memorial."[410] He approached Oletha Faust-Goudeau, now a Kansas senator, in 2004 and made recommendations to erect a memorial at the location of the crash site. As Polson lamented, "No memorial and public recognition had taken place," and something needed to be done. For Polson, the realities of what had happened back in 1965 and how much worse it could have been still bothered him. "When that plane went down, if it had been three hours later and two to three miles due east," he remembered, "it would have struck the Field House killing ten thousand people."[411]

The Field House, which opened a decade prior to the crash on December 3, 1955, was a large, circular sports arena located on the campus of WSU. Polson, a senior in high school during 1965, had plans to attend a basketball game there that afternoon. The WSU Shockers were playing against St. Louis University, and fortunately for the university and Wichita itself, a greater disaster did not occur. Just a few hours after the crash—with jet fuel still

dripping from the roof of the arena and weary firemen soaking the wreckage of Raggy 42 only blocks away—the WSU Shockers won the Missouri Valley outright for the first time in history. They didn't cancel the game.

THE WSU TRAGEDY

Polson cited several reasons why he felt the Piatt Street memorial had remained stagnant for so long. Among these were race, the social climate of the 1960s and the relatively small city of Wichita at the time. But he also recounted confusion over the years concerning another great tragedy involving yet another plane crash and the Wichita community. On October 2, 1970, on their way to a football game with Utah State University in Logan, Utah, several members of the WSU football team were killed when their plane collided with a mountain just outside Silver Plume, Colorado.[412] Of the forty people on board, only eight survived. A memorial fund was established for the WSU plane crash the day after the accident. Two weeks later, there was over $11,000 in donations to build a memorial. One year later, a memorial was erected on the WSU campus, and an annual ceremony has been held there ever since.[413]

Years after the WSU plane crash, many in the community muddled it with the Piatt Street crash of five years earlier due to the relatively close time frame of each occurrence. Even in 2013, a young airman stationed at McConnell, who grew up on Piatt Street, remembered being told by his grandfather that it was the WSU football team that had crashed on Piatt. Only years later did he discover that the Piatt tragedy involved a plane he now knows intimately as a new KC-135 crew chief.[414] In truth, many Wichitans today *still* confuse the WSU plane crash with the Piatt Street plane crash. Therefore, as Polson and countless others knew, establishing a memorial could respectfully distinguish the memories of those lost in both catastrophes.

REFLECTION AT LAST

It was not that Polson's recommendation was somehow new or revolutionary. Clearly, there had been grumblings in the Wichita community for decades regarding the lack of a memorial at the crash site. But in 2004, the right people in the right places at the right time were assembled to put forth the

Planes soar above Piatt Street memorial. *Richard Harris, Kansas Aviation Centennial.*

energy and effort. A committee composed of various members of the Wichita community, city council, military and local businesses worked tirelessly to generate revenue for the memorial. Much work was required. Hundreds of letters were sent out for donations, fundraisers were established, grants were sought after and grass-roots campaigning continued for nearly two years to gather the funds needed to erect a memorial.[415]

At last, six years after the first memorial service at McConnell and at a cost of well over $100,000, a large granite memorial was raised just south of 20th and Piatt Street. It was called a "venture of public and private work."[416] The tenacity and generosity of all involved was finally on display.

The memorial stands approximately thirty feet from the intersection that was the point of impact and rests on the west side of the street, where, nearly half a century earlier, homes were consumed by fiery jet fuel. Leading visitors to the massive memorial are 1,171 bricks, purchased by individual donors from

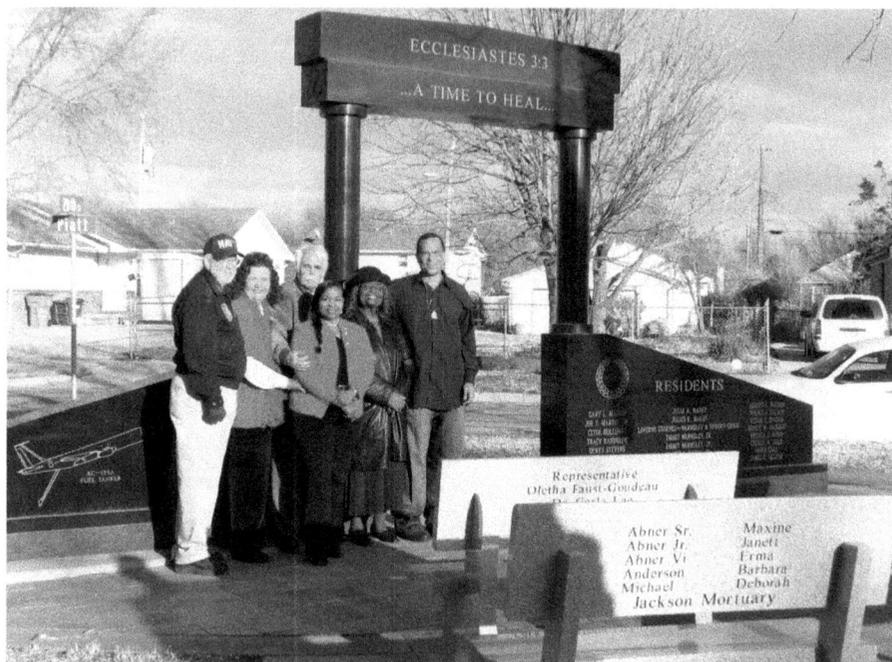

Several members of the Piatt Street memorial committee stand together on January 16, 2012. *From left to right*: Colonel Herb Duncan with the Commemorative AirForce-JayHawk Wing, Dr. Carla Lee, Mr. John Polson, Kansas Senator Oletha Faust-Goudeau, Ms. Sonya M. House and Darryl Woodard. *Richard Harris, Kansas Aviation Centennial.*

the community.[417] Twenty-two feet in length at its base and equipped with reflection benches and a donor-engraved brick plaza, the towering memorial is crowned with a fifteen-foot-high archway inscribed with the scripture "…A Time To Heal…" Located at 2037 North Piatt on 1.45 acres of park grounds set aside in 1971, the lofty granite and brick structure serves as a testament to those who perished.[418] The base of the memorial contains the names of all the victims, both military and civilian. At its unveiling in July 2007, it seemed that closure might take place at last. Thirty lives, taken much too soon, are yet remembered, and the dreadful silence—lasting nearly half a century—has at least been broken. Let it never return.

EPILOGUE

History will have to record that the greatest tragedy of this period of social transition was not the vitriolic words and the violent actions of the bad people, but the appalling silence and indifference of the good people.
—Dr. Martin Luther King Jr., January 27, 1965[419]

Giants roamed the earth in 1965. Their immense girth, strength and influence pressed heavily upon the masses, and their thundering voices swallowed up headlines for an entire decade. They went by the names of Kennedy, King, Johnson, Chavez, Hoffa and McNamara. They cleared paths, making resonating waves in many areas—politics, civil rights, domestic programs, workers' rights, labor unions and Vietnam. These giants, it seemed, were invincible, and their weighty, panoptic shadows cast on American society like a thick blanket.

In the midst of these heavyweights, beneath their towering stature, was the burgeoning city in Kansas named Wichita, which was experiencing its own social upheaval and turmoil as race relations worsened in 1965. And at sixteen days, nine hours and thirty-one minutes into the New Year, disaster struck. Yet, in such a tumultuous, volatile and protean time, the Piatt Street tragedy was but a ripple.

Four days after the crash, President Lyndon B. Johnson was inaugurated, beginning his quest to achieve the Great Society. Four days after that, suffering from a stroke, Winston Churchill passed away in England, and a month later, Malcolm X was gunned down in New York City. In 1965, black

churches burned in the South; murders were rampant in Mississippi; the Vietnam War escalated; race riots broke out in Watts, California; thousands marched in Selma, Alabama; thousands more protested the Vietnam War; and thousands stood up or sat down for equality. No shorter span of time so greatly influenced the course of social America as did the 1960s.

Meanwhile, as publicity waned and the '60s grew louder and increasingly violent, the roar over the Piatt Street crash was reduced to a small chatter. Then, with the 1970s bringing its own grief involving plane crashes—the WSU plane crash in October, the Marshall University plane crash in November and another KC-135 crash in Wichita four years later, on March 5, 1974—Piatt Street faded from view.

Why it took nearly half a century to fully acknowledge the Raggy 42 disaster, why most remained idle while bitterness festered, why hardly any Kansans (in truth, hardly any Wichitans) have knowledge of its occurrence and why so many did so little for so long is a mystery. The seven men serving their nation that morning, and the twenty-three civilians on the ground, deserved more—their lives no less important than any other.

Perhaps, then, a combination of its location in northeast Wichita, declining race relations, civil unrest, social turmoil, apathy, disinterest, resentment, discord, separatism and a multitude of defining events simultaneously occurring in the compact and strife-filled 1960s is to blame. Whatever the reason, the Piatt Street plane crash was quickly and shamefully forgotten.

But thankfully, that time has passed. The city has since grown, and race relations have bettered from their once intolerable state. Laws were enacted to expedite settlements and aid victims of such calamities. Wichita's disaster plan worked and was further enhanced. New families moved into new homes constructed on Piatt Street, and children now frolic on a beautiful playground, where green grass covers the scar of what was once a horrible scene. Off in the distance, a memorial watches over them, ensuring that those who were lost and those who suffered privately for far too long are no longer hidden.

The giants of that era have ceased to roam the earth. They are extinct. The axioms they lived by and left behind are not. As they discovered, it is only by understanding and confronting an unsettled past, no matter how traumatic or ugly it might be, that mankind can take hold of the peaceful present. Clyde G. Stevens, now in his fifties, is headed toward that peaceful present. Clyde was six years old when his father, Dewy Stevens, perished inside of 2037 North Piatt. His father gone and his mother abusive, Clyde was placed in a boys' home for abused and neglected children in Los

Angeles, California. He grew up bitter, angry and confused, never knowing who his father was; he bounced in and out of jail as an adult, abused drugs and alcohol, attempted suicide, but eventually—through God's grace, as he declares—received his life back.[420]

In 2013, forty-eight years later, Clyde returned to the boys' home and learned for the first time how his father died. He had never heard of any Piatt Street crash. No one ever told him. He was not alone.

Without warning and without question, a montage of pain and intertwining fates fixed together by a defining moment of time on January 16, 1965, bequeathed many with grief. But Clyde now believes that the choice to learn from it and move forward or to remain captive is in his hands. He is no longer hidden by giant shadows or ominous clouds; his existence is no longer defined by tragedy. Faced with the vicissitudes of life, Clyde—among others—has gleaned from the value of forgiveness. The skies, for the first time in his life, are clear. And in Wichita, the forecast, too, is sunnier.

NOTES

1. Judith Herman, *Trauma and Recovery: The Aftermath of Violence from Domestic Abuse to Political Terror* (New York: Basic Books, 1992), 1.

CHAPTER 1

2. George C. Herring, *America's Longest War: The United States and Vietnam, 1950–1975*, 4th ed. (New York: McGraw-Hill, 2002), 142.
3. Tonkin Gulf Resolution, Public Law 88-408, 88th Congress, August 7, 1964. General Records of the United States Government. Record Group 11. National Archives.
4. Steve Larsen, *Heritage and Legacy: A Brief History of the 22d Air Refueling Wing and McConnell Air Force Base* (Office of History 22d Air Refueling Wing, 2006), 16.
5. Steven L. McFarland, *A Concise History of the U.S. Air Force*, Air Force History and Museums Programs (Fort Belvoir, VA: Defense Technical Information Center, 1997), 59–61.
6. Larsen, *Heritage and Legacy*, 4.
7. James L. Crowder, Oklahoma Historical Society, Clinton-Sherman Air Force Base, http://digital.library.okstate.edu/encyclopedia/entries/C/CL017.html (accessed January 21, 2012).
8. "SAC Operations Order 83-65 (Lucky Number)," September 11, 1964, *Air Force Report of Collateral Investigation Board*, KC-135 A 57-1442, January 16, 1965 (Wichita, Kansas), Vol. II, Appendix B, quoted in Cornelius P. Cotter's *Jet Tanker Crash: Urban Response to Military Disaster* (Lawrence: University of Kansas Press, 1968), 2.
9. *Wichita Eagle*, "Death Toll Climbs to 30 in Jet Tanker Crash in City," January 18, 1965, 1; Cotter, *Jet Tanker Crash*, 155.
10. Jeanine Widseth, interview with author, January 26, 2013.
11. Jon Roe, "Report Reveals Repeated Delays of KC-135 Flight," *Wichita Beacon*, October 3, 1965.
12. Widseth interview.

13. Ibid.

14. Ibid.

15. Ibid.

16. Ibid.

17. Letter from James K. Musshel to Mr. and Mrs. Henri J. Kenenski, January 18, 1965.

18. Letter written by Daniel E. Kenenski, May 16, 1964.

19. Irene Hubar (Kenenski), telephone interview with author, January 16, 2013.

20. *Wichita Eagle and Beacon*, "Miami Youth Among Crewmen Killed in Crash," January 17, 1965.

21. *Wichita Beacon*, January 21, 1965.

22. Roe, "Report Reveals," *Wichita Beacon*, October 3, 1965.

CHAPTER 2

23. Air Force Report, II, 7, 120, Testimony of Captain Sidney S. Buswell, tanker scheduler, 70th Bomb Wing, quoted in Cotter, *Jet Tanker Crash*, 5.

24. Ibid.

25. Steve Sells, "KC-135A Jet Has Record of Reliability," *Wichita Beacon*, January 17, 1965.

26. *Wichita Eagle and Beacon*, January 17, 1965.

27. *Eagle*, "Air Force Delve for Cause of Crash," January 19, 1965.

28. Air Force Report, II, 7, 84–87, Testimony of Captain Sidney S. Buswell, tanker scheduler, 70th Bomb Wing, quoted in Cotter, *Jet Tanker Crash*, 3; Widseth interview.

29. *Wichita Eagle*, January 13, 1965.

30. Ibid., January 14, 1965.

31. Ibid.

32. USAF Technical Sergeant Brandon Blodgett, interview with author, November 21, 2012.

33. Air Force Report, II, 7, Testimony of Chief Master Sergeant R.H. Grant, the noncommissioned officer in charge, Tanker Flight Line Section, 70th Organizational Maintenance Squadron, Clinton-Sherman AFB, Oklahoma, quoted in Cotter, *Jet Tanker Crash*, 3.

34. Cotter, *Jet Tanker Crash*, 5.

35. Second Air Force Accident/Incident Report, "History of Flight 57-1442," 1965, 1; "Maintenance Group Report," 9.

36. Ibid., "Transcript of Tape Between McConnell Tower and Aircraft, Raggy 42."

37. Martin Van Creveld, *The Age of Air Power* (New York: Public Affairs, 2011). See 191–213 for development of the jet engine in the U.S. Air Force.

38. National Research Council, Committee on Analysis of Air Force Engine Efficiency Improvement Options for Large, Non-fighter Aircraft, National Research Council, *Improving the Efficiency of Engines for Large Non-fighter Aircraft* (Washington, D.C.: National Academies Press, 2007), 50.

39. Sells, "KC-135A."
40. Air Force Report, I, 133A-34, quoted in Cotter, *Jet Tanker Crash*, 5.
41. Ibid., 5.
42. Second Air Force Accident/Incident Investigation Report, "Crash Time Information: KC-135 (Raggy-42)," January 28, 1965 (emphasis added).

Chapter 3

43. Ed Knowles, "Eye Witnesses Relate Tragic Story," *Topeka Capital Journal*, January 17, 1965. Ms. Williams lived diagonally across the intersection of 20th and Piatt and two houses down from where the plane fell.
44. Bill Hirschman, "Day Will Not Die for Those Who Watched in Horror," *Eagle*, January 16, 1985.
45. Ibid.
46. Sonya House, interview with author, November 29, 2012.
47. Tim Kidd, "Witnesses Recall It as a Fiery Hell," *Wichita Beacon*, January 16, 1975.
48. Larry McDonough, telephone interview with author, January 18, 2013.
49. Ibid.
50. Earl Tanner, telephone interview with author, March 4, 2013.
51. Connie Close, "Witnesses Tell Versions of Tragedy," *Wichita Eagle*, January 17, 1965.
52. Knowles, "Eye Witnesses."
53. Victor Daniels, interview with author, November 24, 2012.
54. Knowles, "Eye Witnesses."
55. *Wichita Sunday Eagle and Beacon*, January 17, 1965; Kathy Sipult, "After 5 Years, Cold Day of Fiery Death Is Vivid," *Wichita Eagle*, January 16, 1970.
56. *Wichita Eagle*, January 15, 1995.
57. Tim Brazil, "Whole Ground on Fire," *Wichita Eagle and Beacon*, January 17, 1965.
58. Jim Lapham, "Escape Is Hopeless," *Kansas City Star*, January 17, 1965.
59. Cotter, *Jet Tanker Crash*, 103.
60. Ibid., 19.
61. Brazil, "Whole Ground on Fire," *Wichita Eagle and Beacon*, January 17, 1965.
62. *Wichita Eagle*, "Remember," January 22, 1996.

Chapter 4

63. Ellen Anderson, "Faith, Their Victory," 1965. Mrs. Anderson was a survivor of the crash and sent this poem to the families of the crewmen. It was provided to the author by Irene Hubar.
64. *Wichita Eagle and Beacon*, "Time Can't Erase Bad Memories," January 16, 1985.

65. *Wichita Beacon*, February 15, 1965.

66. *Wichita Eagle*, January 15, 1995; Bob Linder, "Empty Soap Box Spared Her Life" *Wichita Eagle*, January 16, 1967.

67. Clarence William Walker, interview, March 1969, Shriver Papers.

68. Frank H. Carpenter and Leonard H. Wesley Jr., "Community Response to Tragedy: A Case Study of the Air Crash of January 16, 1965 in Wichita, Kansas," Department of Political Science, Wichita State University, May 21, 1965, University of Delaware, Disaster Research Center Library, 8.

69. Ibid.

70. *Wichita Beacon*, February 15, 1965.

71. Ibid., January 16, 1985; Brazil, "Whole Ground on Fire."

72. *Wichita Eagle*, January 15, 1995.

73. *Wichita Eagle and Beacon*, "Dash Through Blazing Grass to Escape Death," January 18, 1965.

74. John Husar, "Rush of Terror Greets Reporter," *Wichita Eagle and Beacon*, January 17, 1965.

75. Connie Close, "Minister at Crash Tells of Child Burning to Death," *Wichita Eagle*, January 18, 1965.

76. *Wichita Beacon*, February 15, 1965.

77. *Wichita Eagle and Beacon*, "Time Can't Erase Bad Memories," January 16, 1985.

78. Ibid.

79. *Wichita Eagle and Beacon*, January 24, 1965.

80. *Wichita Beacon*, February 15, 1965.

81. House interview.

82. Ibid.

83. *Wichita Eagle*, "Dash Through Blazing Grass To Escape Death," January 17, 1965.

84. *Wichita Beacon*, January 16, 1985.

85. Wichita Fire Department Official Report, January 16, 1965, Kansas Firefighters' Museum Archives.

86. *Wichita Beacon*, February 15, 1965.

CHAPTER 5

87. Fire Chief Tom McGaughey, "Fire from the Sky Over Wichita," Disaster Research Center Library, University of Delaware, 1.

88. Video footage by *KAKE News*, January 16, 1965, tape #FO907, box #F050, Special Collections, Ablah Library, Wichita State University; *Capital Journal*, January 17, 1965.

89. Retired Deputy Fire Chief Earl Tanner, telephone interview with author, March 7, 2013.

90. Dan Garrity and Gary Lester, "Depression Made Firemen of McGaughey," *Wichita Eagle*, November 22, 1968.

91. Cotter, *Jet Tanker Crash*, 14.

92. McGaughey, "Fire from the Sky," 1.

93. House interview.

94. McGaughey, "Fire from the Sky," 3.

95. Ibid., 4.

96. Ibid., 5. There is a one minute discrepancy here with the time of 9:30 a.m. and 9:31a.m. Although the official WFD report notes the crash time at 9:30 a.m., the air force and the media reported 9:31 a.m. as the official crash time of Raggy 42.

97. Ibid., 4.

98. Tanner interview.

99. McGaughey, "Fire from the Sky," 4.

100. Ibid., 3–4.

101. Cotter, *Jet Tanker Crash*, 27–28.

102. Ibid., 19.

103. McGaughey, "Fire from the Sky," 1.

104. Ibid., 5.

105. Ibid.

106. Ibid.

107. Ibid., 6.

108. Cotter, *Jet Tanker Crash*, 31.

109. Ibid., 34–35.

110. Wichita Fire Department Official Report, January 16, 1965, Kansas Firefighters' Museum Archives.

111. James Hudson, "Utility Service Restored," *Wichita Eagle,* January 17, 1965.

112. *Topeka Capital Journal,* January 17, 1965; February 14, 1965.

113. McGaughey, "Fire from the Sky," 10–11.

114. *Wichita Eagle,* January 17, 1965, cited 1.5 million gallons of water.

CHAPTER 6

115. *Wichita Beacon,* January 19, 1965. Note that the *Beacon* originally cited twenty-five thousand gallons of jet fuel, but the correct amount was approximately thirty-one thousand.

116. Giulio Douhet, *The Command of the Air* (reprint, Washington, D.C.: Office of Air Force History, 1983).

117. Ibid., 30.

118. John Shy "Jomini," in *Makers of Modern Strategy: From Machiavelli to the Nuclear Age,* edited by Peter Paret (Princeton, NJ: Princeton University Press, 1986), 182.

119. Ibid., 182.

120. Karl Lautenschläger, "Controlling Military Technology," *Ethics* 95, no. 3, Special Issue: *Symposium on Ethics and Nuclear Deterrence* (April 1985), http://www.jstor.org/stable/2381045 (accessed October 11, 2012), 697.

121. Walton S. Moody, *Building a Strategic Air Force* (Washington, D.C.: Air Force History and Museums Program, 1996), 65.

122. Jeremy J. Stone, "Bomber Disarmament," *World Politics* 17, no. 1 (October 1964), http://www.jstor.org/stable/2009385 (accessed October 11, 2012), 15.

123. Ibid., 15.

124. Stephen Budiansky, *Air Power: The Men, Machines, and Ideas that Revolutionized War, from Kitty Hawk to Gulf War II* (New York: Penguin Group, 2004), 354.

125. Walter J. Boyne, *Beyond the Wild Blue: A History of the United States Air Force, 1947–2007*, 2nd ed. (New York: St. Martin's Press, 2007), 110.

126. Eugene Rodgers, *Flying High: The Story of Boeing and the Rise of the Jetliner Industry* (New York: Atlantic Monthly Press, 1996), 170.

127. Budiansky, *Air Power*, 354; Richard H. Kohn and Joseph P. Harahan, eds., *Strategic Air Warfare*, USAF Warrior Studies (Washington, D.C.: Office of Air Force History, 1988), 105.

128. Boyne, *Beyond the Wild Blue*, 110.

129. Ibid.

130. Rodgers, *Flying High*, 170.

131. On this first flight of the Dash 80, however, Johnston couldn't raise the landing gear or flaps after takeoff because the hydraulic controls on the plane failed to work. The official photo for *Time* magazine was taken looking down on the Dash 80 in order to avoid this embarrassment. See Rodgers, *Flying High*, 171–72.

132. Rodgers, *Flying High*, 175.

133. Bill Gilbert, *Air Power: Heroes and Heroism in American Flight Missions, 1916 to Today* (New York: Citadel Press, 2003), 251; Boeing, *Defense, Space and Security: KC-135 Stratotanker*, http://www.boeing.com/defense-space/military/kc135-strat/index.html (accessed January 12, 2012); American Aviation Historical Society, Boeing KC-135 Celebrates Fifty Years of Service, September 8, 2006, http://www.aahs-online.org/articles/KC-135_turns_50.php (accessed January 12, 2012).

134. Steven L. Rearden, "U.S. Strategic Bombardment Doctrine Since 1945," in *Case Studies in Strategic Bombardment*, edited by R. Cargill Hall (Washington, D.C.: Air Force History and Museums Program, 1988), 405, italics mine.

135. Boyne, *Beyond the Wild Blue*, 110.

136. Boeing, *Defense, Space and Security*.

137. Rodgers, *Flying High*, 198.

138. Larsen, *Heritage and Legacy*, 22.

CHAPTER 7

139. Frank Garofalo, "Two Fliers Tell Vivid Crash Stories," *Wichita Beacon*, January 16, 1965.

140. Colonel James Trask Interview, *Wichita Eagle and Beacon*, January 16, 1985.

141. Dale Daugherty, "Explosion Fire Raze 15 Homes," *Wichita Eagle and Beacon*, January 17, 1965.

142. "Crash Investigation Started In Minutes," *Wichita Beacon*, January 19, 1965.

143. Garofalo, "Two Fliers."

144. Rick Colella, "Overweight Landing? Fuel Jettison? What to Consider," *Aero Magazine* (3rd Quarter 2007), http://www.boeing.com/commercial/aeromagazine/articles/qtr_3_07/AERO_Q307_article3.pdf (accessed June 3, 2012).

145. Cotter, *Jet Tanker Crash*, 7.

146. General Murray M. Bywater, interview with *KAKE News*, January 17, 1965, FO907, Special Collections, Ablah Library, Wichita State University.

147. Garofalo, "Two Fliers."

148. Ibid.

149. Testimony of Colonel Tom Murphy, Director of Safety for the 2nd Air Force, *Kansas City Star*, January 17, 1965.

150. *Wichita Eagle*, January 17, 1965.

151. Garofalo, "Two Fliers."

152. *Wichita Beacon*, January 16, 1965.

153. Ibid.

154. *Kansas City Star*, January 17, 1965.

155. *Capital Journal*, January 17, 1965.

156. Technical Sergeant Jason Schaap, "Air Force Pulls Parachutes from KC-135s," March 4, 2008, http://www.afrc.af.mil/news/story.asp?id=123087912 (accessed July 23, 2012).

157. *Topeka Capital Journal*, January 17, 1965.

158. Flight Safety Foundation, Accident Description, http://aviation-safety.net/database/record.php?id=19680730-0 (accessed July 23, 2012).

159. Joseph Heywood, *Covered Waters: Tempests of a Nomadic Trouter* (Guilford, CT: Lyons Press, 2003), 45. At the time of Heywood's writing in 1970 the KC-135 had been in service for thirteen years.

160. *Air Force Report*, Vol. II, Exhibit X, in Cotter, *Jet Tanker Crash*, 11.

CHAPTER 8

161. *Wichita Eagle and Beacon*, "Time Can't Erase Bad Memories," January 16, 1985.

162. John Husar, "Rush of Terror Greets Reporter," *Wichita Eagle and Beacon*, January 17, 1965.

163. *Topeka Capital Journal*, "Asked to Move," January 17, 1965.

164. *Wichita Eagle*, January 15, 1995.

165. Deputy Chief Robert Simpson interview in Cotter, *Jet Tanker Crash*, 27.

166. Captain Raymond L. Wert interview in Cotter, *Jet Tanker Crash*, 76.

167. Captain Lawrence Black interview in Cotter, *Jet Tanker Crash*, 25; Simpson, Wert and Black interviews are on audio recordings at the Disaster Research Center, University of Delaware.

168. *Topeka Capital Journal*, January 17, 1965.

169. Captain Lawrence Black interview in Cotter, *Jet Tanker Crash*, 24.
170. Tanner interview.
171. *Topeka Capital Journal*, January 17, 1965.
172. John Husar article, *Wichita Eagle and Beacon*, January 16, 1985.
173. Ibid.
174. Ibid.
175. Cotter, *Jet Tanker Crash*, 37.
176. Forrest Hintz, "2 Agencies Give Ample Relief Goods," *Wichita Eagle and Beacon*, January 17, 1965.
177. Ibid.
178. Captain Raymond Wert of the Salvation Army, quoted in Cotter, *Jet Tanker Crash*, 79–80.
179. Husar article.
180. Ibid.
181. McGaughey, "Fire from the Sky," 4.
182. Connie Close article, *Wichita Eagle and Beacon*, January 16, 1985.

CHAPTER 9

183. Interview with Rev. Joseph E. Mason, quoted in *Jet Tanker Crash*, 100.
184. *Wichita Eagle, Kansas City Star* and *Topeka Capital Journal*, January 17, 1965.
185. *Wichita Eagle*, "Probers Start Work," January 18, 1965.
186. *Wichita Eagle*, "Air Force Probes Crash Site Debris," January 18, 1965.
187. *Wichita Eagle*, "Loss At Jet Crash Scene Estimated At 3.5 Million," January 24, 1965.
188. *Wichita Eagle*, "Air Force Probes Crash Site Debris," January 18, 1965.
189. *Wichita Eagle*, "Air Force Delve for Cause of Crash," January 19, 1965.
190. Richard Jackson interview with Leonard Wesley and Frank Carpenter on May 5, 1965, quoted in Cotter, *Jet Tanker Crash*, 107.
191. Lester Rosen to Cornelius P. Cotter, November 15, 1965, MS7701, Box 9, Garner Shriver Papers, Special Collections, Ablah Library, Wichita State University.
192. Arnold L. Parr, "A Brief View of the Adequacy and Inadequacy of Disaster Plans and Preparations in Ten Community Crises" (Ohio State University, Department of Sociology, June 1969), Disaster Research Center, 5.
193. *Wichita Eagle*, "Memories of Air Tragedy Recounted," January 16, 1967.
194. *Wichita Eagle and Beacon*, "Life Goes on Bravely in Plane Crash Area," January 17, 1965.
195. Ibid.
196. *Wichita Eagle*, "Rescue Units Draw Praise," January 18, 1965.
197. Ibid.
198. *Wichita Eagle and Beacon*, "Life Goes on Bravely"; Garofalo, "Two Fliers."
199. Ibid.

200. *Wichita Eagle*, "Promise of Finished Homes Given to Displaced Persons," January 18, 1965.
201. *Wichita Eagle and Beacon*, "Life Goes On Bravely"; Garofalo, "Two Fliers."
202. *Topeka Capital Journal*, "Homes Opened," January 17, 1965.
203. Forrest Hintz, "2 Agencies Give Ample Relief Goods," *Wichita Eagle and Beacon*, January 17, 1965.
204. *Wichita Eagle and Beacon*, "Life Goes on Bravely"; Garofalo, "Two Fliers."
205. *Wichita Eagle*, "Rescue Units Draw Praise," January 18, 1965.

CHAPTER 10

206. *Wichita Beacon*, "Fair Housing law needed," July 8, 1967.
207. *Wichita Beacon*, "Two Groups Have Common Goal but Differ," July 14, 1967.
208. "A Survey of the Visual Character and Design Principles for Building in the College Hill Neighborhood," *Design in the College Hill Neighborhood*, September 1998, prepared by Winter & Company, Boulder, Colorado, Special Collections, Ablah Library, Wichita State University.
209. Rebecca White, "College Hill History Part of Wichita's Struggle for National Status," interview with Jeff Roth, *KWCH News*, August 2, 2012, http://articles.kwch.com/2012-08-02/college-hill_33005802 (accessed October 3, 2012).
210. *Wichita Eagle*, "Air Force Delve for Cause of Crash," January 19, 1965.
211. *Wichita Eagle and Beacon*, "Destruction Stunned City," January 16, 1985.
212. Carpenter and Wesley, "Community Response," 27–28.
213. Ibid.
214. Ibid., 30.
215. Ibid., 29.
216. Ibid., 33.
217. Cotter, *Jet Tanker Crash*, 68–70.
218. Carpenter and Wesley, "Community Response," 20.
219. James E. Garmon interview in Cotter, *Jet Tanker Crash*, 105.
220. Carpenter and Wesley, "Community Response," 34.
221. Ibid., 57.
222. Cotter, *Jet Tanker Crash*, 71.
223. Carpenter and Wesley, "Community Response," 30.

CHAPTER 11

224. John F. Kennedy, Radio and Television Report to the American People on Civil Rights, June 11, 1963, John F. Kennedy Presidential Library and Museum, http://www.jfklibrary.org/Asset-Viewer/Archives/JFKWHA-194-001.aspx (accessed June 3, 2012).

225. Robert A. Caro, *The Years of Lyndon Johnson: The Passage of Power* (New York: Alfred A. Knoft, 2012), 8. Caro also noted that although Andrew Johnson, a southerner from Tennessee, completed Abraham Lincoln's term, he was not elected. Maurice Isserman and Michael Kazin, *America Divided: The Civil War of the 1960s* (New York: Oxford University Press, 2000), 111.

226. Kennedy, *Radio and Television Report*, June 11, 1963.

227. Nell Irvin Painter, *Exodusters: Black Migration to Kansas after Reconstruction* (New York: W.W. Norton & Company, 1976), 108–09.

228. Benjamin Singleton, "Report and Testimony of the Select Committee of the United States Senate to Investigate the Cause of the Removal of the Negroes from the Southern States to the Northern States," 46th Cong., 2nd sess., 1880, S. Rep. 693, III, 382, emphasis in original, Kansas State Historical Society Archives.

229. Beccy Tanner, "'District Was Meeting Place': Former Slaves Started New Lives in Wichita," *Wichita Eagle*, March 16, 1989.

230. Singleton, Senate Report 693, III, 383–84.

231. Craig Miner, *Kansas: The History of the Sunflower State, 1854–2000* (Lawrence: University Press of Kansas, 2002), 81.

232. Warren M. Banner, *A Review of the Economic and Cultural Problems of Wichita, Kansas, January–February, 1965* (New York: National Urban League, 1965), 3.

233. Ibid.

234. Louis Goldman, Carl A. Bell Jr. et al., *School and Society in One City* (Wichita. KS: USD 259, July 1969), 28; U.S. Department of Commerce, Bureau of the Census, General Population Characteristics: Kansas (PC (1)-B18), Table 23.

235. "Travel Kansas Cross-Roads of a Continent," State Highway Commission of Kansas Map, 1945.

236. The American Institute of Aeronautics and Astronautics (AIAA)—Wichita Section, *Images of America: Wichita's Legacy of Flight* (Charleston, SC: Arcadia Publishing, 2003), 71.

237. AIAA, *Wichita's Legacy of Flight*, 9.

238. Gretchen Eick, "'Lift Every Voice': The Civil Rights Movement and America's Heartland, Wichita Kansas, 1954–1972" (PhD diss., University of Kansas, 1997), 77.

239. Banner, *Problems*, 5.

240. Ibid., 70.

241. Gretchen Cassel Eick, *Dissent in Wichita: The Civil Rights Movement in the Midwest, 1954–72* (Chicago: University of Illinois Press, 2001), 24.

242. Kansas Advisory Committee to the U.S. Commission on Civil Rights, *Police-Community Relations in the City of Wichita and Sedgwick County* (Washington, D.C.: U.S. Commission on Civil Rights, July 1980), 7.

243. *Topeka Capital Journal*, "23 Civilians Die," January 17, 1965.

244. Craig Miner, *Wichita: The Magic City* (Wichita, KS: Sedgwick County Historical Museum Association, 1988), 205.

245. Miner, *Magic City*, 201.

246. National Register of Historic Places, Calvary Baptist Church, Wichita, Kansas, National Register # 88001905, http://www.kshs.org/resource/national_register/nominationsNRDB/Sedgwick_CalvaryBaptistChurchNR.pdf (accessed June, 21, 2010); Dreck Spurlock Wilson, *African-American Architects: A Biographical Dictionary, 1865–1945* (New York: Routledge, 2004).

247. Calvary Baptist Church at 601 North Water and the Arkansas Valley Lodge building at 615 North Main are all that remain of the African American business district. See *Wichita Eagle*, "District Was Meeting Place," March 16, 1989. Josiah Walker reference cited in National Register of Historic Places, Calvary Baptist Church, Wichita, Kansas, National Register # 88001905.

248. National Register of Historic Places, Calvary Baptist Church.

249. Interview with Eric Key, recorded in *Sunflower Journeys* episode 1903—"Embracing Community" KTWU, 2006, produced by John Njagi.

250. Eick, "'Lift Every Voice,'" 79.

251. Angela Miller, "Changes in Location of the African American Community in Wichita: An Overview with Three Oral Histories," study for the Kansas African American Museum, History 520 (Wichita State University Class, Fall 2000, 11, Special Collections, Ablah Library, Wichita State University, Vertical File-Wichita-African American Community.

252. Ibid., 11.

253. Ibid.

254. Eick, *Dissent in Wichita*, 79.

255. Miner, *Magic City*, 205.

256. Ibid., 206.

257. Ibid., 205.

258. Eick, *Dissent in Wichita*, 22. Eick also notes that the Piatt area east of Grove was not open to African Americans until the later 1950s. The homes in this area were initially starter homes, built for whites who migrated from Oklahoma and Arkansas to work in the aircraft industries.

259. Gretchen Eick, interview with author, January 17, 2012.

260. Ibid.

261. Miner, *Magic City*, 171.

262. Eick, "'Lift Every Voice,'" 80.

263. Banner, *Problems*, 70.

264. Eick, "'Lift Every Voice,'" 155.

265. Banner, *Problems*, 70.

266. Eick, "'Lift Every Voice,'" 155.

267. Al Polczinski, "The Negro in Wichita," *Wichita Beacon*, July 5, 1967.

268. Ibid.

269. Sydney Harris, "How to End Prejudice," *Wichita Beacon*, October 4, 1965.

CHAPTER 12

270. House interview.

271. Carpenter and Wesley, "Community Response," 21.

272. Ibid., 21–22.

273. Mark 1:3 King James Version.

274. Miner, *Magic City*, 206.

275. *Eagle*, January 16, 1985.

276. House interview.

277. Deon Wolfenbarger, "African American Resources in Wichita, Sedgwick County, Kansas," Kansas State Historical Society, http://www.kshs.org/resource/national_register/MPS/AfricanAmericanResourcesinWichitaKS.pdf (accessed November 4, 2012), 15.

278. Restrictive covenant in Wichita, Abstract of Title, Lot 22, Block 1, Paul's Addition, quoted in Wolfenbarger, *African American Resources in Wichita*, 12.

279. Mike Wright, *What They Didn't Teach You About the '60s* (Novato, CA: Presidio Press, Inc., 2001), 53.

280. Ibid., 53.

281. Carpenter and Wesley, "Community Response," 42.

282. *Topeka Capital Journal*, "Bars Gleam Brightly," January 17, 1965.

283. Steve Sells, "Chute Cords' Role Called Negligible in Jet Crash," *Wichita Eagle*, January 20, 1965.

284. USAF, Aircraft Accident/Incident Report of KC-135 #57-1442 (Raggy 42), 1965.

285. Sells, "Chute Cords."

286. "Teardown Deficiency Report," 5A65-53-TDR-P, January 19, 1965.

287. Sells, "Chute Cords."

288. Ibid.

289. "Teardown Deficiency Report."

290. Ibid.

291. National Museum of the Air Force, Republic F-105D Thunderchief & F-100 Super Sabre in Southeast Asia, http://www.nationalmuseum.af.mil/factsheets/factsheet.asp?id=311 (accessed December 2012).

292. Air Force Historian Dan Williams, e-mail to author, January 30, 2013; Steve Larsen, *Heritage and Legacy: A Brief History of the 22d Air Refueling Wing and McConnell Air Force Base* (Office of History 22d Air Refueling Wing, 2006), 49.

293. While working for Boeing in 1965, Larry McDonough (who later became general counsel for Learjet) advised the author that several weeks after the crash he heard a Boeing employee (tug operator) speculate that a drogue chute from one of the bombers got sucked up into the KC-135's engine. How the employee obtained such knowledge was never determined, and the rumor was deemed unfounded. Larry McDonough, telephone interview with author, January 18, 2013.

294. Eugene Rogers, *Flying High: The Story of Boeing and the Rise of the Jetliner Industry* (New York: Atlantic Monthly Press, 1996), 180–81.

295. "Tex Johnston" YouTube video, 1:44, http://www.youtube.com/watch?v=X0sDN-CQZCs (accessed March 1, 2011).

296. Sells, "Chute Cords."

297. In a letter dated January 27, 1965, from a Ms. Clemmons of the Institute of Logepedics, she mentioned the "many small children and adults" who would have perished if the plane would have crashed there.

298. Gen. Murray M. Bywater, *KAKE News*, January 16, 1965, Tape #F0907, Special Collections, Ablah Library, Wichita State University.

299. Carpenter and Wesley, "Community Response," 43–44.

300. Survivor interview with author, January 11, 2012.

301. *Wichita Eagle and Beacon*, January 17, 1965.

CHAPTER 13

302. Roe, "Report Reveals."

303. Ron Sylvester, "Federal Judge Wesley Brown Dies at Age 104," *Wichita Eagle*, January 24, 2012. Kansas.com http://www.kansas.com/2012/01/24/2187734/federal-judge-wesley-brown-dies.html (accessed January 25, 2012).

304. A. G. Sulzberger, "Wesley E. Brown, Oldest Judge in Nation's History, Dies at 104," *New York Times*, January 25, 2012, http://www.nytimes.com/2012/01/26/us/wesley-e-brown-oldest-judge-in-nations-history-dies-at-104.html?_r=0 (accessed January 25, 2012).

305. Sylvester, "Federal Judge Wesley Brown."

306. Kent Britt, "Judge Removes Mystery Cloak from Jet Crash," *Wichita Beacon*, March 28, 1967.

307. Ibid.

308. Ibid.

309. Ibid.

310. Boeing Company, "Flight Data Recorder Rule Change," *Aero Magazine* 2 (Spring 1998), retrieved from http://www.boeing.com/commercial/aeromagazine/aero_02/textonly/s01txt.html (accessed November 4, 2012).

311. *Wichita Eagle*, "Air Force Delve For Cause of Tragedy," January 19, 1965.

312. Carpenter and Wesley, "Community Response," 43.

313. Bill Hirschman, "Autopilot Suspected, but Cause Unknown," *Wichita Eagle and Beacon*, January 16, 1985.

314. Lawrence V. Mott, *The Development of the Rudder: A Technological Tale*, Studies in Nautical Archaeology 3 (College Station: Texas A&M University Press, 1997).

315. USAF Pilot Ben Jamison, e-mail message to author, January 13, 2013.

316. Flight Manual USAF series KC-135R/T aircraft T.O. 1C-135(K)(I)-1 Reference Data, Change 12-1, March 2011.

317. Wolfgang Langewiesche, *Stick and Rudder: An Explanation of the Art of Flying* (New York: McGraw-Hill, 1972), 185.

318. Ibid., 185.

319. Clark Tibbitts, "Inventions and Discoveries," *American Journal of Sociology* 36, no. 6 (May 1931): 893, http://www.jstor.org/stable/2767450 (accessed November 4, 2011).

320. Ibid.

321. William Scheck, "Lawrence Sperry Genius on Autopilot," *Aviation History* 15, no. 2 (2004): 46–61. http://connection.ebscohost.com/c/articles/14271981/lawrence-sperry-genius-autopilot (accessed November 20, 2011).

322. *Airlift Tanker: History of U.S. Airlift and Tanker Forces* (Paducah, KY: Turner Publishing, 1995), 60, italics added.

323. Hirschman, "Autopilot Suspected."

324. Ibid.

325. Testimony of William S. Goodin, *Wichita Beacon*, January 16, 1965.

326. USAF Pilot Ben Jamison, e-mail message to author, January 13, 2013.

327. Hirschman, "Autopilot Suspected."

328. Second Air Force Accident/Incident Report, 57-1442, 1965.

329. Hirschman, "Autopilot Suspected."

330. Excerpt from the tape of Airplane 632 flown by a Boeing crew and KC-135 #57-1442 (Raggy 42) on January 12, 1965, Air Force Safety Center, Kirtland AFB, New Mexico.

331. Hirschman, "Autopilot Suspected."

332. Ibid.

333. Ibid.

334. Ibid.

CHAPTER 14

335. National Transportation Safety Board, Aircraft Accident Report of United Airlines Flight 585, NTSB Libraries, http://www.ntsb.gov/doclib/reports/2001/AAR0101.pdf (accessed November 12, 2011), 4 and Appendix D (air/ground communications).

336. Ibid.

337. Ibid.

338. NTSB, "Uncontrolled Collision with Terrain for Undetermined Reasons, United Airlines Flight 585, Boeing 737-291, N999UA, 4 Miles South of Colorado Springs, Colorado, March 3, 1991," Aircraft Accident Report NTSB/AAR-92/06, Washington, D.C., 1992.

339. NTSB, "Uncontrolled Collision with Terrain, United Airlines Flight 427, Boeing 737-300, N513AU near Aliquippa, Pennsylvania September 8, 1994," Aircraft Accident Report NTSB/AAR-99/01, Washington, D.C., 1994, 6.

340. Bill Adair, *The Mystery of Flight 427: Inside a Crash Investigation* (Washington, D.C.: Smithsonian Institution Press, 2002), 44.

341. NTSB, Aircraft Accident Report NTSB/AAR-99/01, 52.

342. Ibid.

343. Ibid.

344. Ibid.

345. Adair, *Mystery of Flight 427*, 162–63.

346. NTSB, Aircraft Accident Report NTSB/AAR-99/01, 77.

347. NTSB, Aircraft Accident Report of United Airlines Flight 585, NTSB Libraries, http://www.ntsb.gov/doclib/reports/2001/AAR0101.pdf (accessed November 12, 2011), 112.

348. NTSB, Aircraft Accident Report NTSB/AAR-99/01, 295.

349. Ibid., 295.

350. See Adair's substantive investigation, *Mystery of Flight 427*, for more information on unscheduled rudder deflection and the three flights mentioned.

351. NTSB, Aircraft Accident Report of United Airlines Flight 585.

352. Roe, "Report Reveals."

353. USAF, Aircraft Accident Report, KC-135 #57-1442 (Raggy 42), 1965.

354. Ibid.

355. Roe, "Report Reveals."

356. Ibid.

357. David McCullough, *The Course of Human Events*, CD, 2005, read by the author (New York: Simon and Schuster Audio, 2005).

358. Also see R. Key Dismukes, Benjamin A. Berman, Loukia D. Loukopoulos, *The Limits of Expertise: Rethinking Pilot Error and the Causes of Airline Accidents* (Burlington, VT: Ashgate Publishing, 2007), 231, 294. The authors describe the crash of American Flight 1340 on February 9, 1998, at O'Hare International Airport, Chicago, Illinois, in which the autopilot malfunctioned and "drove the aircraft toward the ground near decision height." The authors stated, "We suggest that these situations severely challenge human capabilities and that it is unrealistic to expect reliable performance, even from the best of pilots." David Gero, *Aviation Disasters: The World's Major Civil Airliner Crashes Since 1950*, 4th ed. (London: Haynes Publishing, 2006), 47–48. Gero describes how on March 1, 1962, a Boeing 707-123B (N7506A) American Airlines Flight 1 leaving New York International Airport to Los Angeles experienced "unexpected rudder deflection to the left, producing yaw, side-slip and roll that in turn led to a loss of control." Frayed wires on the rudder control system caused a "'hard-over' signal by the yaw damper, a mechanism designed to sense the onset of a lateral control abnormality and automatically adjust the rudder, and of which the servo is a component."

Chapter 15

359. Wichita City Manager Russell E. McClure to Congressman Garner E. Shriver, May 4, 1966, MS7701, Box 9, Garner Shriver Papers, Wichita State University Libraries, Special Collections and University Archives.

360. Carpenter and Wesley, "Community Response," 31.

361. Robert C. Casad, "A Commentary on the Kansas Wrongful Death Act," 13 U. Kan. L. Rev. 515 (1964–1965), 523, http://hdl.handle.net/1808/861 (accessed June 12, 2011).

362. Colonel Dwight W. Covell to Congressman Garner E. Shriver, May 8, 1967, Shriver Papers.

363. Guide to Congressional Papers of Kansas Congressman Garner E. Shriver, Special Collections, Ablah Library, Wichita State University, http://specialcollections. wichita.edu/collections/ms/77-01/77-1-a.pdf (accessed January 22, 2013).

364. Garner E. Shriver to Frank T. Priest, August 10, 1965, Shriver Papers.

365. H.R. Report No. 104, 89th Cong.,1st sess., February 24, 1965. Sec.3; H.R. 8958-Public Law 87-393 for Midwest City crash; H.R. 11644, Public Law 86-476 for Little Rock crash, Shriver Papers.

366. "Remove Limit 1st Session on Claims McConnell Air Crash," Public Law 89-65, 89th Cong., 1st sess., 1965. Shriver Papers.

367. Ibid., sec 3.

368. Cotter, *Jet Tanker Crash*, 137, italics in original.

369. Dale W. Bruce to Congressman Garner E. Shriver, April 26, 1967, Shriver Papers.

370. Cornelius P. Cotter to Lester Brown, March 24, 1967, Shriver Papers.

371. Dolores Quinlisk, "KC-135 Crash Hardships Linger," *Wichita Eagle*, August 5, 1965.

372. *Wichita Eagle*, "Damage Suit Action in KC-135 Crash Halts for Data on Similar Accidents," March 29, 1967.

373. Clarence William Walker, interview, March 1969, Shriver Papers.

374. Report of the Fair-Mark Committee, 1967, 1, Shriver Papers.

375. Dale W. Bruce to Congressman Garner E. Shriver, April 21, 1967, Shriver Papers.

376. "Remove Limit 1st Session on Claims McConnell Air Crash."

CHAPTER 16

377. Report of the Fair-Mark Committee, 1967, 12, Shriver Papers.

378. Marvin Barnes, "KC-135 Crash Payments Now Total $386,377," *Wichita Beacon*, November 25, 1967.

379. Ibid.; Kathy Sipult, "A Day of Death Vivid After 5 Years," *Wichita Eagle*, January 16, 1970.

380. Civil Action Case #3585, Report of the Fair-Mark Committee, 1967, 5, Shriver Papers.

381. Ibid.

382. Nancy Harris, "8 Suits Settled In 1965 Crash: U.S. to Pay $160,000 in Tanker-Crash Suits," *Wichita Eagle*, March 27, 1967.

383. Summary Report of Claims, Air Force Accident, January16, 1965, Wichita, Kansas, Shriver Papers.

384. Harris, "8 Suits Settled."
385. Ibid.
386. Ibid.
387. Ibid.
388. Barnes, "KC-135 Crash Payments."
389. Ibid.
390. Hirschman, "Destruction Stunned City."
391. Clayton Koppes, "Victim of Disaster Lives in Agony," *Wichita Eagle,* January 17, 1966.
392. Harris, "8 Suits Settled."
393. Hirschman, "Destruction Stunned City."
394. Memo from Congressman Garner E. Shriver, "Recap-Air Force Claims Wichita Air Disaster-1-16-1965," Shriver Papers.
395. Hirschman, "Destruction Stunned City"; *Wichita Eagle,* "Damage Suits in Jet Tanker Crash Pass $1-Million," February 22, 1966.
396. Memo from Congressman Garner E. Shriver.
397. Marvin Barnes, "Boeing Wins Crash Suit Dismissal," *Wichita Beacon,* January 15, 1968.
398. Harris, "8 Suits Settled."
399. Cotter, *Jet Tanker Crash,* 153.
400. Widseth interview.
401. Hubar interview.

CHAPTER 17

402. Bill Hirschman, "Day Will Not Die for Those Who Watched In Horror," *Wichita Eagle,* January 16, 1985.
403. Joshua 5:6, King James Version.
404. David McCullough, *The Path Between the Seas: The Creation of the Panama Canal, 1870–1914* (New York: Simon and Schuster), 1977.
405. Judith R. Johnson and Craig L. Torbenson, "Stories from the Heartland: African American Experiences in Wichita, Kansas," *Kansas History* 21, no.4 (1998–99): 222.
406. Ibid.
407. Kathy Sipult, "After 5 Years, Cold Day of Fiery Death Is Vivid," *Wichita Eagle,* January 16, 1970.
408. Widseth interview.
409. Deb Gruver, "Crash Victims Given Tribute Families Recall Tragic Incident," *Wichita Eagle,* June 10, 2001.
410. John Polson, telephone interview with author, January 31, 2013.
411. Ibid.

412. *Wichita Eagle and Beacon*, "WSU Grid Team Plane Crashes; 29 of 40 Aboard Feared Dead," October 3, 1970; National Transportation Safety Board, Martin 404, N464M 8 Statute Miles West of Silver Plume, Colorado, October 2, 1970. Aircraft Accident Report NTSB/AAR-71-4, Washington, D.C., 1970. http://www.airdisaster.com/reports/ntsb/AAR71-04.pdf (accessed November 12, 2012).

413. "Memorial Fund Plans Formed," *The Sunflower* 75, no. 11 (October, 9, 1970); "Football 70 Funds Grow to 11,600 in Donations," *The Sunflower* 75, no. 13 (October 16, 1970), FF 1-47, Box 7, Wichita State University Libraries, Special Collections and University Archives.

414. Thomas Carter, interview with author, January 18, 2013.

415. City Council Proceedings, (Wichita, Kansas), City of Wichita Council Minutes, January 10, 2006, www.wichita.gov/NR/.../0/01102006Council_Minutes.doc (accessed December 12, 2012).

416. Quote from Dr. Carla Lee during the City Council Proceedings in Wichita, Kansas, December 19, 2006. The total cost of the project is also noted in the same meeting, www.wichita.gov/NR/rdonlyres/.../12192006MINUTES.doc (accessed December 12, 2012).

417. Christiana M. Woods, "Memorial in Place, 42 Years," *Wichita Eagle*, June 29, 2007.

418. Wichita Park and Recreation, "Piatt Memorial Park," the City of Wichita Website, http://www.wichita.gov/CityOffices/Park/Parks/PiattMemorial/ (accessed December 12, 2012); City Council Proceedings, (Wichita, Kansas), City of Wichita Council Minutes November 9, 2004, www.wichita.gov/nr/.../0/11092004council_minutes.doc (accessed December 12, 2012).

Epilogue

419. Dr. Martin Luther King Jr., "Struggle for Racial Justice," speech at Recognition Dinner, Atlanta, Georgia, January 27, 1965 (*Newsweek* file, Emory University Special Collections, Atlanta Georgia).

420. Clyde G. Stevens, e-mail message to author, April 9, 2013.

BIBLIOGRAPHY

BOOKS

Adair, Bill. *The Mystery of Flight 427: Inside a Crash Investigation*. Washington, D.C.: Smithsonian Institution Press, 2002.

Boyne, Walter J. *Beyond the Wild Blue: A History of the United States Air Force, 1947–2007*. 2nd ed. New York: St. Martin's Press, 2007.

Budiansky, Stephen. *Air Power: The Men, Machines, and Ideas That Revolutionized War, from Kitty Hawk to Gulf War II*. New York: Penguin Group, 2004.

Caro, Robert A. *The Years of Lyndon Johnson: The Passage of Power*. New York: Alfred A. Knopf, 2012.

Cotter, Cornelius P. *Jet Tanker Crash: Urban Response to Military Disaster*. Lawrence: University of Kansas Press, 1968.

Creveld, Martin Van. *The Age of Air Power*. New York: Public Affairs, 2011.

Douhet, Giulio. *The Command of the Air*. New York: Coward-McCann, Inc., 1942. Reprint, Washington, D.C.: Office of Air Force History, 1983.

Eick, Gretchen Cassel. *Dissent in Wichita: The Civil Rights Movement in the Midwest, 1954–72*. Chicago: University of Illinois Press, 2001.

Gilbert, Bill. *Air Power: Heroes and Heroism in American Flight Missions, 1916 to Today*. New York: Citadel Press, 2003.

Hall, R. Cargill, ed. *Case Studies in Strategic Bombardment*. Washington, D.C.: Air Force History and Museums Program, 1988.

Herman, Judith. *Trauma and Recovery: The Aftermath of Violence from Domestic Abuse to Political Terror*. New York: Basic Books, 1992.

Herring, George C. *America's Longest War: The United States and Vietnam, 1950–1975*. 4th ed. New York: McGraw-Hill, 2002.

Heywood, Joseph. *Covered Waters: Tempests of a Nomadic Trouter*. Guilford, CT: Lyons Press, 2003.

Isserman Maurice, and Michael Kazin. *America Divided: The Civil War of the 1960s*. New York: Oxford University Press, 2000.

Kohn, Richard H., and Joseph P. Harahan, eds. *Strategic Air Warfare*. USAF Warrior Studies. Washington, D.C.: Office of Air Force History, 1988.

Langewiesche, Wolfgang. *Stick and Rudder: An Explanation of the Art of Flying*. New York: McGraw-Hill, 1972.

Larsen, Steve. *Heritage and Legacy: A Brief History of the 22d Air Refueling Wing and McConnell Air Force Base*. Office of History 22d Air Refueling Wing, 2006.

McFarland, Steven L. *A Concise History of the U.S. Air Force*. Air Force History and Museums Programs. Fort Belvoir, VA: Defense Technical Information Center, 1997.

McWilliams, John C. *The 1960s Cultural Revolution*. Westport, CT: Greenwood Press, 2000.

Miner, Craig. *Kansas: The History of the Sunflower State, 1854–2000*. Lawrence: University Press of Kansas, 2002.

———. *Wichita: The Magic City*. Wichita, KS: Wichita-Sedgwick County Historical Museum Association, 1988.

Moody, Walton S. *Building a Strategic Air Force*. Washington, D.C.: Air Force History and Museums Program, 1996.

Mott, Lawrence V. *The Development of the Rudder: A Technological Tale*. Studies in Nautical Archaeology 3. College Station: Texas A&M University Press, 1997.

Painter, Nell Irvin. *Exodusters: Black Migration to Kansas after Reconstruction*. New York: W.W. Norton & Company, 1976.

Paret, Peter, ed. *Makers of Modern Strategy: From Machiavelli to the Nuclear Age*. Princeton, NJ: Princeton University Press, 1986.

Price, Jay. *Wichita's Legacy of Flight*. Charleston, SC: Arcadia Publishing, 2003.

Rodgers, Eugene. *Flying High: The Story of Boeing and the Rise of the Jetliner Industry*. New York: Atlantic Monthly Press, 1996.

Turner Publishing, *Airlift Tanker: History of U.S. Airlift and Tanker Forces*. Paducah, KY: Turner Publishing, 1995.

Wilson, Dreck Spurlock. *African-American Architects: A Biographical Dictionary, 1865–1945*. New York: Routledge, 2004.

Wright, Mike. *What They Didn't Teach You About the 60s*. Novato, CA: Presidio Press, Inc., 2001.

NEWSPAPERS

Kansas City Star
Lawrence Journal-World
London Times
New York Times
Topeka Capital Journal

Wichita Beacon
Wichita Eagle

Manuscript Sources and Archives

Disaster Research Center, University of Delaware Library, Newark, DE.

Kansas Collection, Spencer Research Library, University of Kansas, Lawrence, KS.

Kansas Firefighters' Museum Archives, Wichita, KS.

Kansas State Historical Society, Topeka, KS.

Special Collections, Ablah Library, Wichita State University, Wichita, KS.

Topeka-Shawnee County Public Library, Topeka, KS.

Wichita Public Library, Wichita, KS.

Wichita-Sedgwick County Historical Museum, Wichita, KS.

Articles

American Aviation Historical Society. "Boeing KC-135 Celebrates Fifty Years of Service." September 8, 2006. http://www.aahs-online.org/articles/KC-135_turns_50.php (accessed January 12, 2012).

Boeing Company. "Flight Data Recorder Rule Change." *Aero Magazine* 2 (Spring 1998). Retrieved from: http://www.boeing.com/commercial/aeromagazine/aero_02/textonly/s01txt.html (accessed November 4, 2012).

Casad, Robert C. "A Commentary on the Kansas Wrongful Death Act." 13 U. Kan. L. Rev. 515 (1964–1965). http://hdl.handle.net/1808/861 (accessed June 12, 2011).

Colella, Rick. "Overweight Landing? Fuel Jettison? What to Consider." *Aero* Magazine 3rd Quarter (2007). http://www.boeing.com/commercial/aeromagazine/articles/qtr_3_07/AERO_Q307_article3.pdf (accessed June 3, 2012).

Johnson, Judith R., and Craig L. Torbenson, "Stories from the Heartland: African American Experiences in Wichita, Kansas." *Kansas History* 21, no. 4 (1998–99).

Lautenschläger, Karl. "Controlling Military Technology." *Ethics* 95, no. 3, Special Issue: *Symposium on Ethics and Nuclear Deterrence* (April 1985). http://www.jstor.org/stable/2381045 (accessed October 11, 2012).

Scheck, William. "Lawrence Sperry Genius on Autopilot." *Aviation History* 15, no. 2 (2004). http://connection.ebscohost.com/c/articles/14271981/lawrence-sperry-genius-autopilot (accessed November 20, 2011).

Stone, Jeremy J. "Bomber Disarmament." *World Politics* 17, no. 1 (October 1964). http://www.jstor.org/stable/2009385 (accessed October 11, 2012).

Tibbitts, Clark. "Inventions and Discoveries" *American Journal of Sociology* 36, no. 6 (May 1931). http://www.jstor.org/stable/2767450 (accessed November 4, 2011).

DISSERTATIONS AND PAPERS

Eick, Gretchen. "'Lift Every Voice': The Civil Rights Movement and America's Heartland, Wichita Kansas, 1954–1972." PhD diss., University of Kansas, 1997.

Miller, Angela. "Changes in Location of the African American Community in Wichita: An Overview with Three Oral Histories." Study for the Kansas African American Museum, Fall 2000. Special Collections, Ablah Library, Wichita State University.

PUBLIC DOCUMENTS

National Register of Historic Places, Calvary Baptist Church, Wichita, Kansas, National Register # 88001905. http://www.kshs.org/resource/national_register/nominationsNRDB/Sedgwick_CalvaryBaptistChurchNR.pdf (accessed June, 21, 2010).

National Research Council, Committee on Analysis of Air Force Engine Efficiency Improvement Options for Large, Non-fighter Aircraft, National Research Council. Improving the Efficiency of Engines for Large Non-fighter Aircraft. Washington, D.C.: National Academies Press, 2007.

Singleton, Benjamin. Senate Report 693, III: 382.

Tonkin Gulf Resolution. Public Law 88-408, 88th Congress, August 7, 1964. General Records of the United States Government. Record Group 11. National Archives.

WEBSITES

Boeing.com. "Defense, Space and Security: KC-135 Stratotanker." http://www.boeing.com/defense-space/military/kc135-strat/index.html (accessed January 12, 2012).

Crowder, James L. "Clinton-Sherman Air Force Base." Oklahoma Historical Society. http://digital.library.okstate.edu/encyclopedia/entries/C/CL017.html (accessed January 21, 2012).

National Museum of the Air Force. "Republic F-105D Thunderchief & F-100 Super Sabre in Southeast Asia." http://www.nationalmuseum.af.mil/factsheets/factsheet.asp?id=311 (accessed December 2012).

Wichita Park and Recreation. "Piatt Memorial Park." City of Wichita Website. http://www.wichita.gov/CityOffices/Park/Parks/PiattMemorial/ (accessed December 12, 2012).

REPORTS

Banner, Warren M. A Review of the Economic and Cultural Problems of Wichita, Kansas, January-February, 1965. New York: National Urban League, 1965.

Carpenter, Frank H., and Leonard H. Wesley Jr. "Community Response to Tragedy: A Case Study of the Air Crash of January 16, 1965 in Wichita, Kansas."

Department of Political Science, Wichita State University, May 21, 1965. University of Delaware, Disaster Research Center Library.

City Council Proceedings (Wichita, Kansas). City of Wichita Council Minutes, January 10, 2006. www.wichita.gov/NR/.../0/01102006Council_Minutes.doc (accessed December 12, 2012).

Goldman, Louis, Carl A. Bell Jr., et al. School and Society in One City. Wichita, KS: USD 259, July 1969.

H.R. Report No. 104, 89th Cong. 1st sess., February 24, 1965.

Kansas Advisory Committee to the U.S. Commission on Civil Rights. Police-Community Relations in the City of Wichita and Sedgwick County. Washington, D.C.: U.S. Commission on Civil Rights, July 1980.

McGaughey, Tom. "Fire from the Sky Over Wichita." Disaster Research Center Library, University of Delaware.

National Transportation Safety Board. "Uncontrolled Collision with Terrain for Undetermined Reasons, United Airlines Flight 585, Boeing 737-291, N999UA, 4 Miles South of Colorado Springs, Colorado, March 3, 1991." Aircraft Accident Report NTSB/AAR-92/06. Washington, D.C., 1992.

———. "Uncontrolled Collision with Terrain, United Airlines Flight 427, Boeing 737-300, N513AU near Aliquippa, Pennsylvania, September 8, 1994." Aircraft Accident Report NTSB/AAR-99/01. Washington, D.C., 1994.

Parr, Arnold L. "A Brief View of the Adequacy and Inadequacy of Disaster Plans and Preparations in Ten Community Crises." Ohio State University, Department of Sociology, June 1969. University of Delaware, Disaster Research Center Library.

The Report of the Fair-Mark Committee, 1967. Special Collections, Ablah Library, Wichita State University.

Second Air Force Accident/Incident Report, 57-1442, 1965. Air Force Safety Center. Kirtland AFB, New Mexico.

U.S., Department of Commerce, Bureau of the Census. General Population Characteristics: Kansas (PC (1)-B18). Table 23.

Winter & Company. "A Survey of the Visual Character and Design Principles for Building in the College Hill Neighborhood." Design in the College Hill Neighborhood, Wichita, Kansas. September 1998. Winter & Company, Boulder, Colorado. Special Collections, Ablah Library, Wichita State University.

Wolfenbarger, Deon. "African American Resources in Wichita, Sedgwick County, Kansas." Kansas State Historical Society. http://www.kshs.org/resource/national_register/MPS/AfricanAmericanResourcesinWichitaKS.pdf (accessed November 4, 2012).

INDEX

A

Adams, James M. 20
aerial refueling 46
Air Refueling Wing
 ARW 11
Allen, Alvin T. 69
Autopilot (KC-135) 20, 101, 103, 104,
 111, 147

B

B-52 43
Black, Lawrence E. 59
"block busting" 82
Boeing Aircraft Company 46
Bolden, Albert L. 29
Brown, Wesley E. 96
Bywater, Murray M. 54, 139, 145

C

Carpenter, Frank 74
Churchill, Winston 61
Clinton-Sherman Air Force Base 11
Collateral Investigation Board Report
 97, 101, 110
Cotter, Cornelius P. 115, 119

D

Dale, Harvey 118
Daniels, Victor 24
Davidson, John L. 3, 15
death toll 62
disaster plan
 "Wichita Disaster Plan" 35
Douhet, Giulio 43, 137, 151

E

Eick, Gretchen Cassel 83, 142

F

Fair-Mark Committee 116
Faust-Goudeau, Oletha 125
Federal Tort Claims Act 114

G

Garmon, James E. 73, 75, 141
Goodwin, Guy L. 98, 114
Gulf of Tonkin Resolution 10

H

Hayes, Edmond G. 75, 117
House, Sonya 22, 88
H.R. 4546 114

J

Jackson, Robert 28, 69
Jenkins, Joseph W. 3, 15
Johnson, Lyndon B. 10, 114, 129

K

Kelley, Pat 67, 69
Kenenski, Daniel E. 3, 14
King, Martin Luther, Jr. 76
Klem, Thomas 54

L

Lewis, Chester I. 83, 84, 89, 94, 98,
 110, 111, 114

M

Martin, Joe T. 29, 118
Mason, J. E. 29
Massey, Delbert J. 21, 54
McConnell Air Force Base 10, 51
McGaughey, Tom 24, 31, 33, 69, 136
McKee, Kenneth 21
Memorial
 Piatt Street Memorial 125
Meyers, George 69, 75, 117
Migration
 African-American Exodus 79, 89

N

National Transportation Safety Board
 NTSB 106

O

O'Keefe, Terry 97
Operation Holiday 71, 74
Operation Lucky Number 10, 11, 18,
 42, 51
Organizational Maintenance Squadron
 OMS 11

P

Polson, John 125, 126, 149

Pond, E. M. 39
Power control unit
 PCU 107

R

Residential segregation 84, 88, 89

S

settlement process 112
Shriver, Garner E. 113
Singleton, Benjamin "Pap" 78
Strategic Air Command 10
 SAC 10, 11, 18, 42, 43, 46, 48, 51,
 53, 71, 133
Sullivan, Arthur W. 3, 15
Szmuc, Czeslaw 3, 11, 16, 17, 18, 19,
 20, 21, 53, 54, 55, 56, 92, 94,
 101, 103, 104, 110

T

Tactical Air Command
 TAC 10
temporary duty assignment
 TDY 14
Trask, James 52

U

"unscheduled rudder displacement" 101

W

Walker, Clarence 28, 74
Went, Reginald 3, 15
Wesley, Leonard 74
Wichita Fire Department 37
Wichita Police Department 39
Wichita State University
 WSU 55, 92, 136, 143, 147, 150,
 153, 155
Widseth, Gary J. 3, 12
Widseth, Jeanine 12

Z

Zuckert, Eugene M. 114

ABOUT THE AUTHOR

D. W. Carter is a historian, author and educator in Kansas, specializing in military and social history. Originally from Elizabethtown, Kentucky, Carter first arrived in Wichita upon military orders stationing him at McConnell Air Force Base in 2003. Since then, Carter considers himself a transplant Kansan who currently resides in its capital city, Topeka.

D. W. Carter with his 1941 Corona typewriter. *Author's collection.*

* 9 7 8 1 5 4 0 2 0 8 4 9 1 *